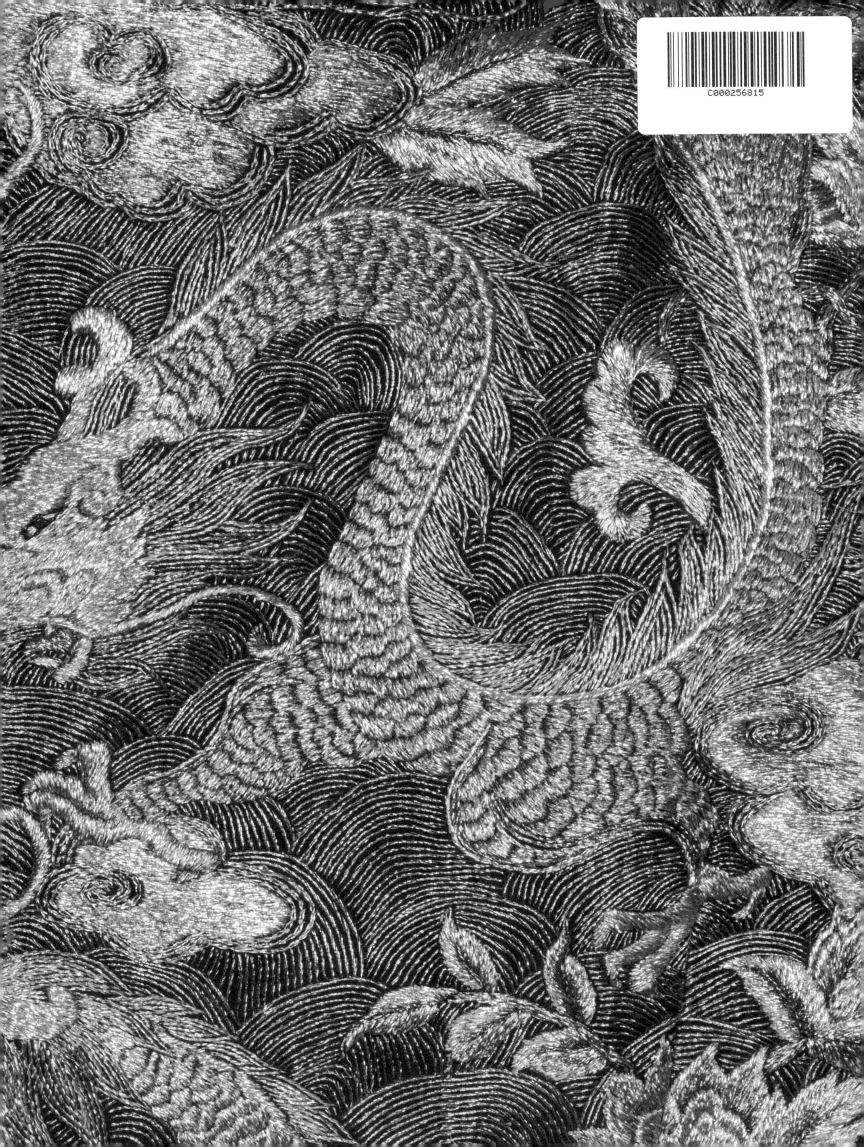

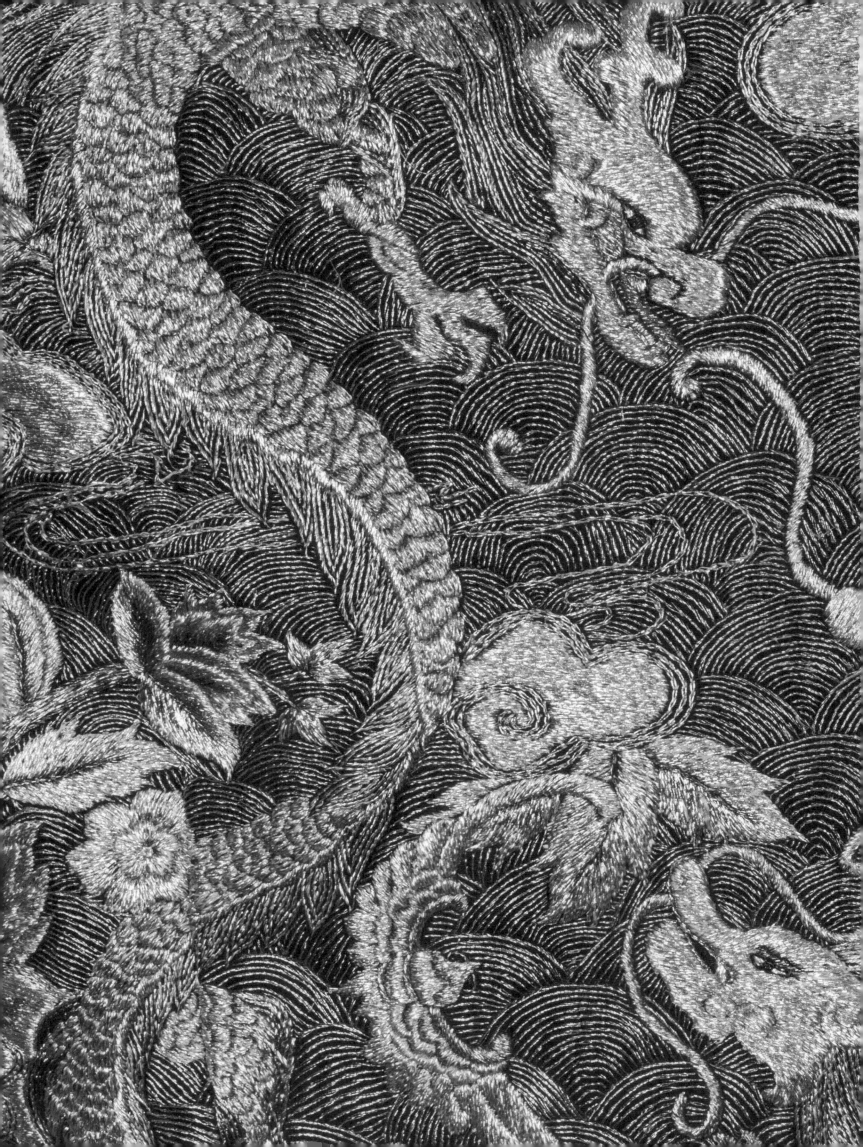

GUO PEI

COUTURE
BEYOND

Liebe Lea!

Toï Toï Toï
für die Premiere "Die Gezeichneten"
und vielen Dank für
Deine Arbeit !!! ...

Klaus

Zürich 23.09.2018

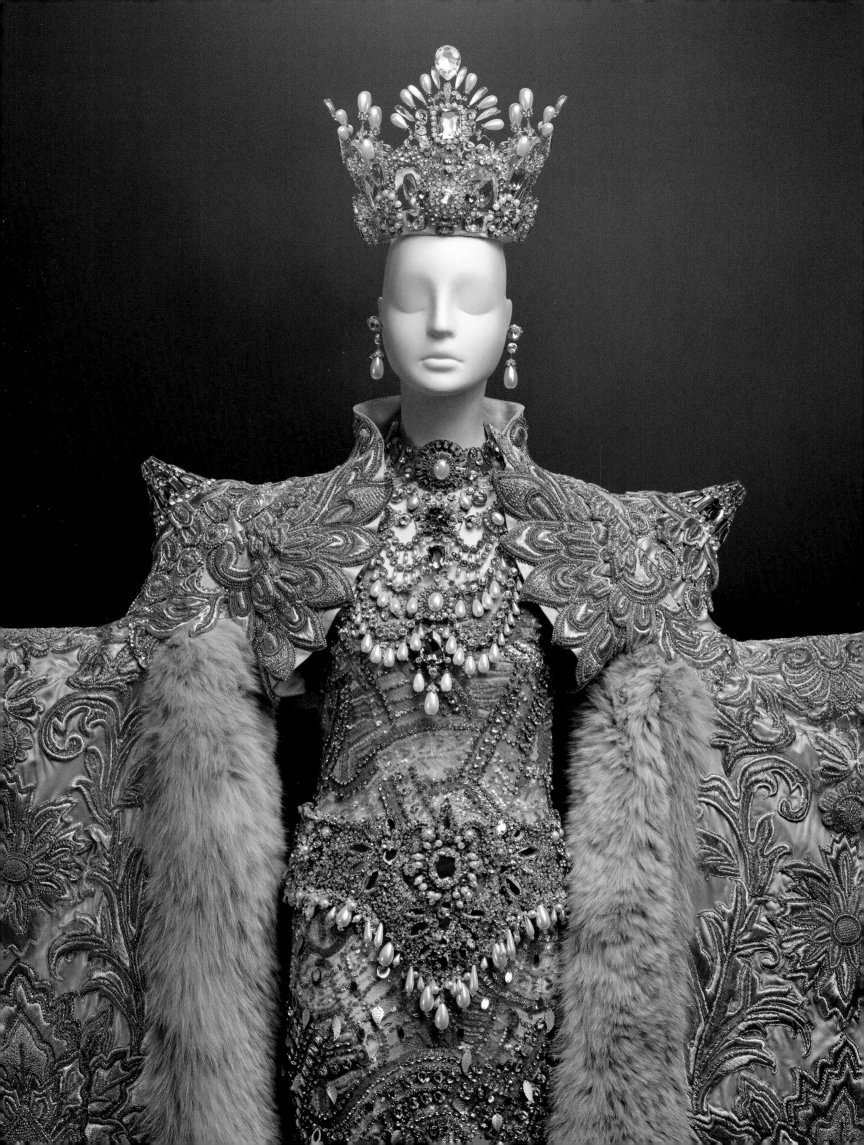

GUO PEI
COUTURE
BEYOND

FOREWORD BY
PAULA WALLACE

INTRODUCTION BY
LYNN YAEGER

PHOTOGRAPHY BY
HOWL COLLECTIVE

Rizzoli **Electa**

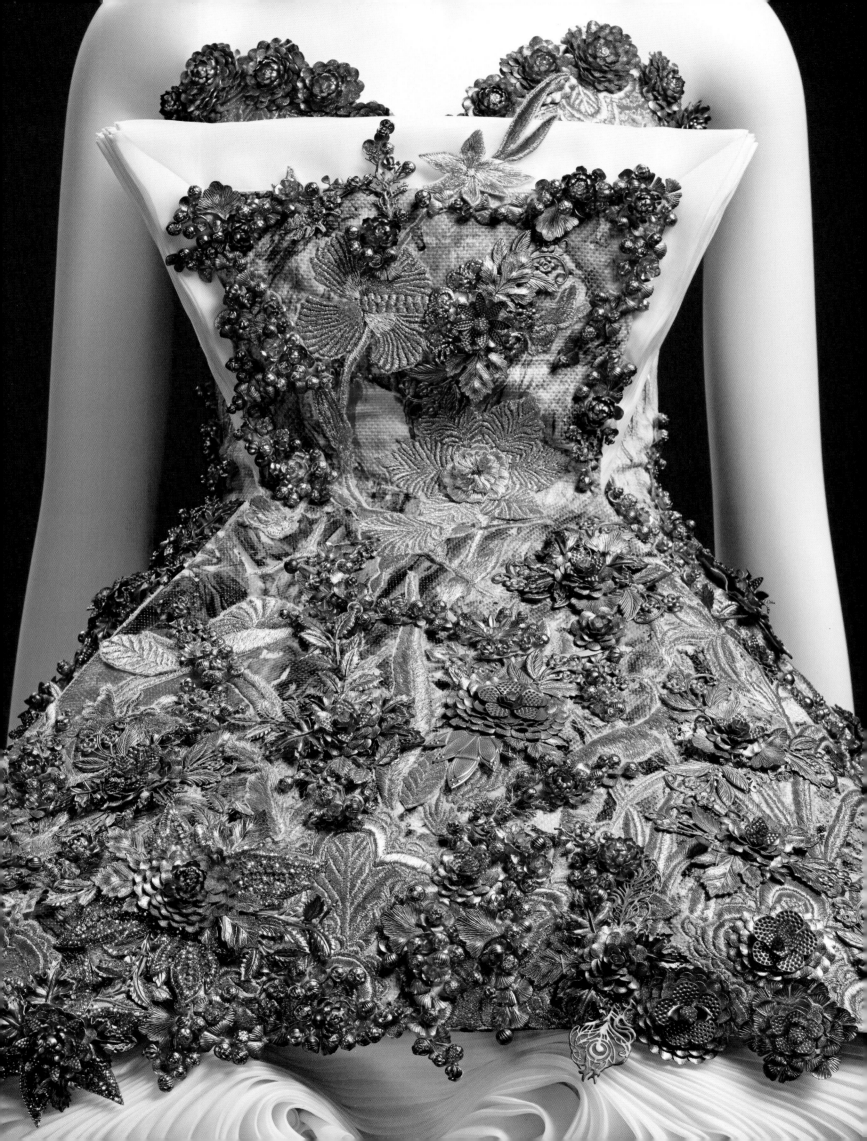

CONTENTS

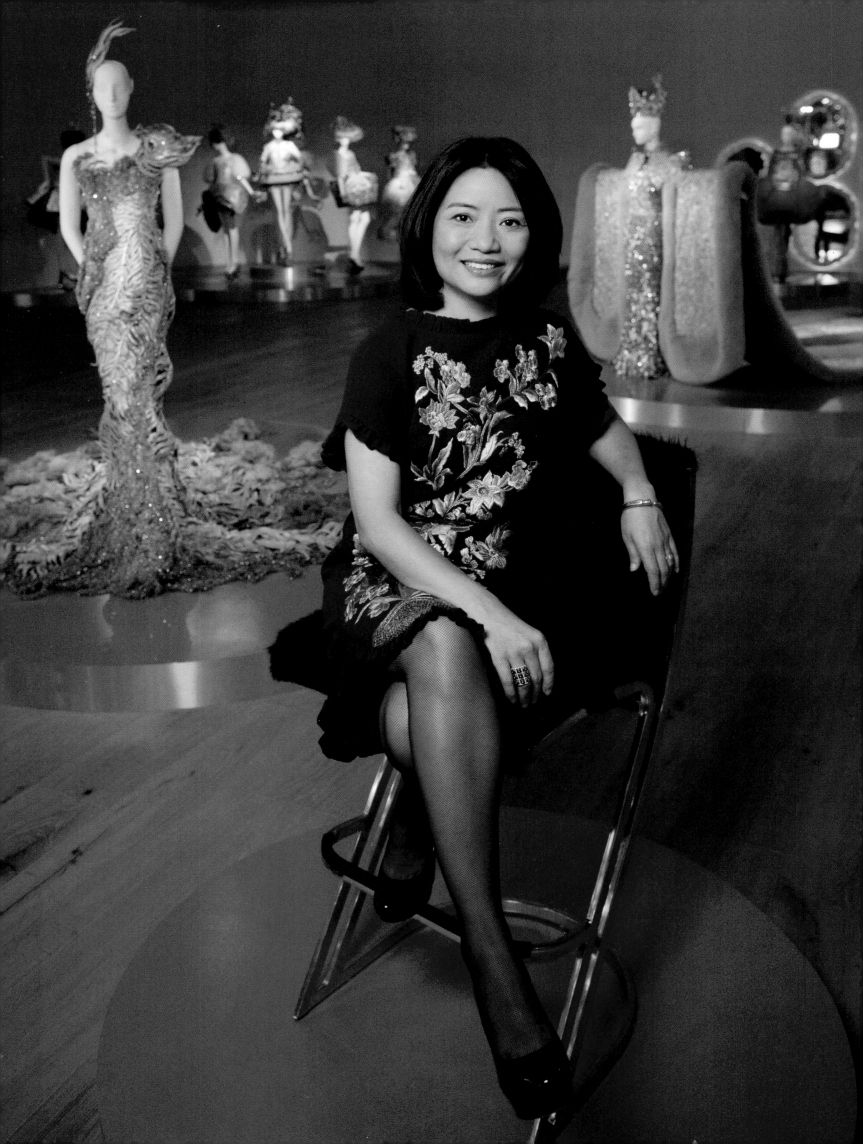

THE GRANDEST LESSON OF GUO PEI

FOREWORD BY PAULA WALLACE

Prepare to be transported.

This transcendent volume, the world's first book to present the boundless oeuvre of Chinese *couturière* Guo Pei, will transform you. Drawing from China's cultural history, the peerless designer marries imperial mythos with her own treasury of personal history to create garments that confound the imagination. Her technical precision, combined with the sheer grandeur of her vision, works a kind of magic on you.

Guo's journey from her childhood in Beijing to the venerable Chambre Syndicale de la Haute Couture in Paris provides an inspiring story for students and ambitious designers the world over. She began working as a designer in 1987, at the age of twenty, in the very nascence of her nation's rise to global prominence. Within a decade, celebrities and personalities throughout China clamored to wear her creations. If the carpet was red, the gown was Guo Pei. Her debut on the world stage occurred in the summer of 2008, when nearly three hundred of her designs were featured during the opening, closing, and medal ceremonies of the Beijing Olympics. The world took note. The world wanted more.

Today, Guo leads three hundred embroiderers and two hundred designers and technicians at her ateliers in Beijing and Paris. These master artisans create more than three thousand fashion works every year for more than five hundred clients across the globe. Guo Pei also presents at Paris Couture Week.

Her talents are multifarious, dizzying, kaleidoscopic. She is a storyteller, memoirist, visionary, entrepreneur, and cultural archivist; each garment weaves together literary, autobiographical, and historical references with tailoring and detail that astonish in scope and sophistication. These creations embody a tactile paradox — technically perfect and perfectly organic, such as the triple-tiered tutu on page 28 or the delicate folioed pleats of the dress on page 38.

When presented with such manifold opulence, the most natural reactions are humility and awe. Standing in the presence of these creations shakes the soul from its mooring, like looking upon Jan and Hubert Van Eyck's Ghent Altarpiece or Raphael's *The School of Athens* for the first time. The mind reels.

From whence could such genius spring?

Guo was born in her grandmother's house in Beijing, near the Sun Temple, a royal park, where her family took walks every evening. As a girl, she was enthralled by the ancient symbology of her childhood, as well as by the family stories her grandmother would tell — stories of seeing imperial gowns, of embroidering butterflies and peonies for her own dresses in the last years of the Qing Dynasty. Young Guo would fall fast asleep, dreaming of clothes as impossibly multiform and layered as the Forbidden City itself. What we see when we look at Guo's designs today are the manifestations of that dreamed reality.

HOWL, the photography collective that produced the otherworldly images in this book — and which includes SCAD photography alumni Jim Lind, Patrick O'Brien, and Elliot Ross, along with Forest Woodward — have created a fabulistic mise-en-scène that seems born in the mind of Guo herself. Every page invites the viewer to step through the looking glass and into a world where East and West, past and future, dream and reality, live in a complementary coexistence, a Double Happiness of design.

HOWL captured these photographs in the Lowcountry of Georgia and South Carolina, near the university's campus in Savannah, a landscape rife with its own magic, lore, and paradox. Contradictions shimmer and hum on the page. A porcelain siren rises from the sea, beneath the sentinel stare of the historic Cockspur Island Light, at the mouth of the Savannah River (pages 62–63). Sumptuous golden gowns rake across timeless sands (pages 86–87), evocative of what seems to be one of Guo's ultimate themes: time itself.

Time is the great lesson of Guo's oeuvre, for time is the greatest luxury of all. Her clothes themselves feel timeless, the garments of gods, eternal, immortal.

Guo's legacy, which will only grow in the coming decades, teaches future generations of designers through the opulent character of her work, the daring trajectory of her career, and her unceasing pursuit of perfection in every realm of life and work. She and SCAD share much in common, including a belief in the power of history to inform innovation and a desire to be a positive force in the world, always focused on the good, the true, the beautiful.

This book promises to transport you to destinies unbound. Brace yourself, dear reader, for your very breath to be taken from you. And then breathe. Let the beauty fill you. This is couture, beyond.

MADE IN CHINA

INTRODUCTION BY LYNN YAEGER

When Guo Pei was a little girl, her grandmother used to tell her bedtime stories about the sumptuous ensembles that fine ladies wore before the Communists came to power—fantasias of silk and satin, marvels of ornamentation and opulence. "My grandmother taught me about elegance," Guo recalls. "Every night when I was four or five, she described the dresses that women wore in the old days, and I pictured them before I fell asleep.... She told me about how she used a thread to embroider flowers onto her clothes. Back then, there weren't photos, but my imagination could run freely."

Guo's girlish imagination would end up taking her to places she could scarcely have imagined. But, as Yeats once wrote, in dreams begin responsibilities. Her life has been a series of surprising, almost unbelievable twists and turns; her resolve, her tenacity, and her confidence have transformed that nursery reverie into a blazing reality. Let others worry about the practicality of their designs; let other heads be occupied by streetwear and athleisure. For Guo, the holy grail is to create fashions that are the stuff dreams are made of.

The singularity of her vision has paid off: In 2016, Guo was named one of *Time* magazine's 100 Most Influential People; *The Business of Fashion* included her as one of the five hundred people shaping the global fashion industry today. Guo is currently the only Chinese designer permitted by the highly selective Chambre Syndicale de la Haute Couture to show her collections during Paris Couture Week.

But it was perhaps the night of May 4, 2015, that Guo burst onto the international stage as a world-class star in the fashion galaxy. That evening, Rihanna swanned up the steps of the Metropolitan Museum of Art to attend the Met Gala, enveloped in Guo's fifty-five-pound canary yellow fur-trimmed cape, an ensemble which purportedly took seamstresses a cool fifty thousand hours and more than two years to complete. Three people were charged with helping carry the cloak's sixteen-foot train. The Costume Institute's exhibition that season was titled "China Through the Looking Glass," and Guo's now-iconic look for Rihanna was the irrefutable jewel in the crown that starry night, landing on the cover of *Vogue*'s annual Met Gala special edition.

One could argue that a literal golden thread connects the designer's early days of sartorial deprivation to the glorious pinnacle from which she now presides. Guo was born in 1967,

during the height of China's Cultural Revolution, when, she says, "it was unimaginable for me to think of fabrics as smooth as silk, because the clothes we wore were made from coarse cotton. It was unfathomable then how butterflies and flowers could be sewn on such fabrics and be brought to life." Far from flora-embellished gowns, the requisite uniform of the time was the strictly utilitarian Mao suit, worn by both men and women, made of dull fabrics in a stultifyingly drab palette.

Guo's parents were both members of the Communist Party of China; her father was a battalion leader in the People's Army. A daughter who wanted to embroider butterflies onto her clothes—precocious with a needle, she could sew by the time she was two years old—was an uncomfortable, even dangerous liability. In fact, when she altered a dress to make it nominally more stylish, a teacher at her school accused her of being a capitalist.

Still, as it turns out, the darkest hour is often just before dawn: in 1982, Beijing Second Light Industry School admitted its first-ever class of fashion design majors. Five hundred people applied, and Guo was among the twenty-six who were accepted. If it was hardly a place where her dreams could run wild, it was at least a start. When she described to one of her instructors the kind of gossamer gowns she wanted to create, he referred her to a costume shop. "Why don't you make something that can sell?" he admonished. (In an echo of that disapproving grade school teacher, he also accused her of being bourgeois.)

Upon graduation, she landed a job at one of the first privately owned fashion companies in China, an early example of the burgeoning economic openness taking root in the country's post-Mao period. Everything the factory made sold out immediately—after all those years of drab, sad suits, the population was apparently thirsty for fashion. A colorful coat that Guo designed became a surprise hit—it had a hood, a real novelty at the time.

The designer credits this grueling job with teaching her about perseverance. She was responsible for designing one thousand garments a year, and she claims she keeps to this crazy pace—today her personal army of embroiderers, cutters, and technicians creates three to four thousand couture items per year. The designing, she insists, is the easy part—the execution is the challenge.

If Mao described his socioeconomic plans for China as the Great Leap Forward, Guo made giant leaps of her own. In 1995, she geared up her considerable courage, held her breath, and left the factory job to establish her own atelier in Beijing, which she called Rose Studio. Here she could give life to those beautiful childhood reveries, though assembling a team that was willing and able to understand and execute her ideas was no easy feat.

At first, it seemed as if it would be impossible to find the skilled embroiderers she needed, but then Guo heard of some craftspeople who once worked for the royal family and still resided in the Hubei province in the countryside. She went there; she looked for windows with embroidered curtains; she knocked on doors. Persistence was rewarded: now she has hundreds of embroiderers at her studio. She trained many of them herself.

Clearly, her rigorous tutelage has paid off, for the creations that grace her catwalks are incredibly detailed flights of fancy, postmodern trips into a land of militant make-believe. Dresses gleam with a cascade of shimmering stalactites; frocks open like spectral flowers; voluptuous skirts are as delicious as the most scrumptious soufflé. Guo, no proponent of the less-is-more school of aesthetics, gleefully gilds the lily.

Her achievement is all the more impressive when we think about what the phrase "Made in China" has meant, even in the very recent past. It is, let's face it, an expression that connotes a cookie-cutter sensibility — the production of millions of identical widgets rolling off an assembly line to be shipped off to the four corners of the earth. Guo's very personal obsession, her insistence on the unique character of each of her creations, the impossibility of duplicating these incredible ensembles, stands in defiance of this stereotype. In her capable hands (and the *petites mains* of her highly talented atelier), "Made in China" takes on a whole new meaning.

Many of Guo's designs incorporate ancient yet familiar Chinese symbols: the lotus, representing purity of mind and spirit; *ruyi*, representing the head of a scepter, symbolizing the power to grant wishes; the mountain and wave, commonly used on the hems of royal court robes; and the meander, or "cloud and thunder" pattern, representing rain and abundance. "My favorite motif is the dragon," she says. When she was young, she remembers walking around Beijing and seeing the dragon statues in the park, a mute link to the city's past: "I think that

fashion shouldn't just be about the present, and I care more about the meaning behind the details. As such, the embroidery and motifs you see on my clothing have stories behind them."

Lately, Guo's references have become more global. For Fall 2017, the designer offered an homage to the codes of haute couture itself, featuring comparatively slender silhouettes "In the past, I wanted to express a feeling," she said, explaining the collection. "This time, it's a lot simpler; it's a tribute to the era of haute couture, when life was more beautiful and dresses were more beautiful, as well." To achieve this laudable goal, she partnered with the venerable French jewelry house Chopard, matching the intense sparkle of emeralds and diamonds to the gilded goddess gowns on her catwalk.

Backstage after Guo's Spring 2017 couture show — which included the octogenarian model Carmen Dell'Orefice as a red queen swathed in scarlet, and a green-gold gown of such dramatic proportions it would put a Renaissance couturier to shame — she was asked by *Vogue* whether in fact the extravaganzas on the runway were meant to be worn. Guo replied blithely, "I don't care; the creation is enough." On another occasion she explained, "I don't consider my work to be within the limits of conventional fashion, nor do I follow trends, creatively or commercially."

And sometimes the once-in-a-lifetime experience of wearing a gown of spun sugar that seems to have tumbled from the pages of a fairy tale is just too seductive to resist. Guo likes to tell the story of an ordinary woman who came to her bent on purchasing a dress for a very special occasion. "One day a mother came to me with her savings [$8,000] and asked me to make a wedding dress for her daughter," she says. Guo told the woman she should perhaps give that money, a sizable amount, to her daughter, but the mother replied that if she did, "it would be nothing more than $8,000. But if she spent the money on the wedding dress it would enlarge her love as a mother, it would carry her blessings, and her love for her daughter."

It's a strange story, and one that can raise an eyebrow. But it somehow gets to the center of Guo's art — how beneath the magnificent satin and lace, the incredible beading and breathtaking embroidery, lies the beating heart of desire. In the end, the very existence of such a work of art can lift us out of our ordinary lives — and, if only for a moment, deliver us into the realm of the sublime.

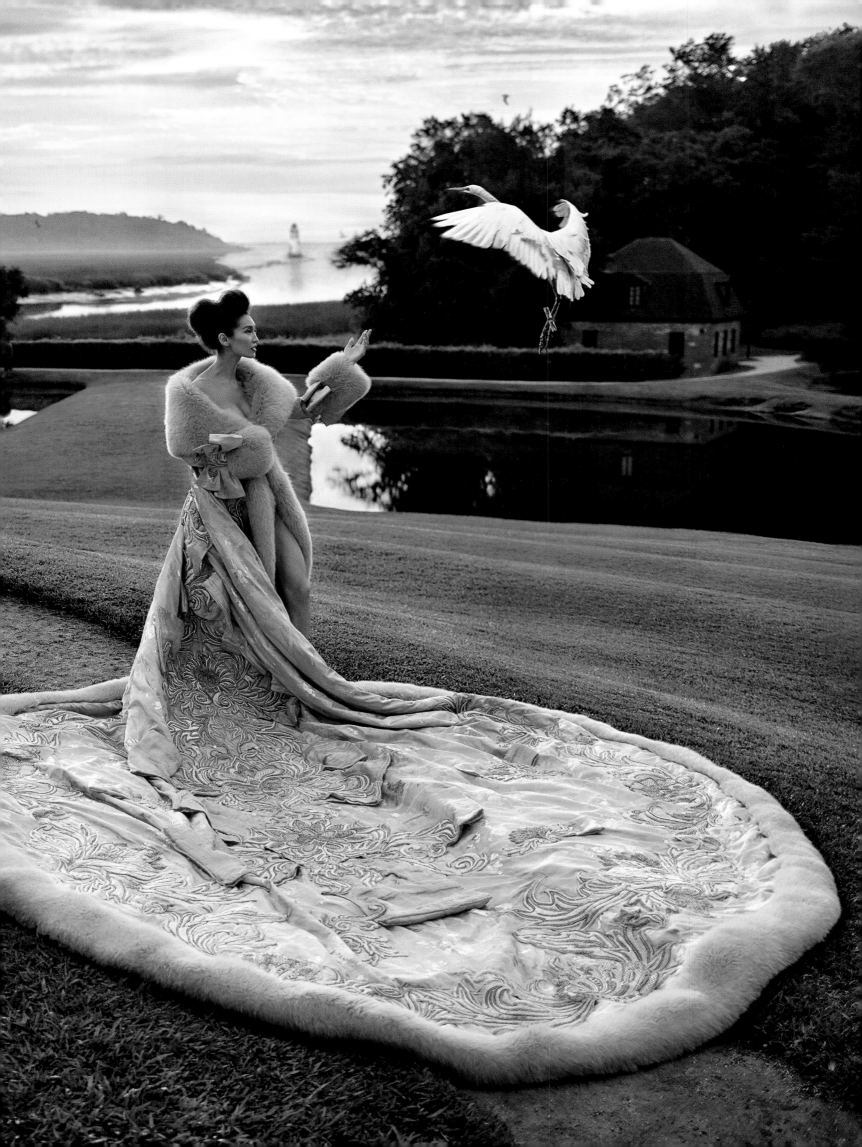

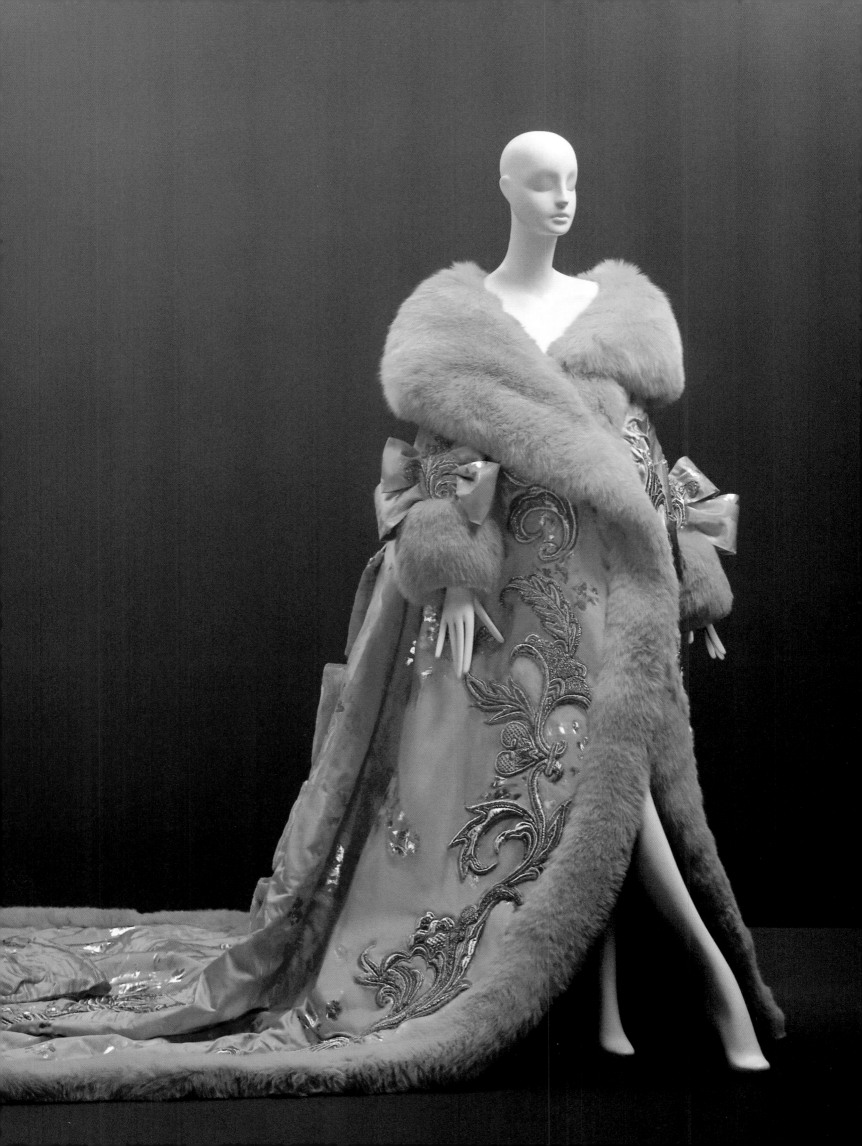

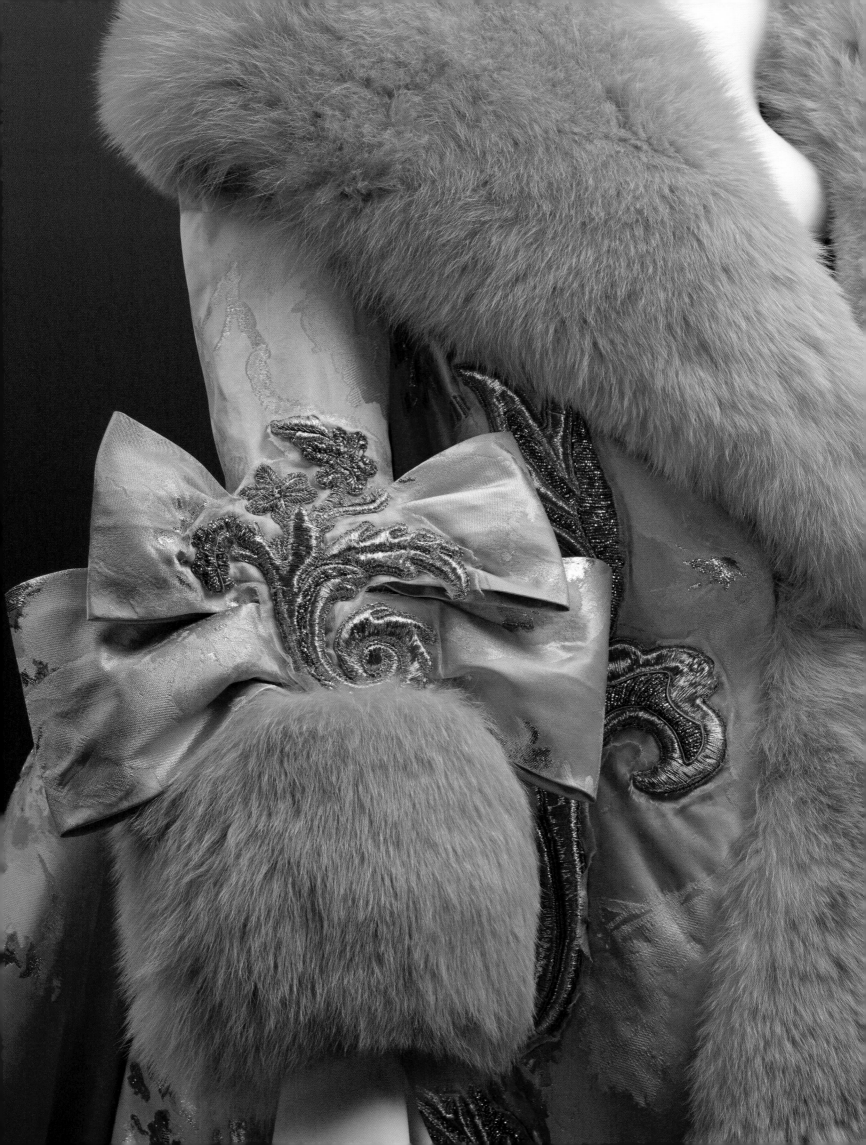

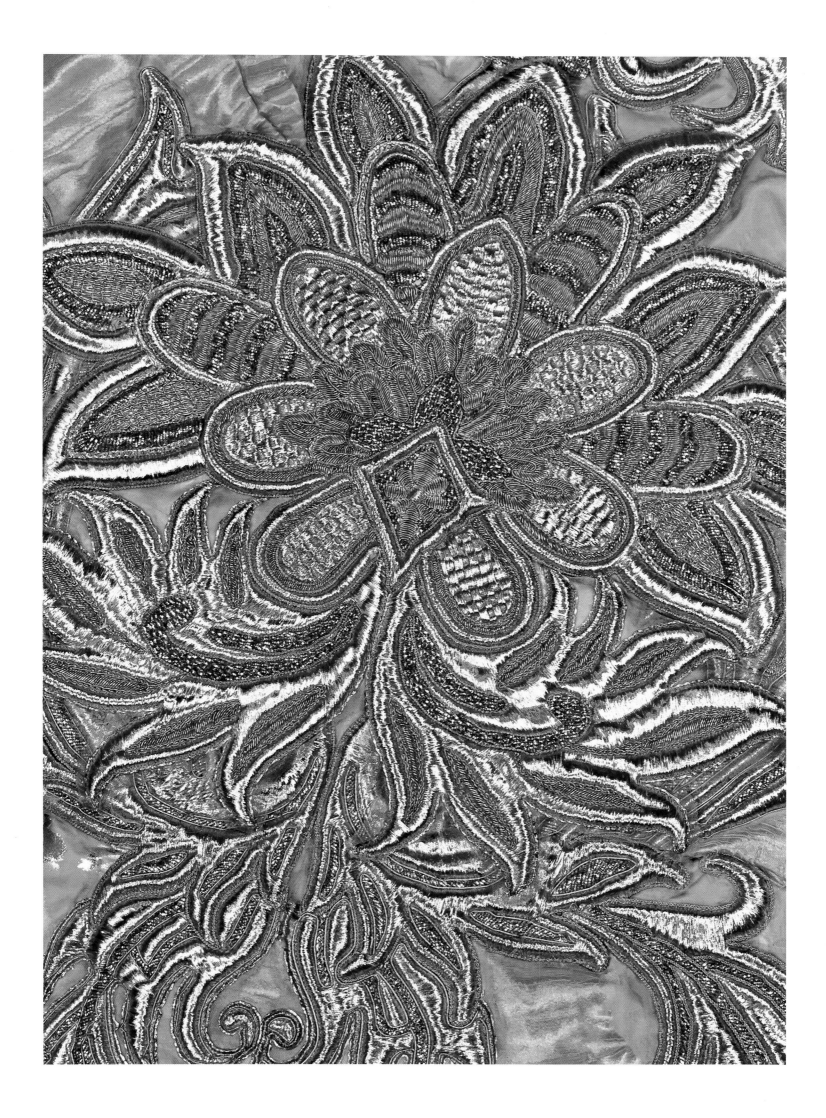

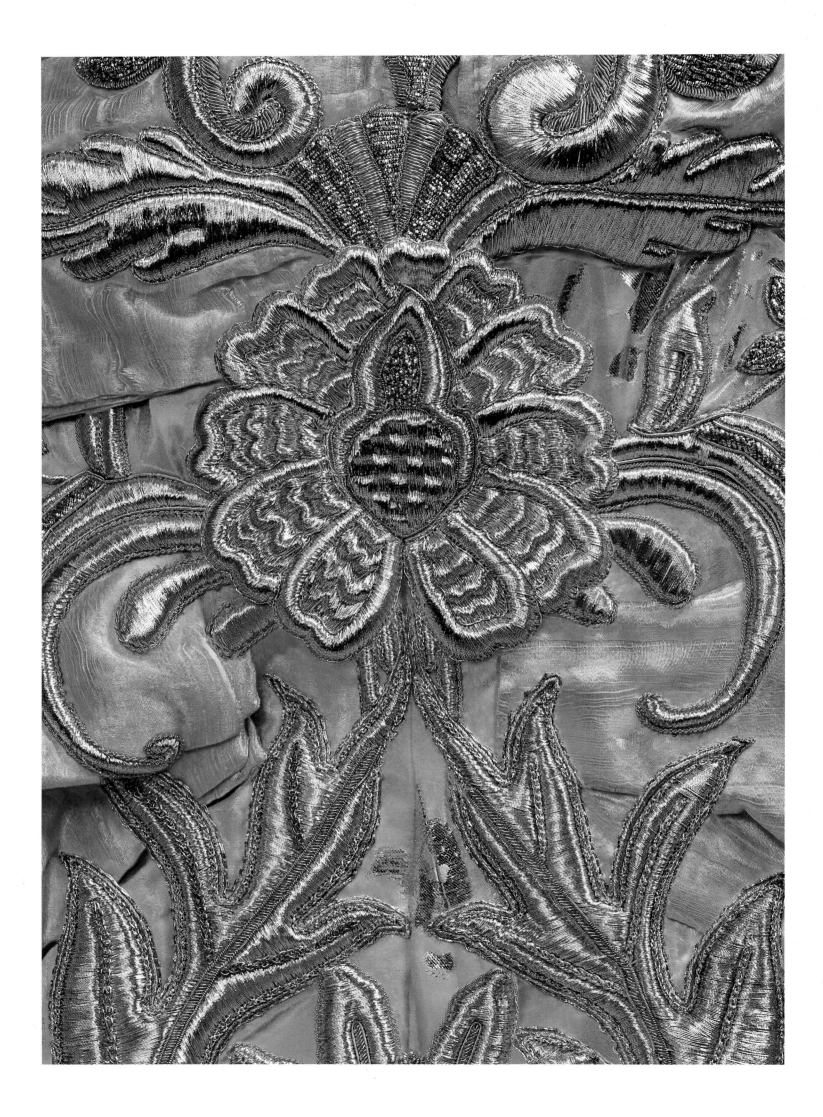

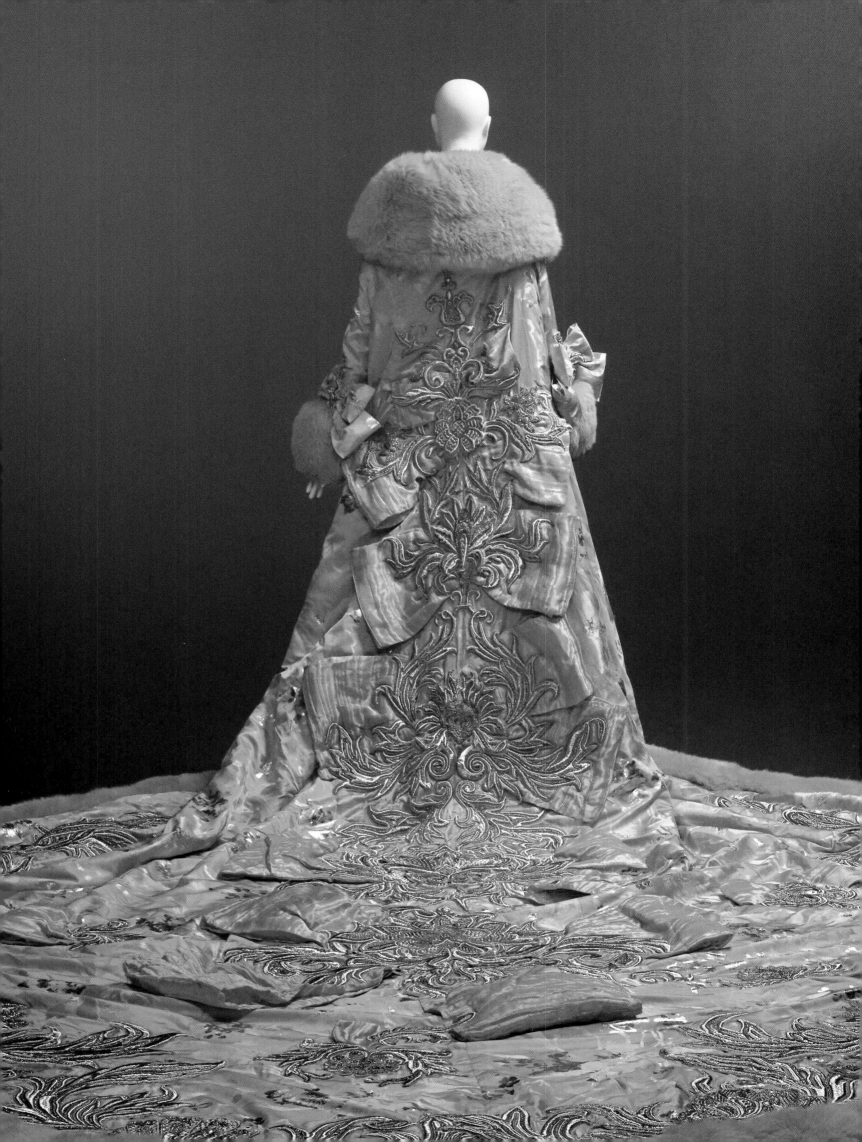

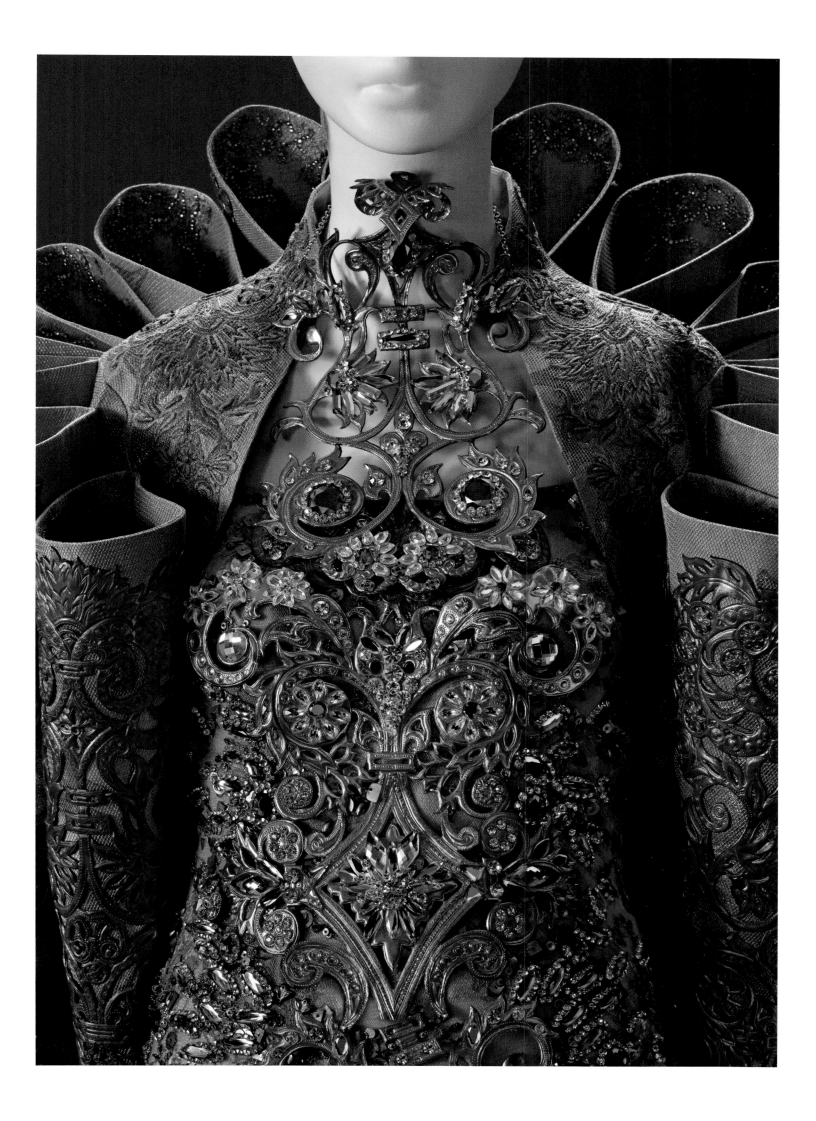

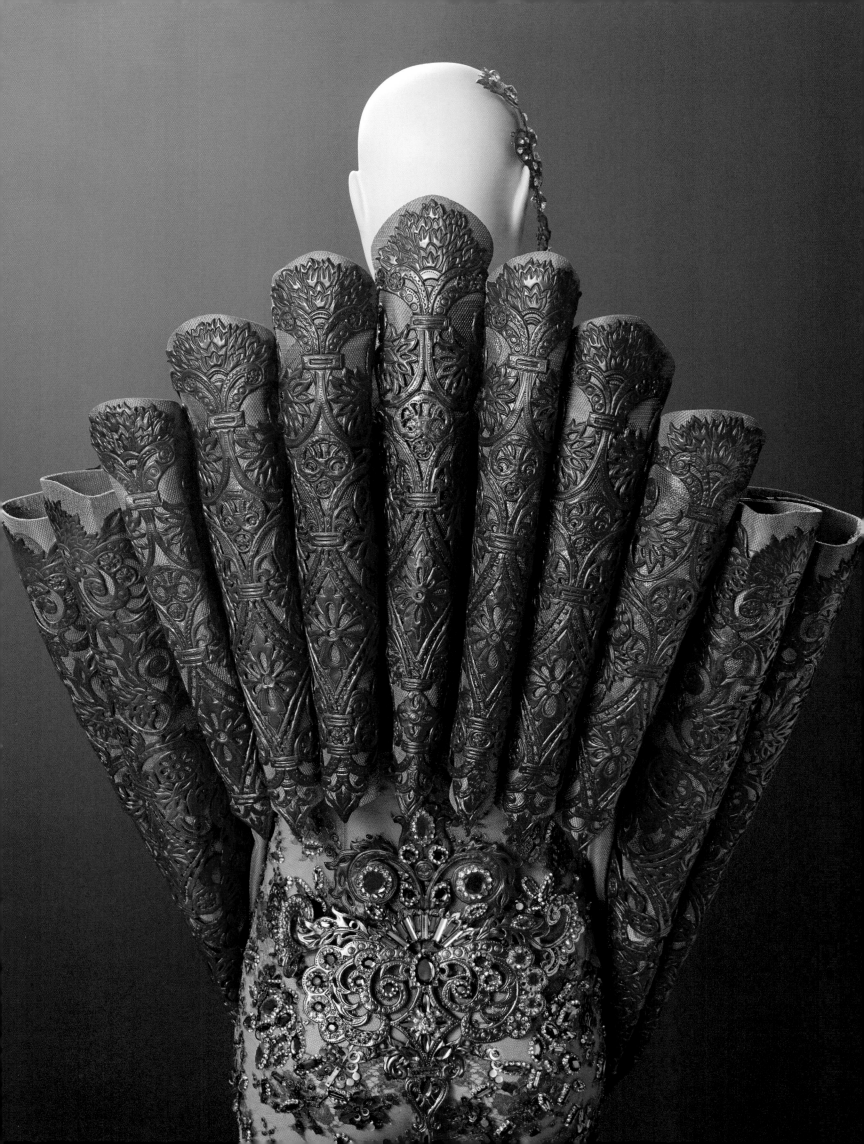

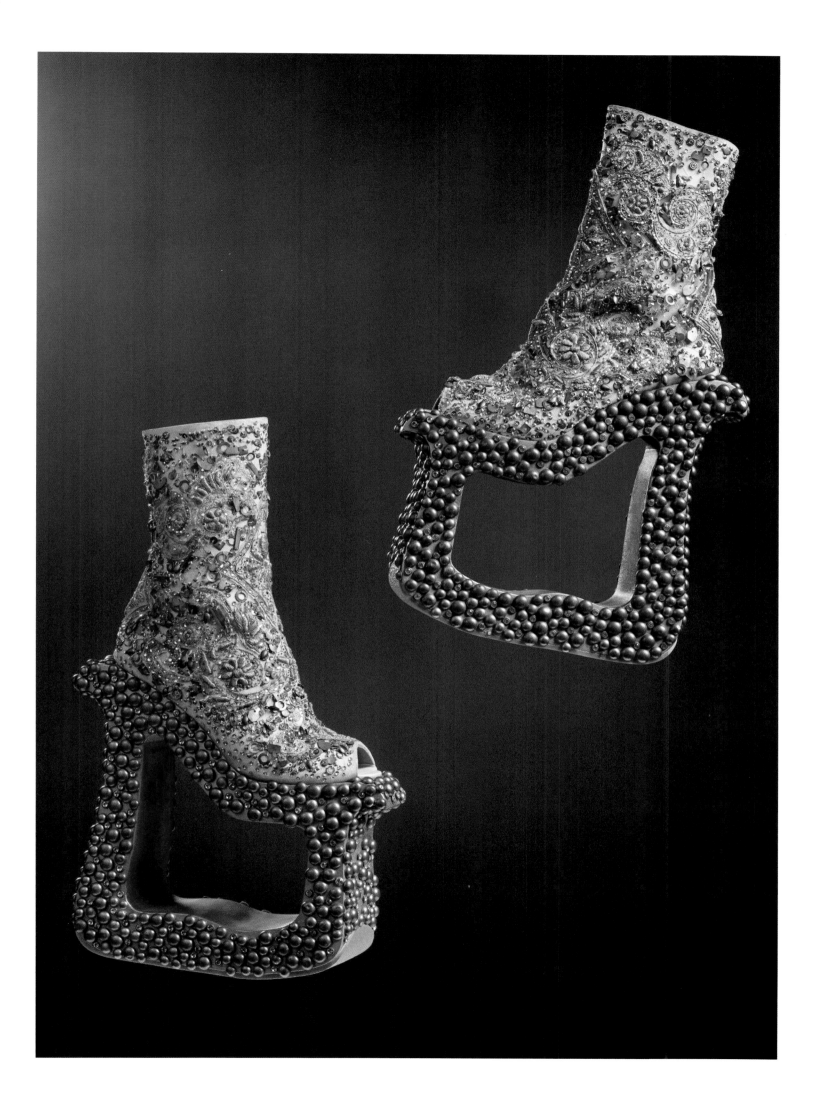

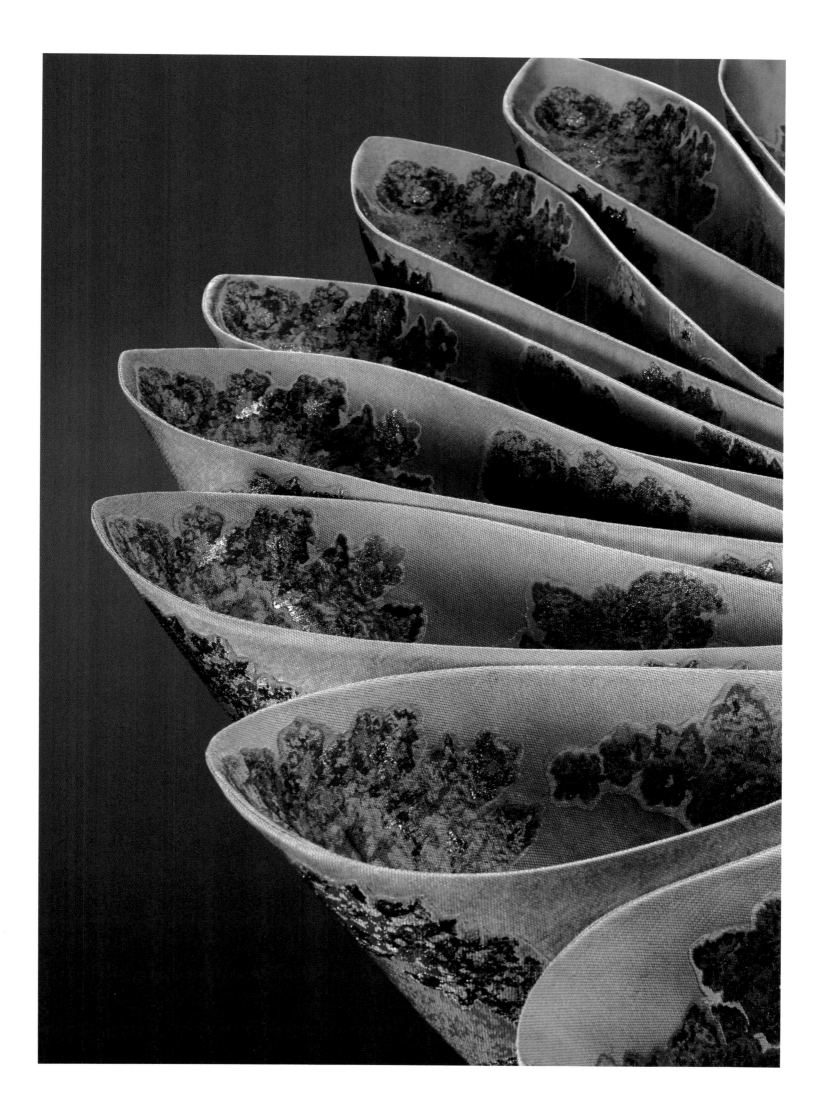

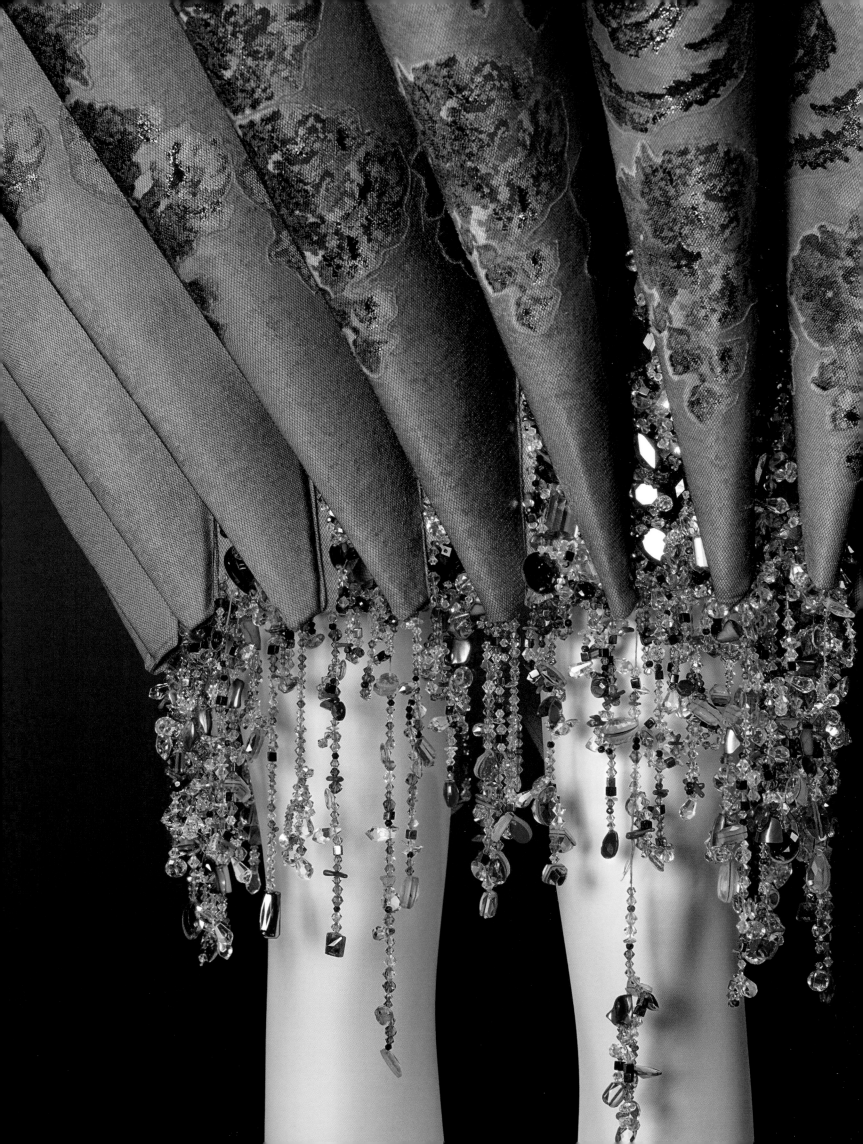

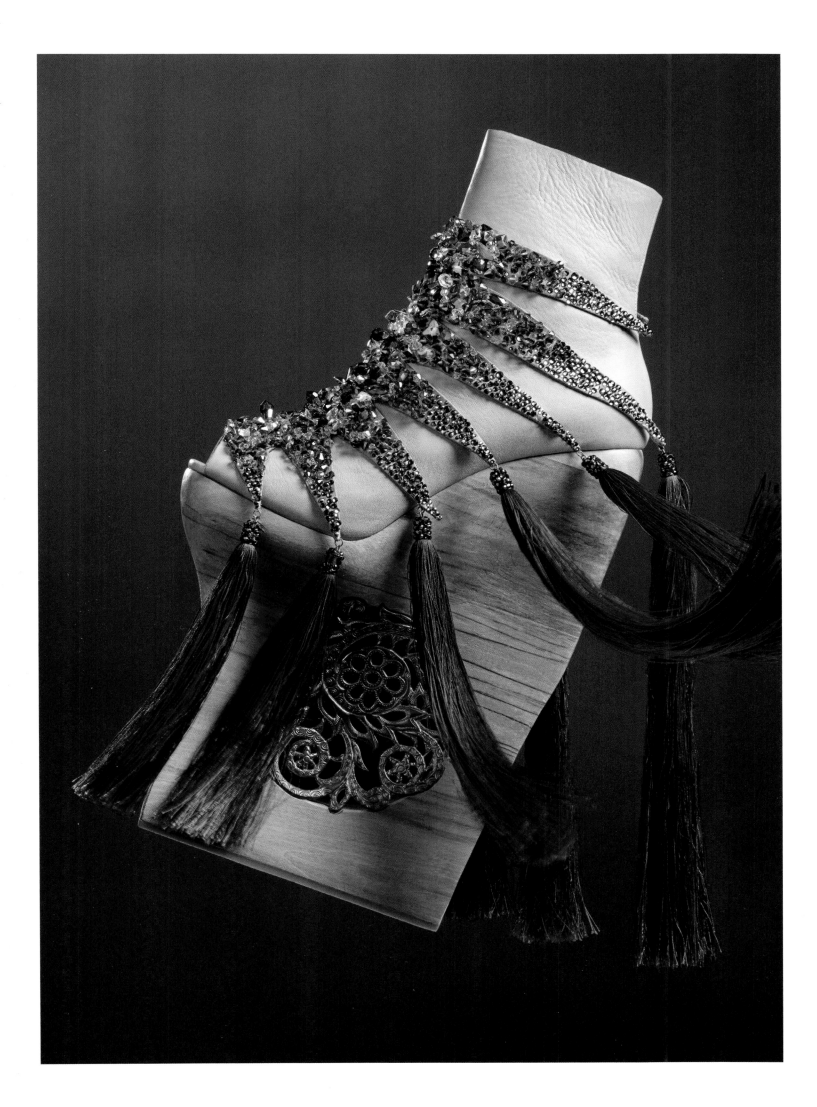

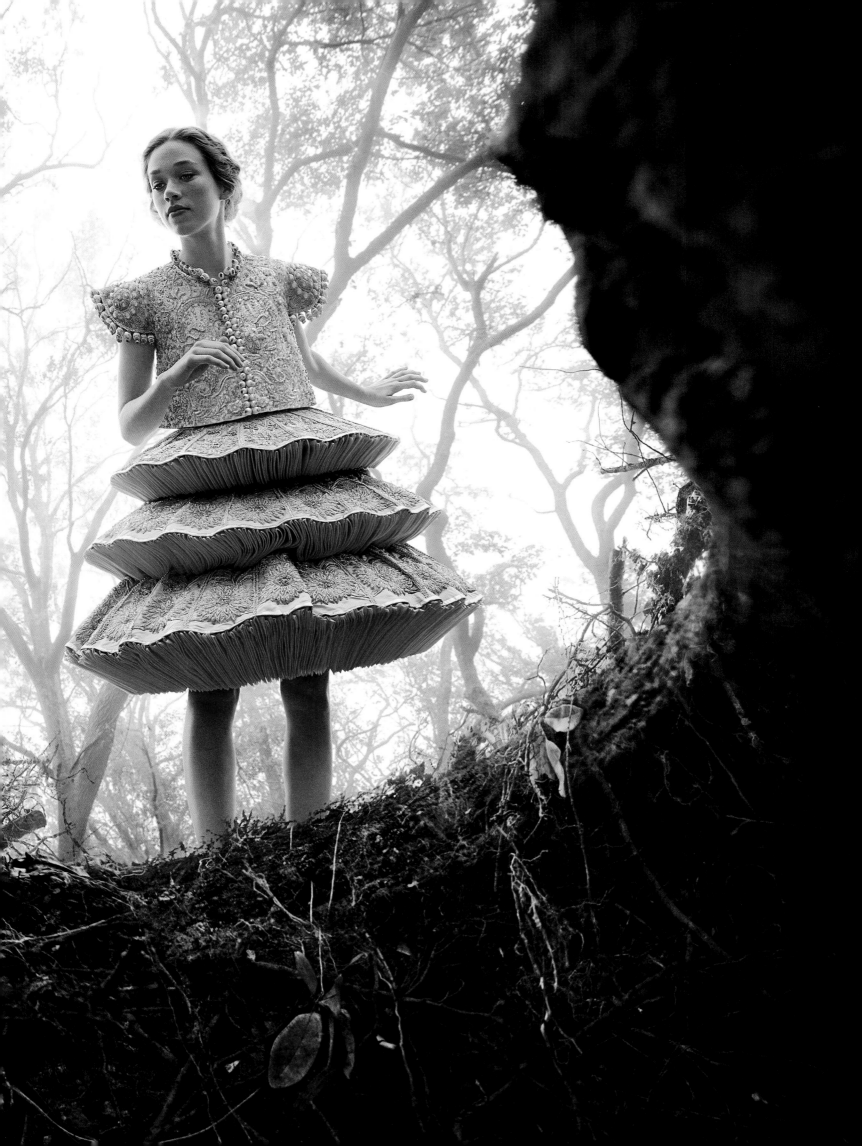

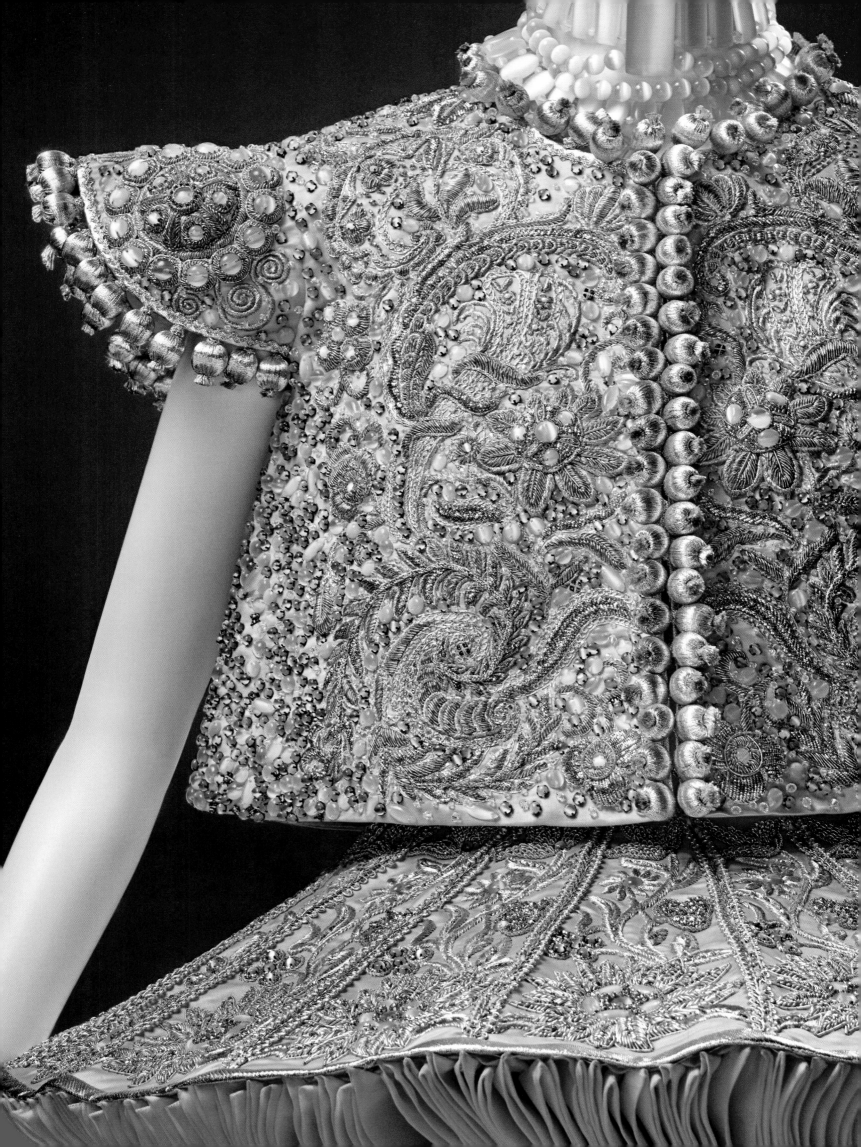

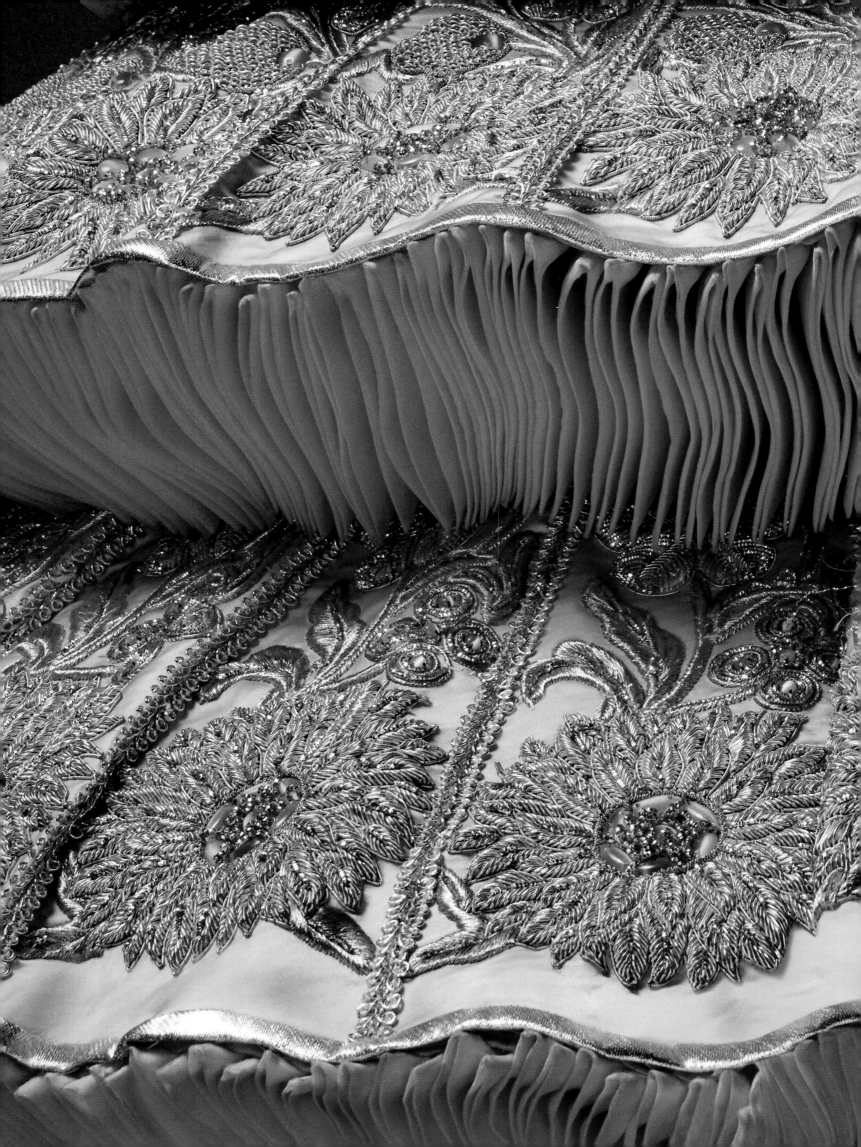

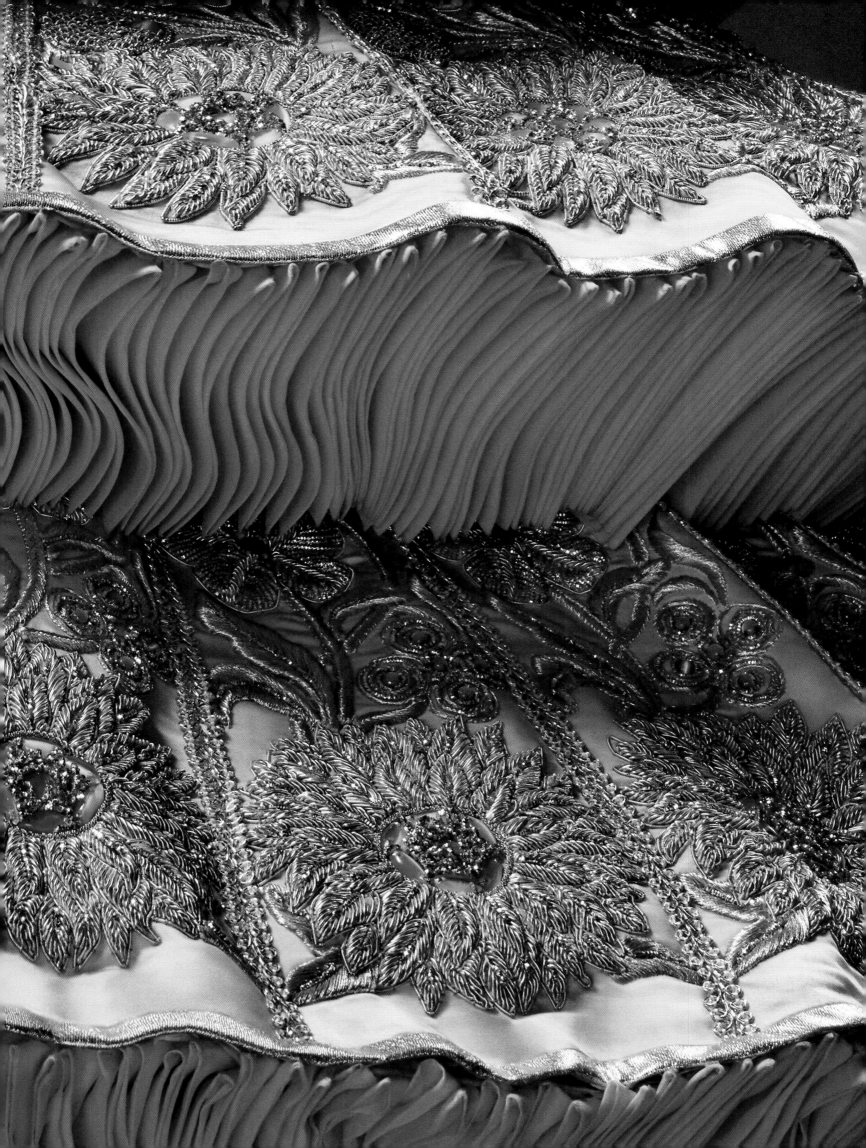

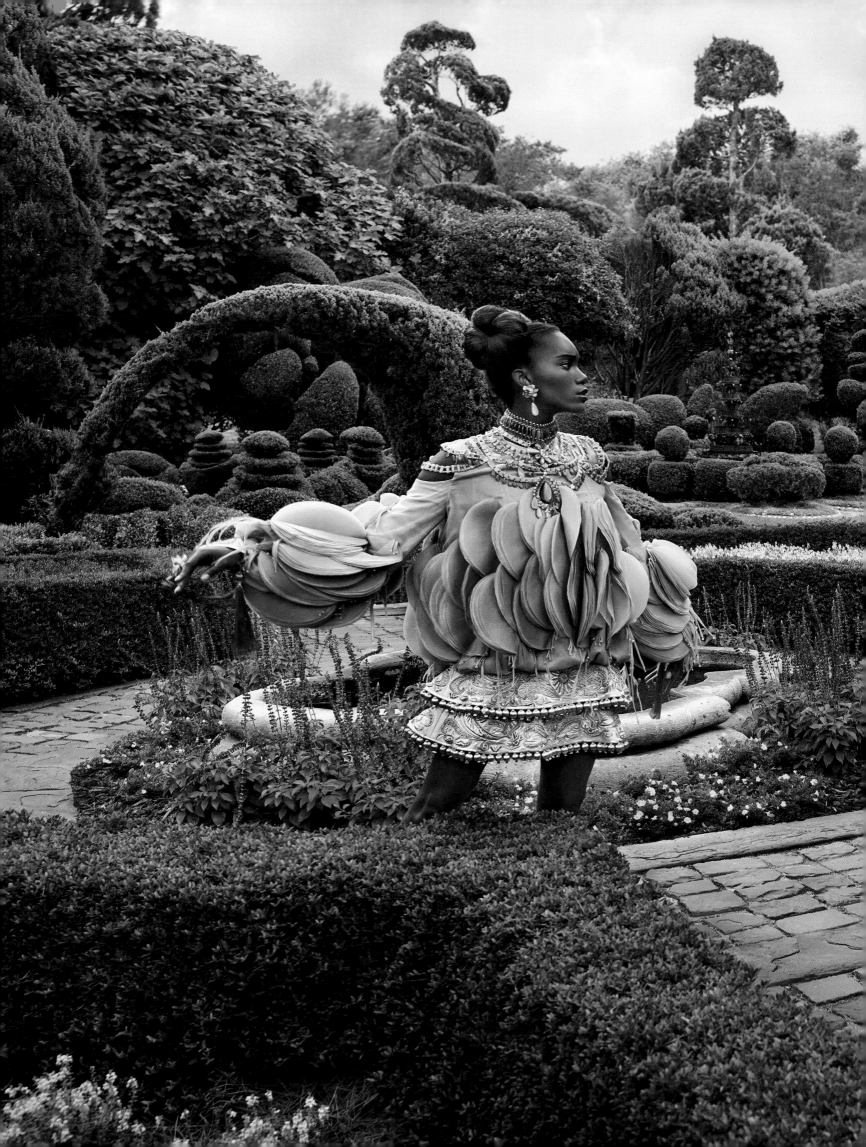

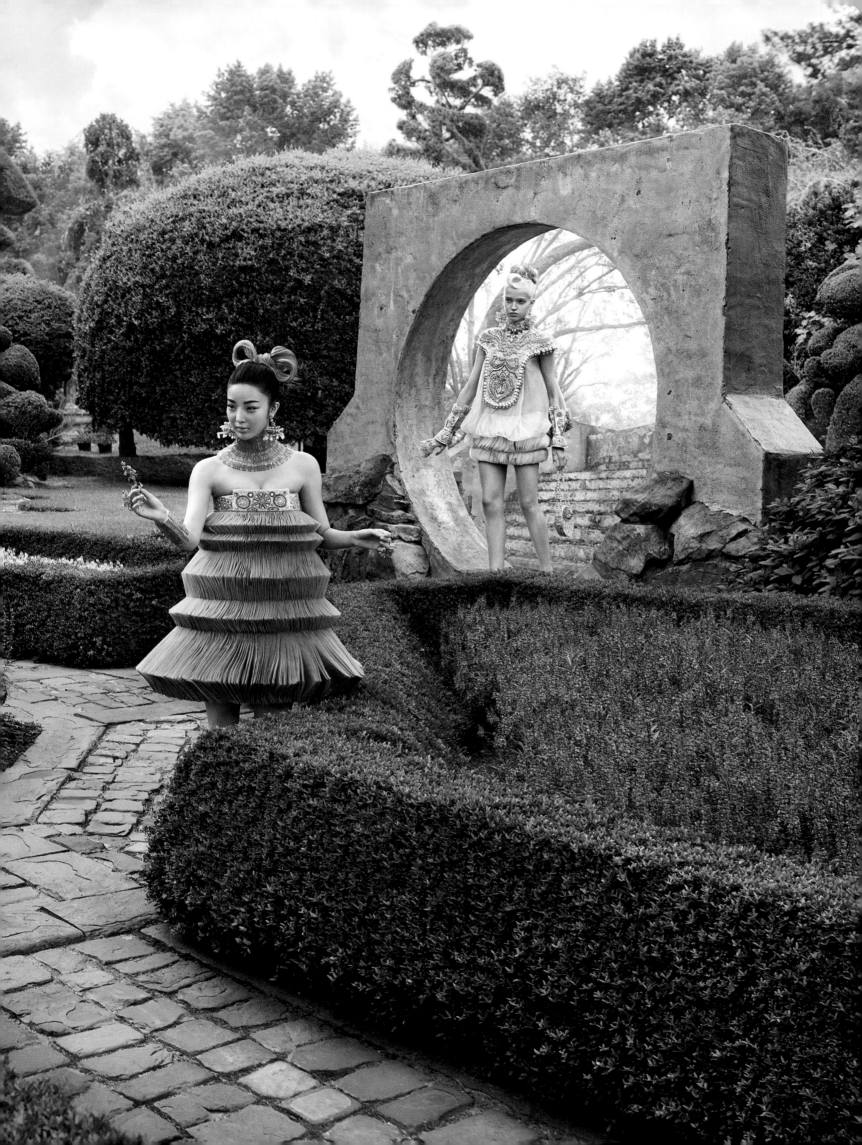

| AN AMAZING JOURNEY IN A CHILDHOOD DREAM, 2008

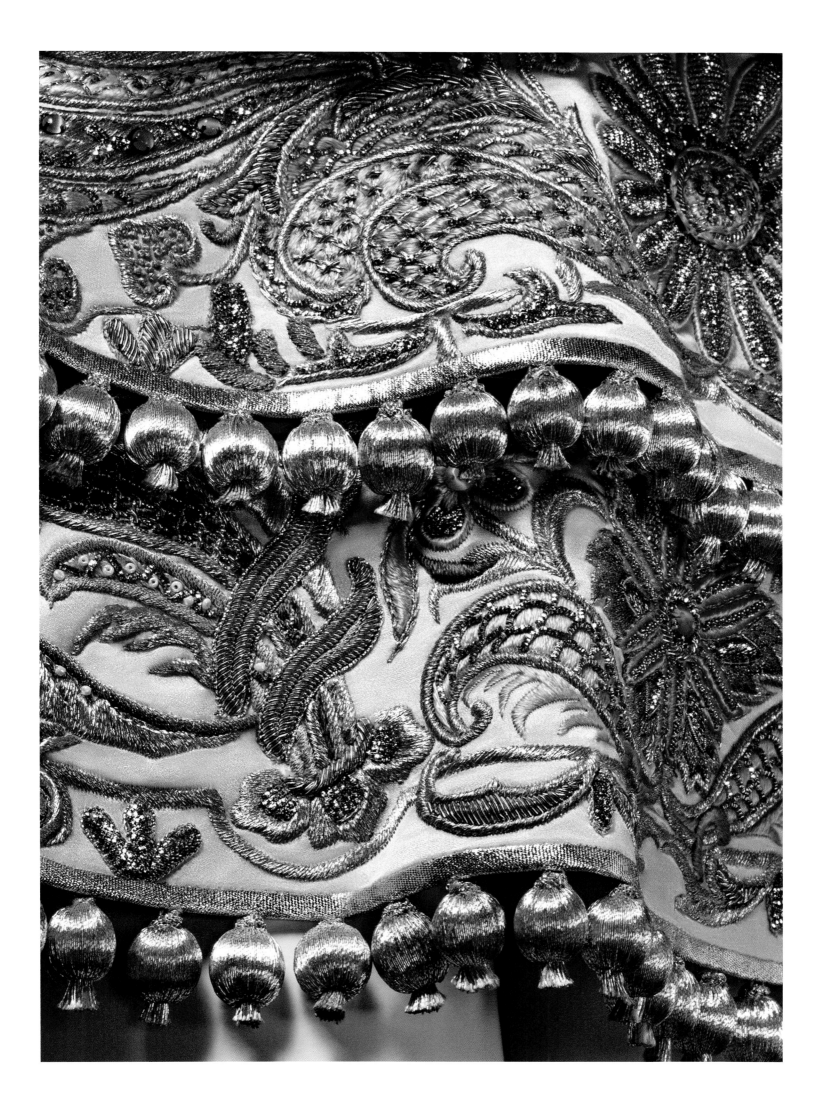

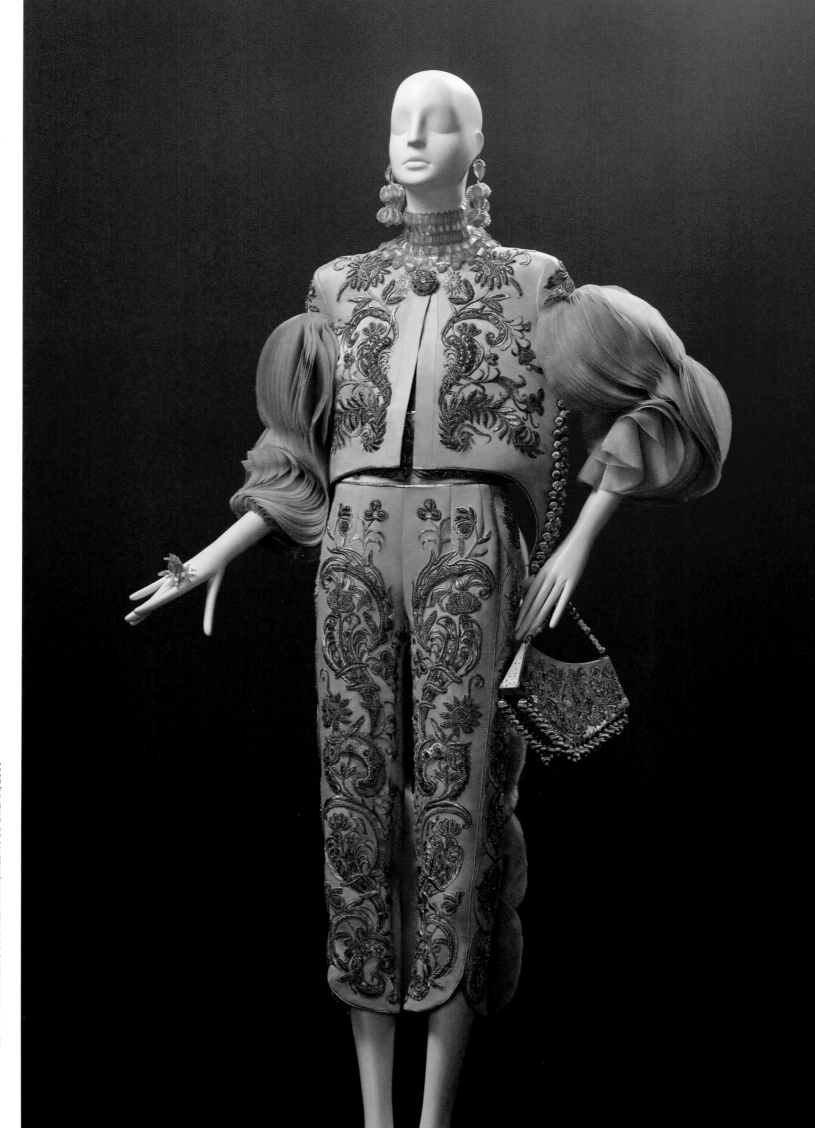

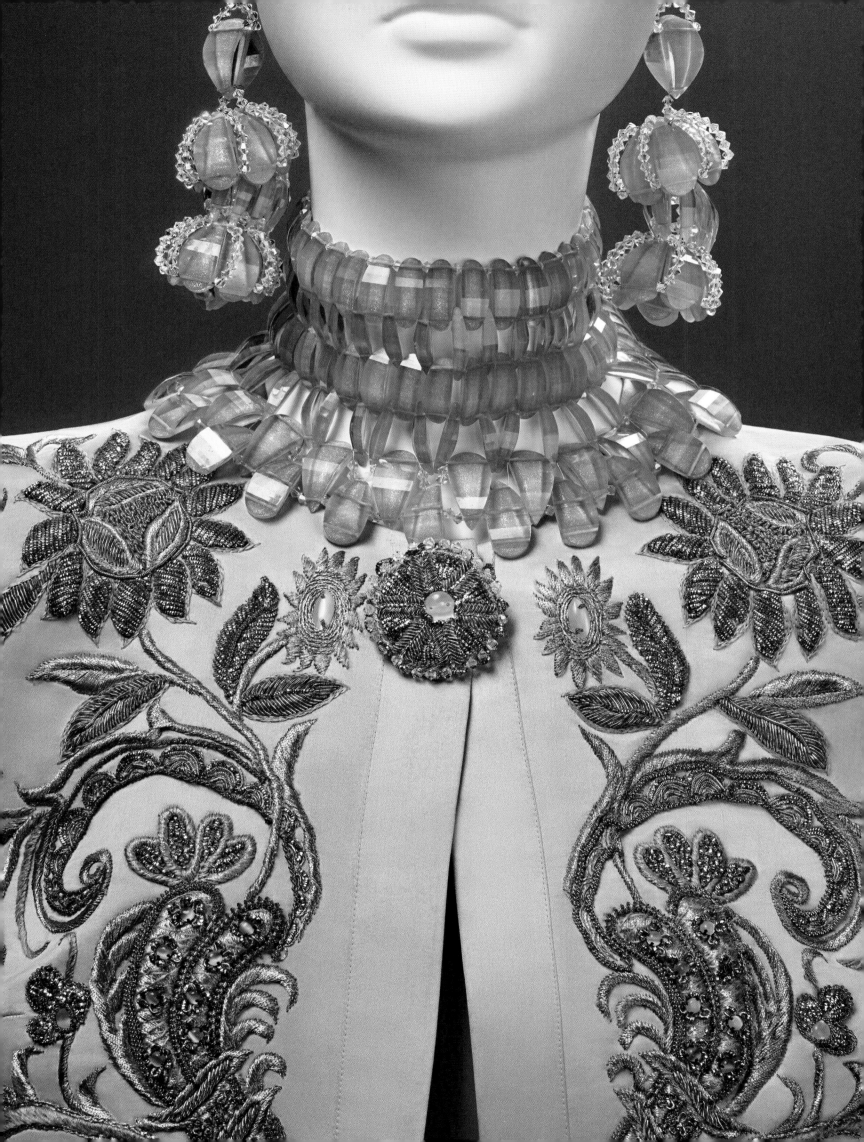

| AN AMAZING JOURNEY IN A CHILDHOOD DREAM, 2008

|

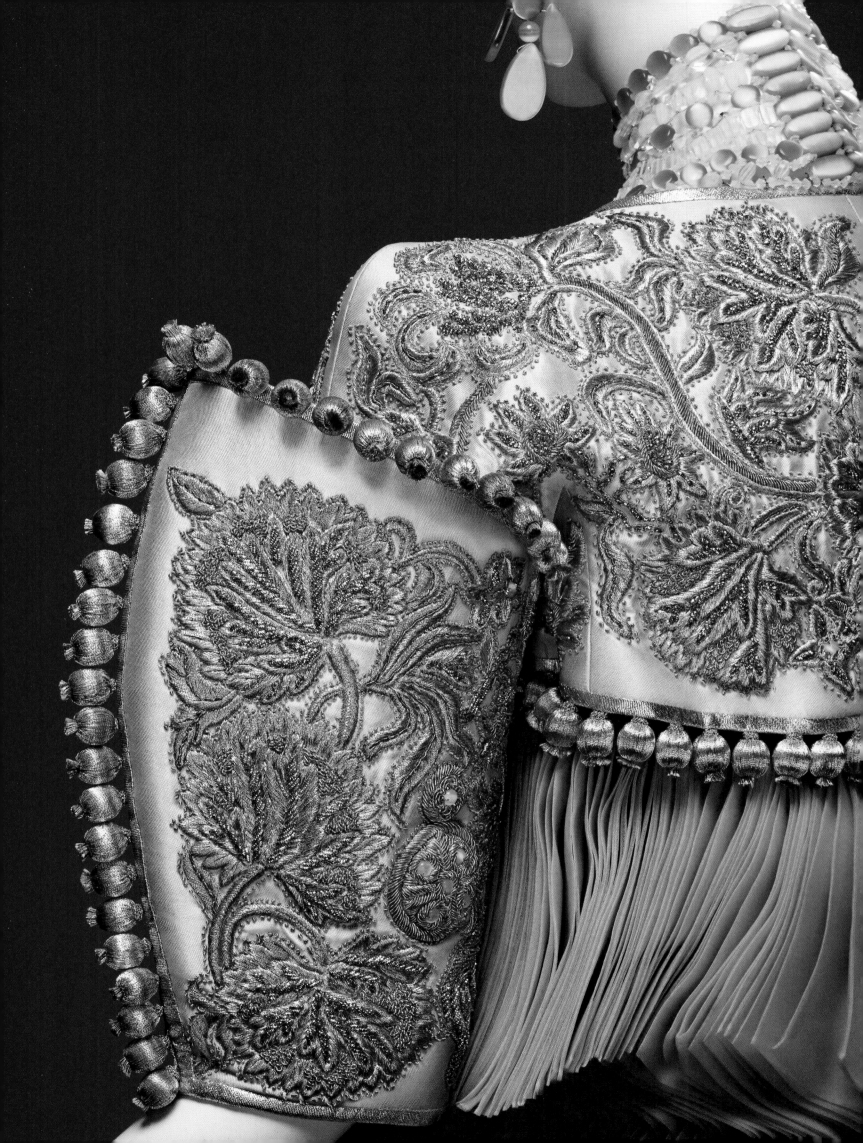

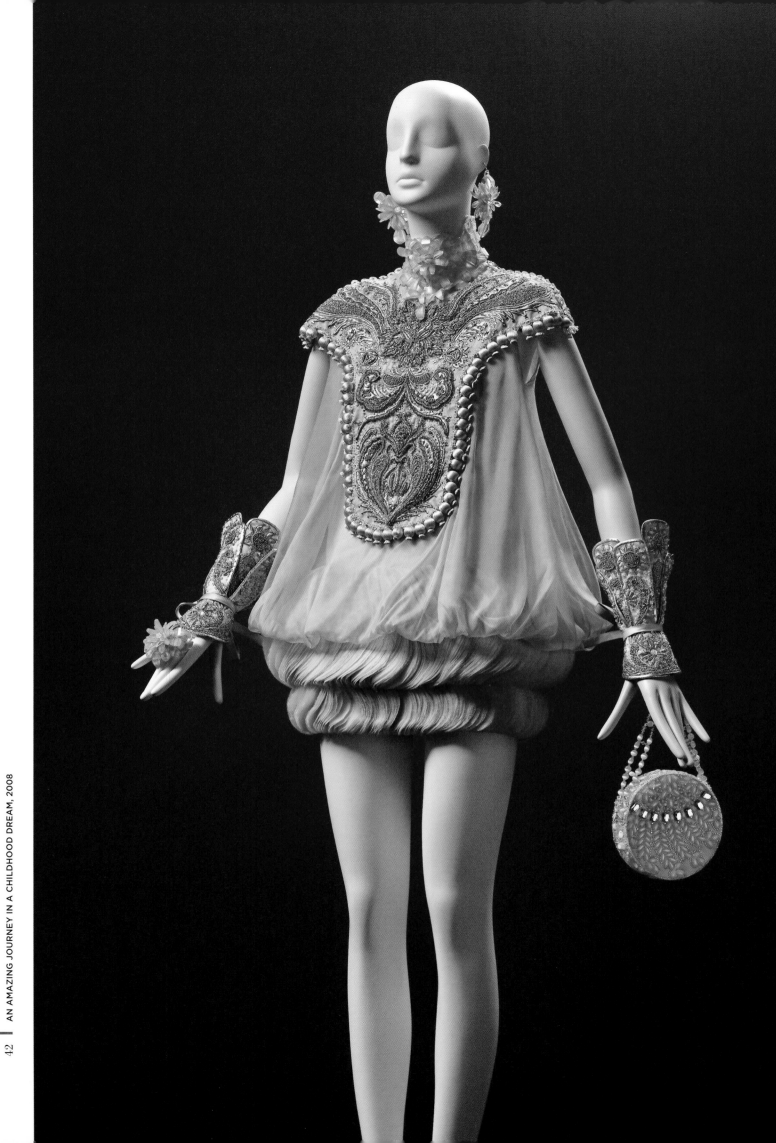

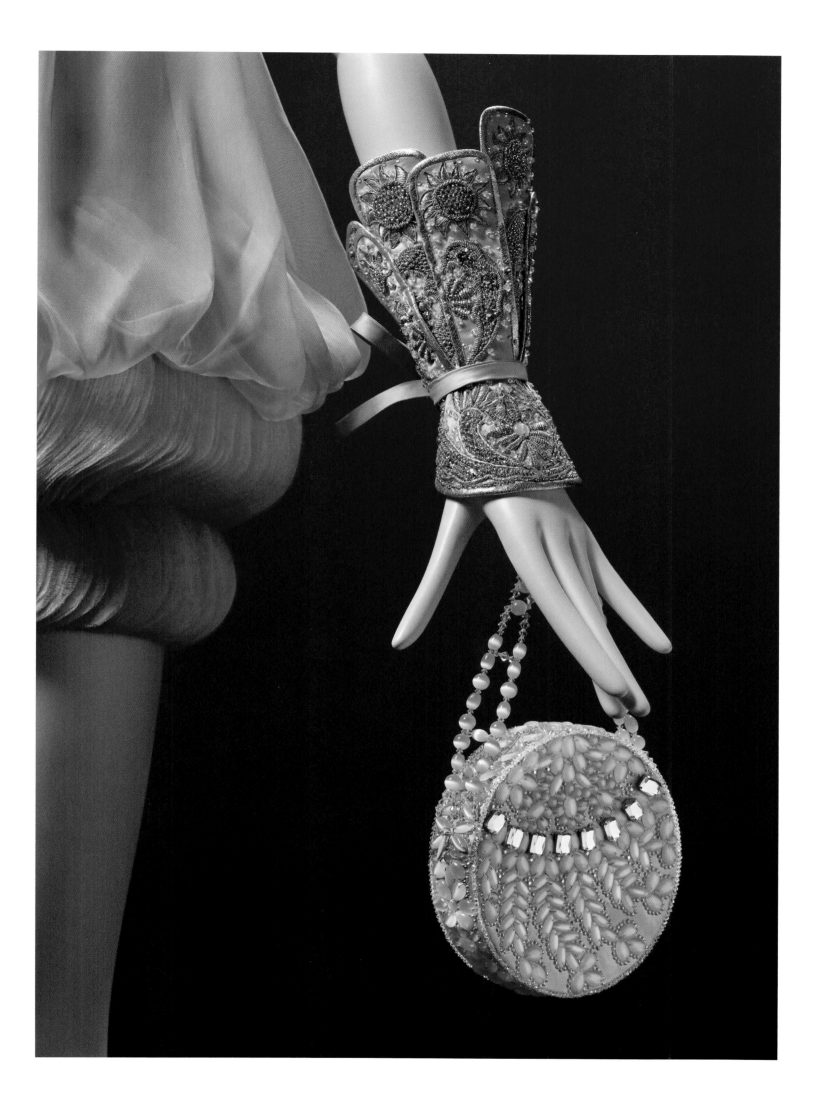

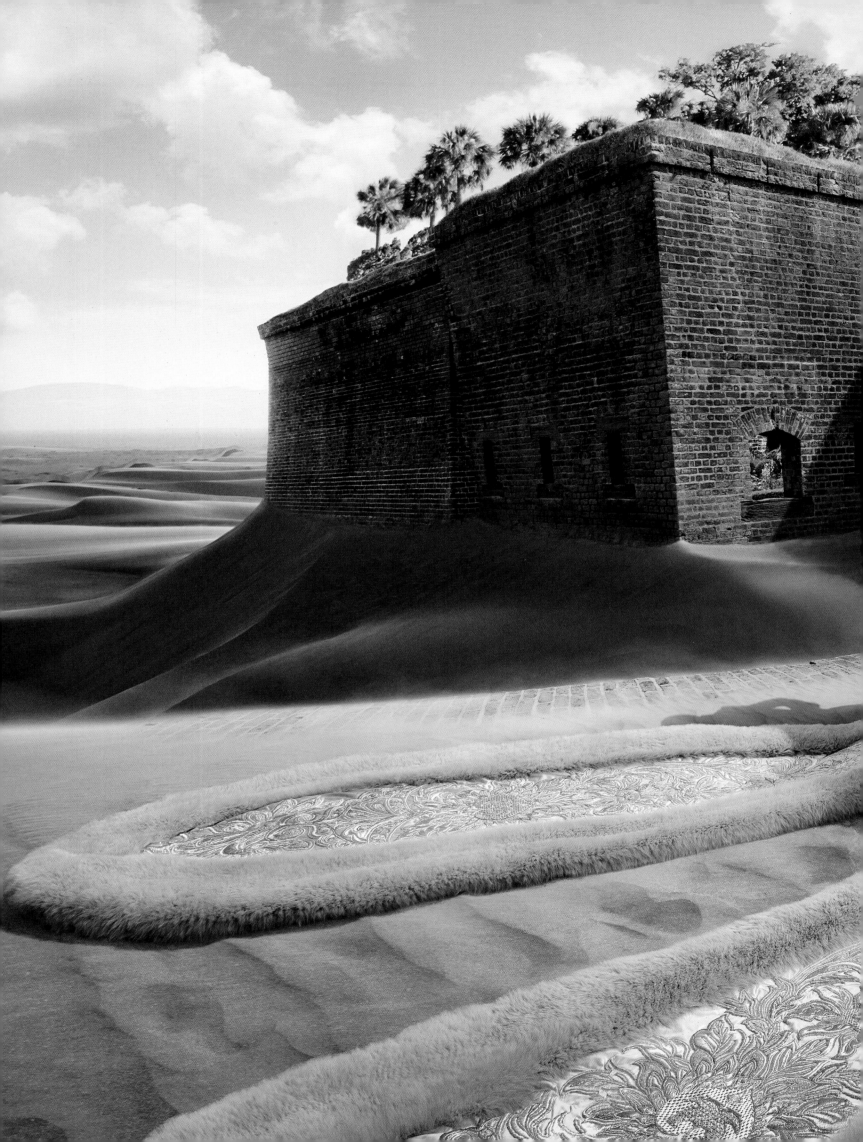

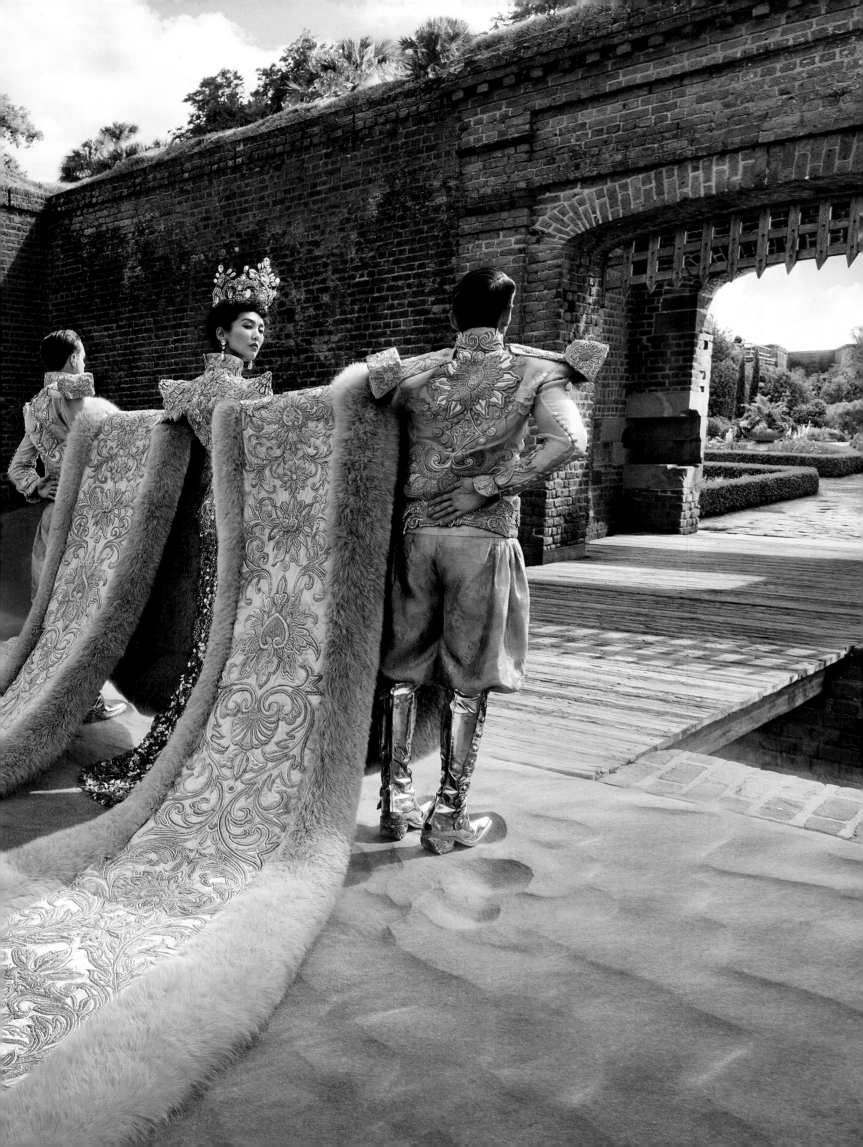

ONE THOUSAND AND TWO NIGHTS, 2010

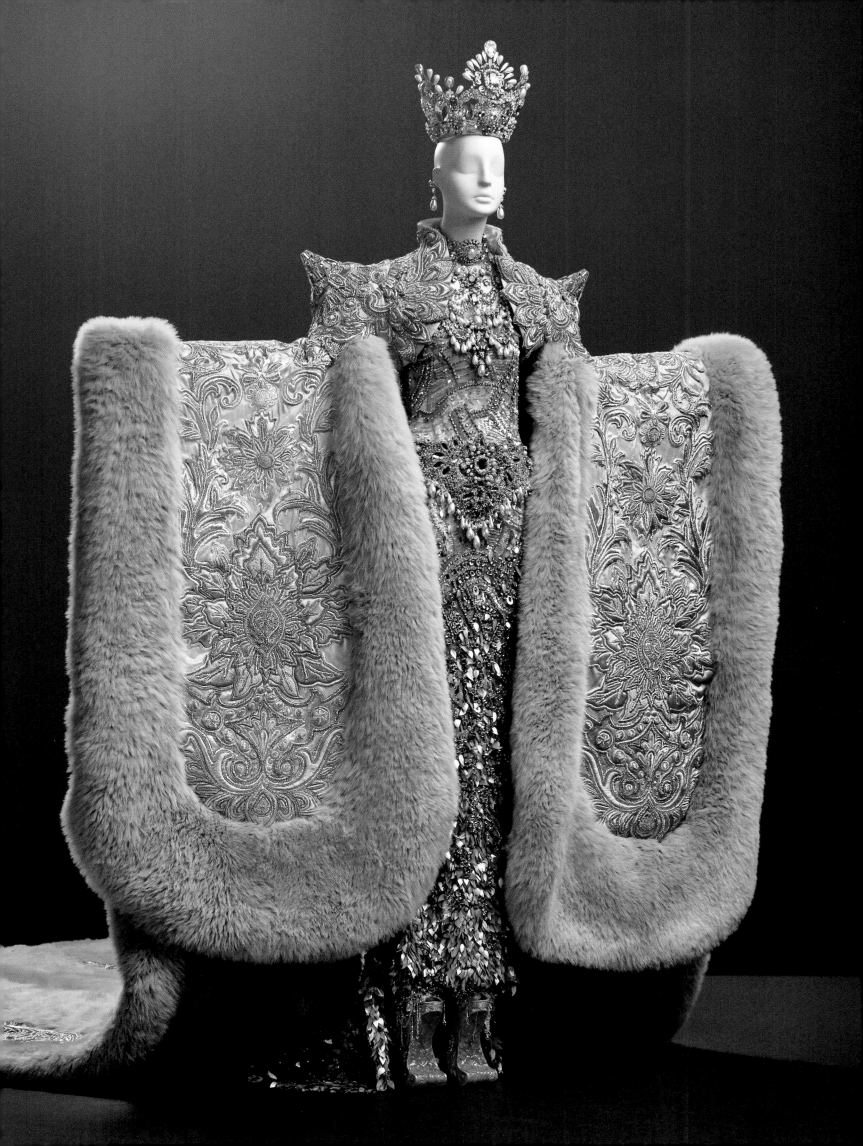

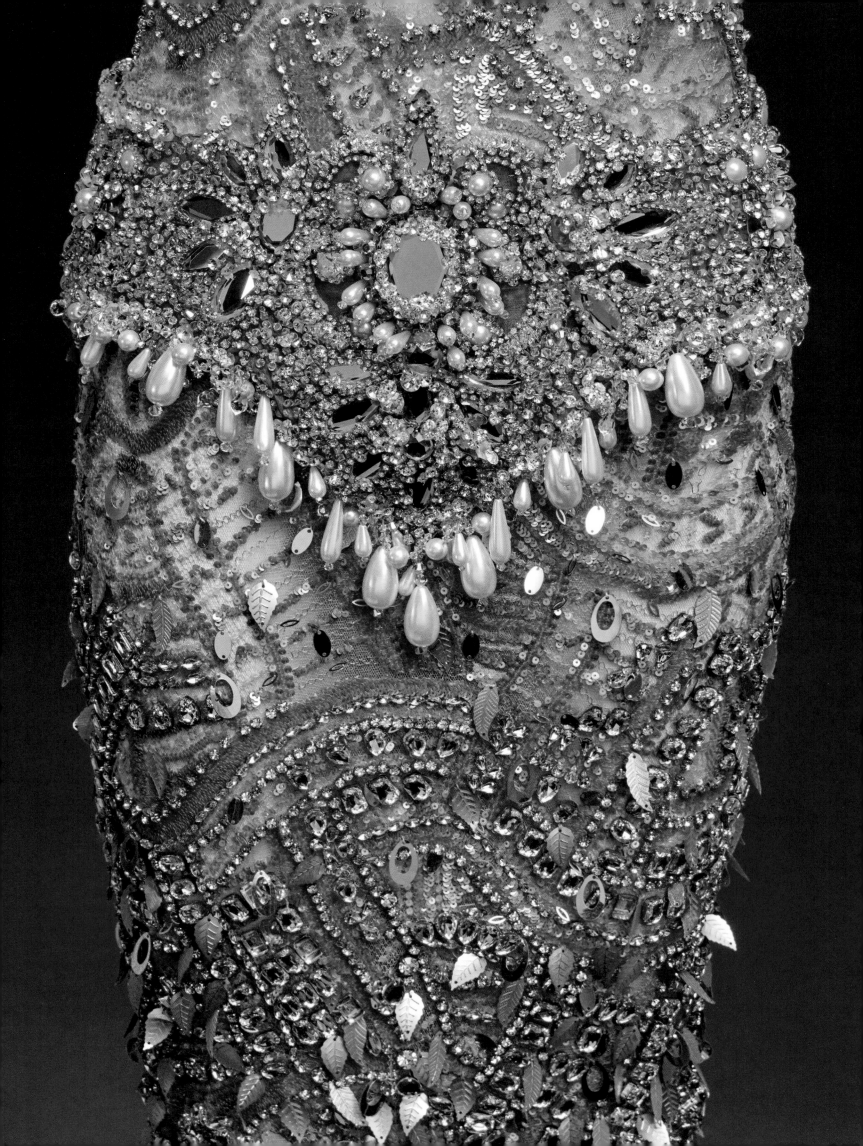

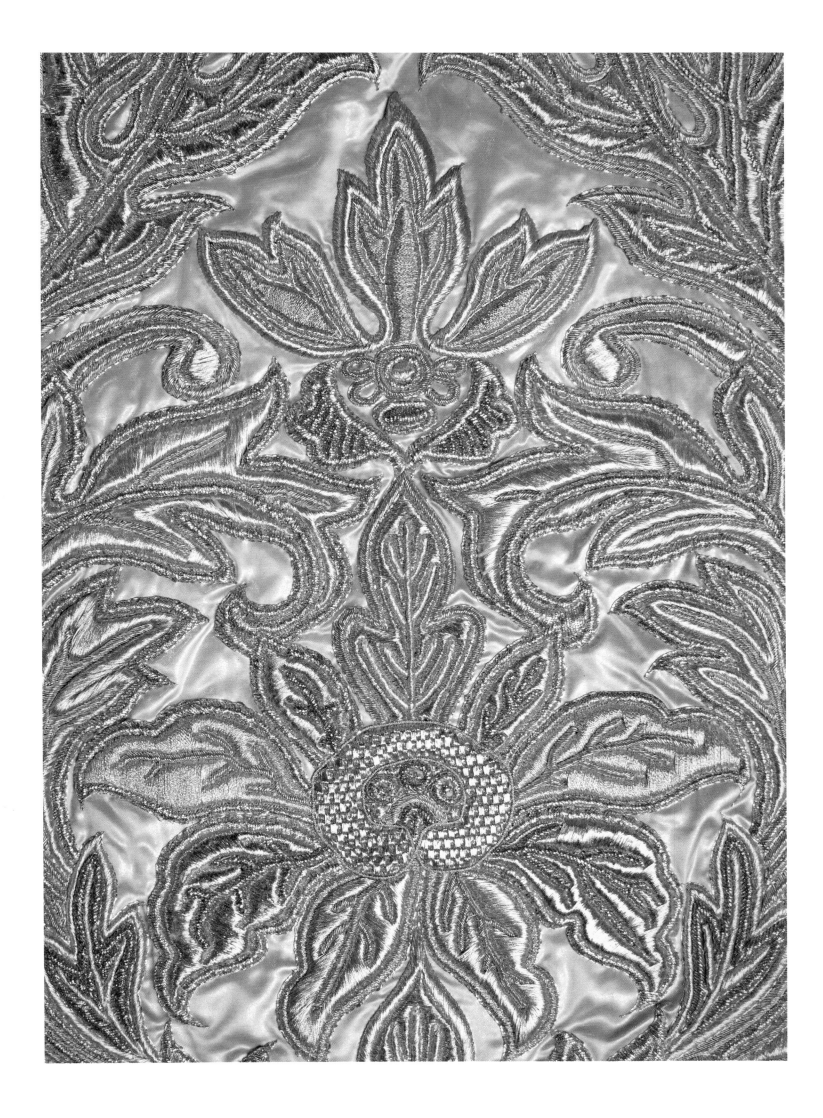

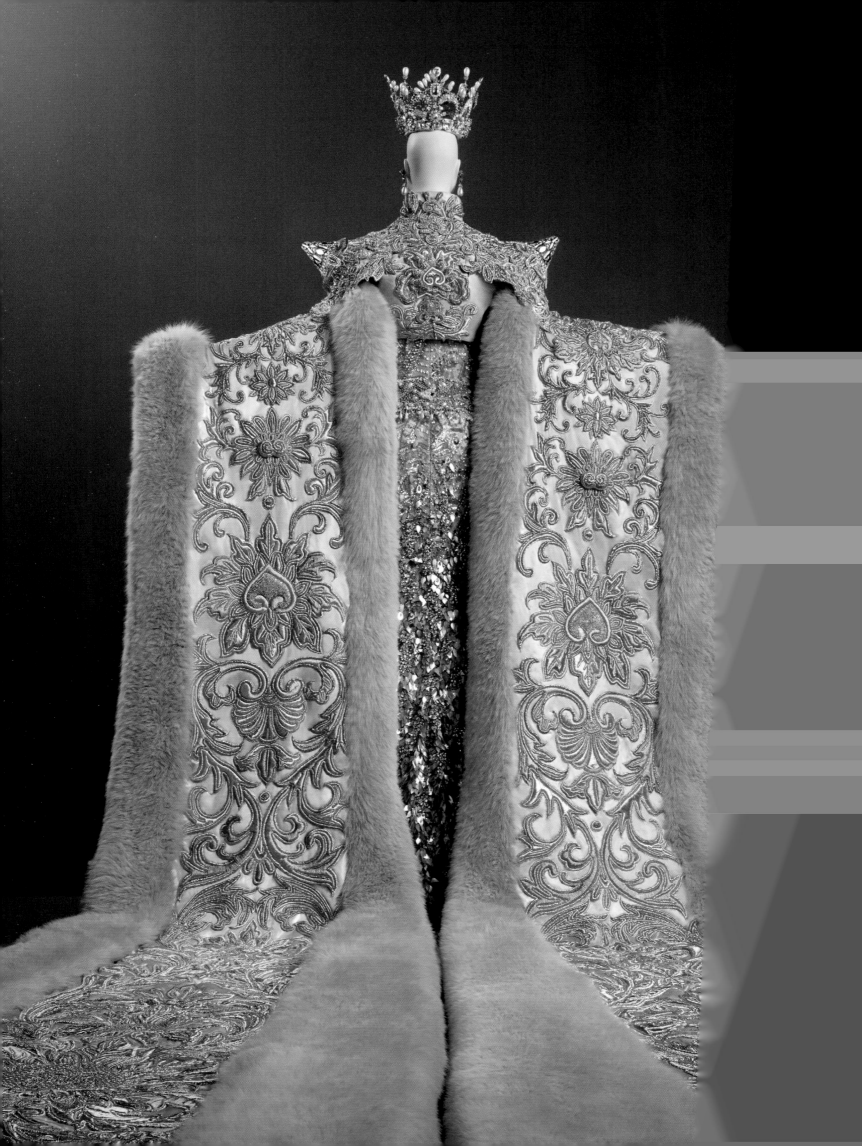

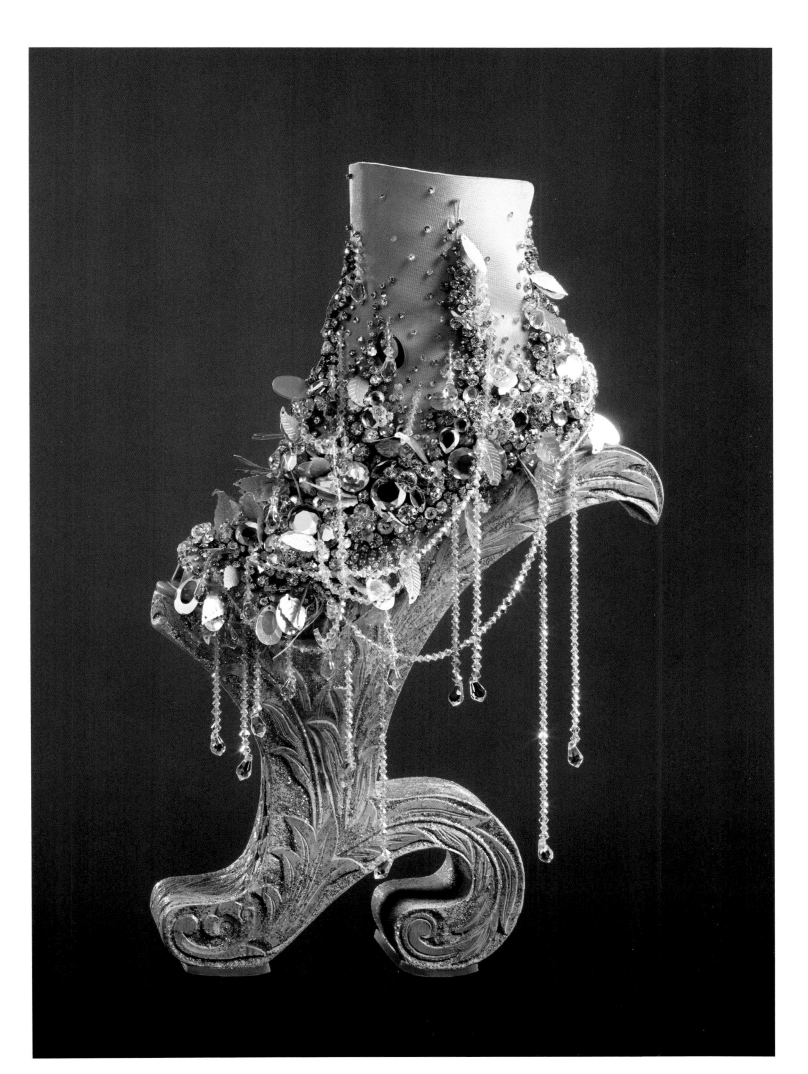

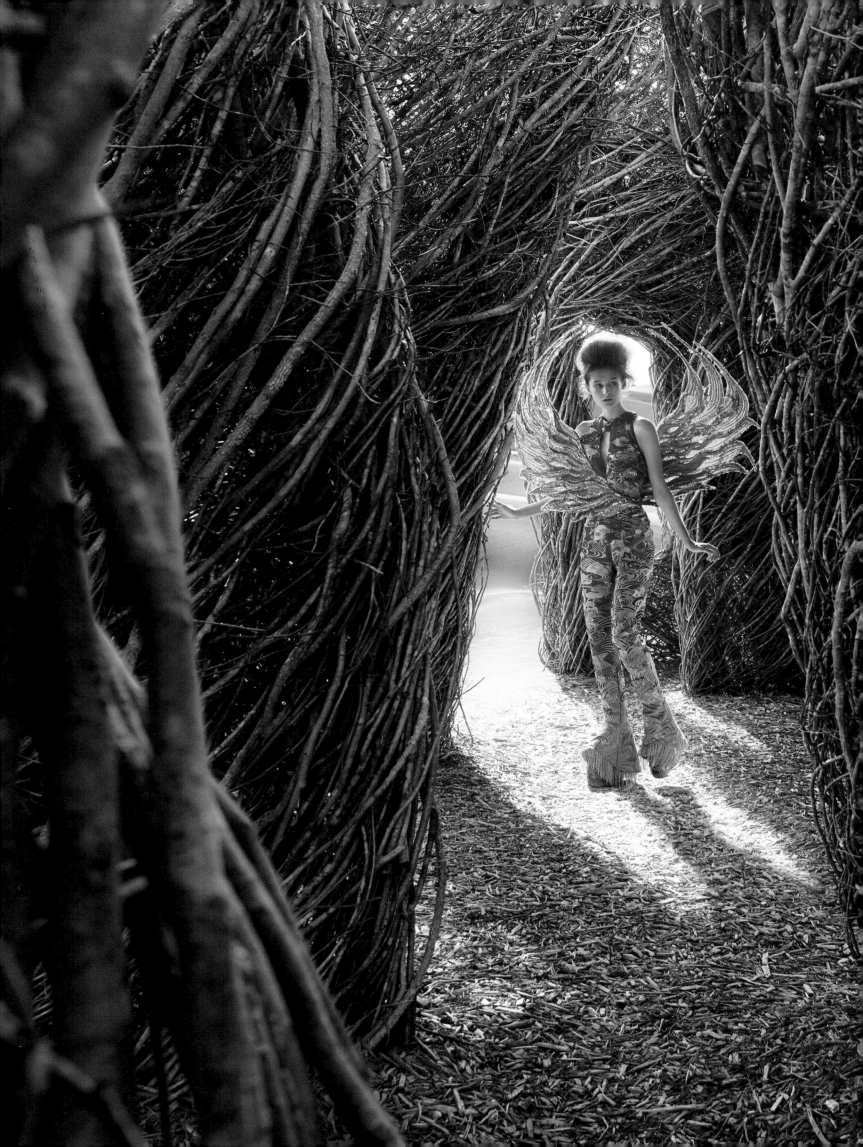

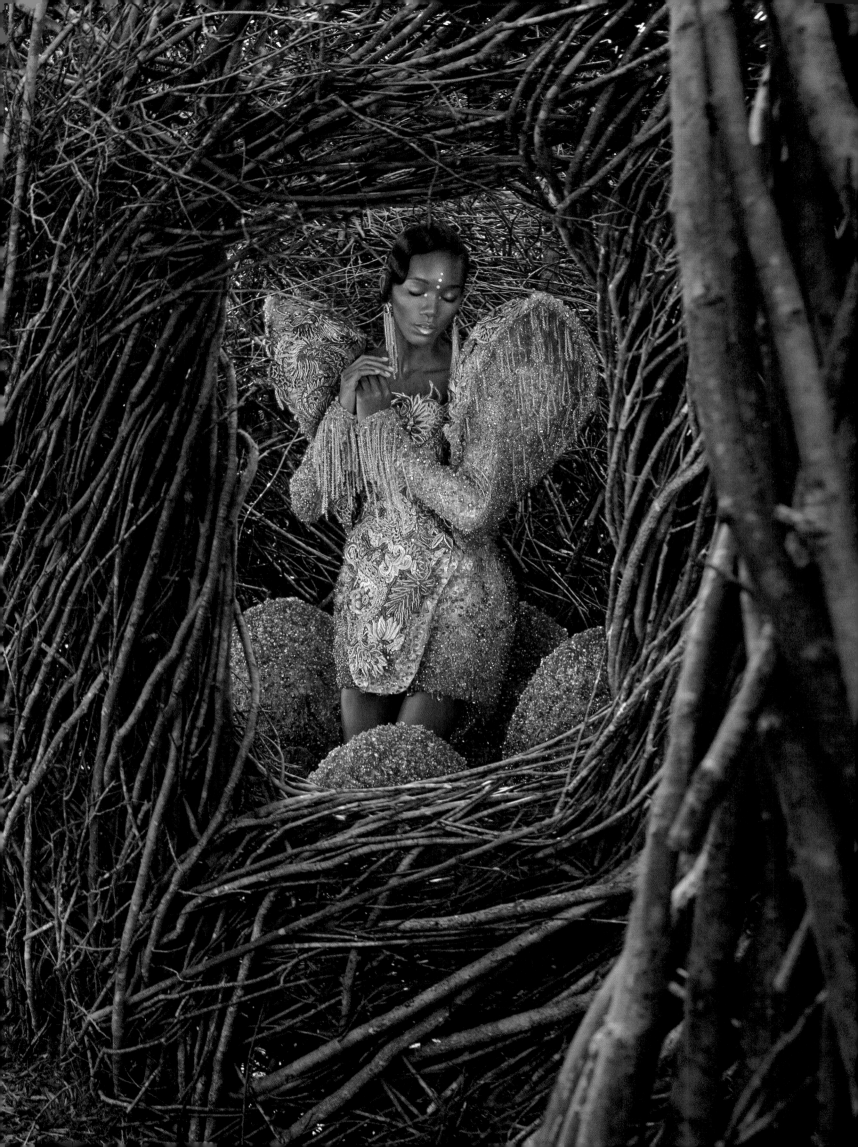

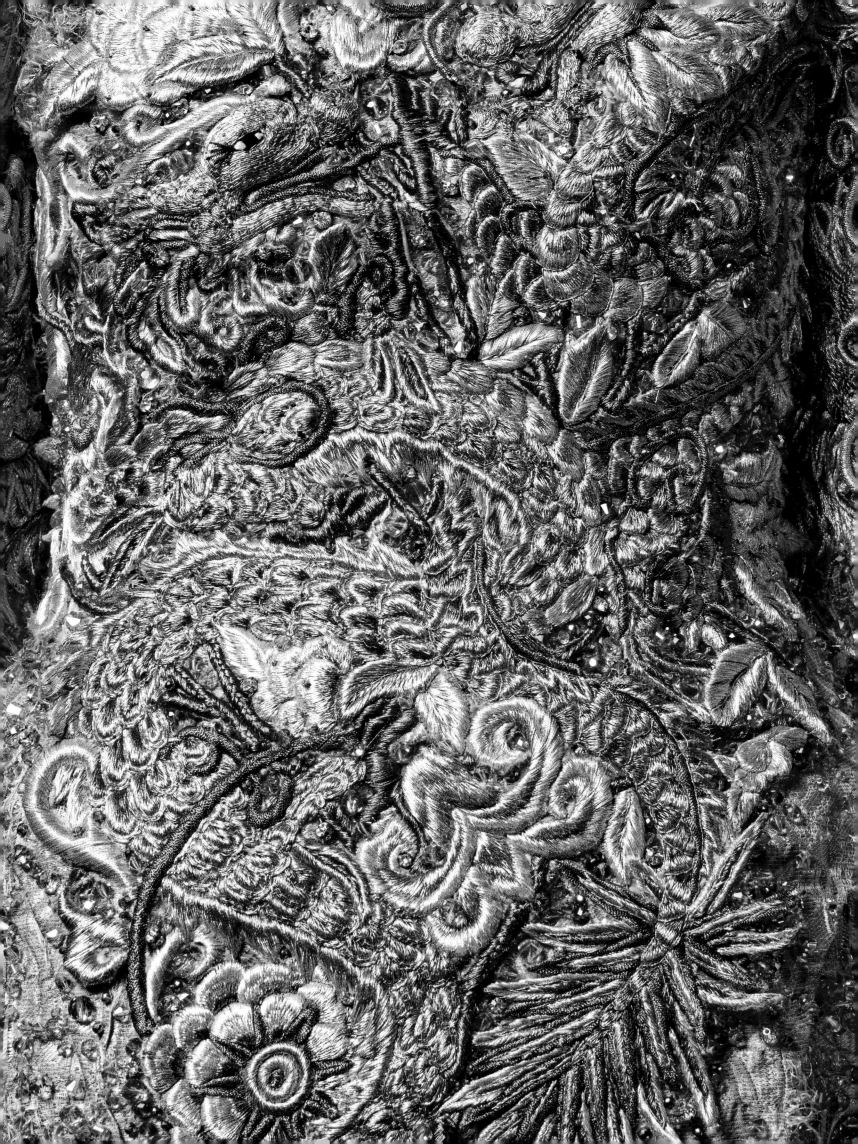

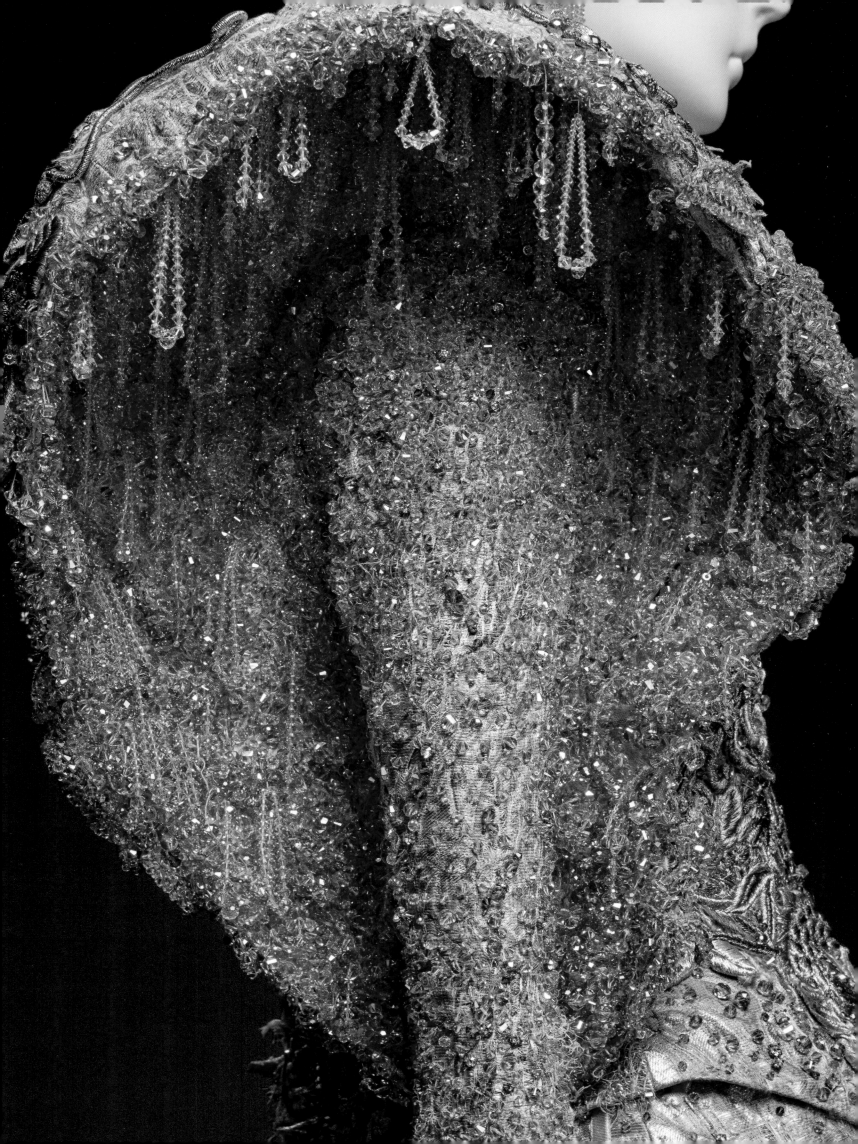

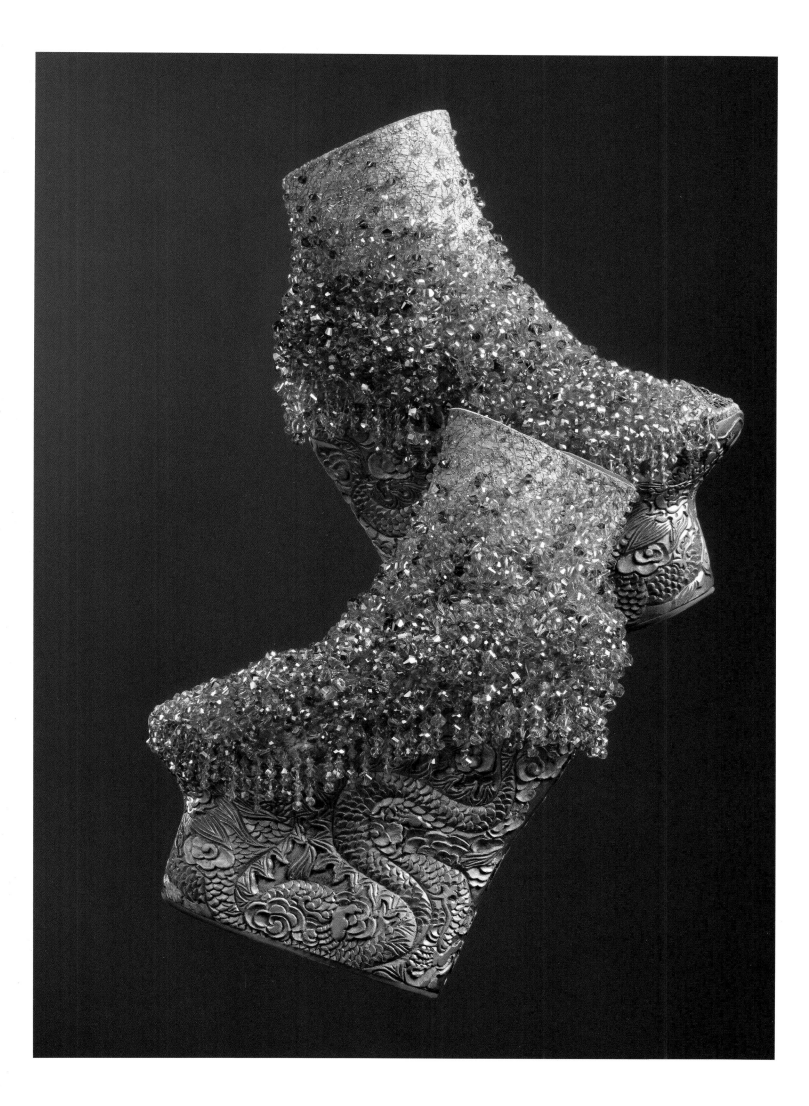

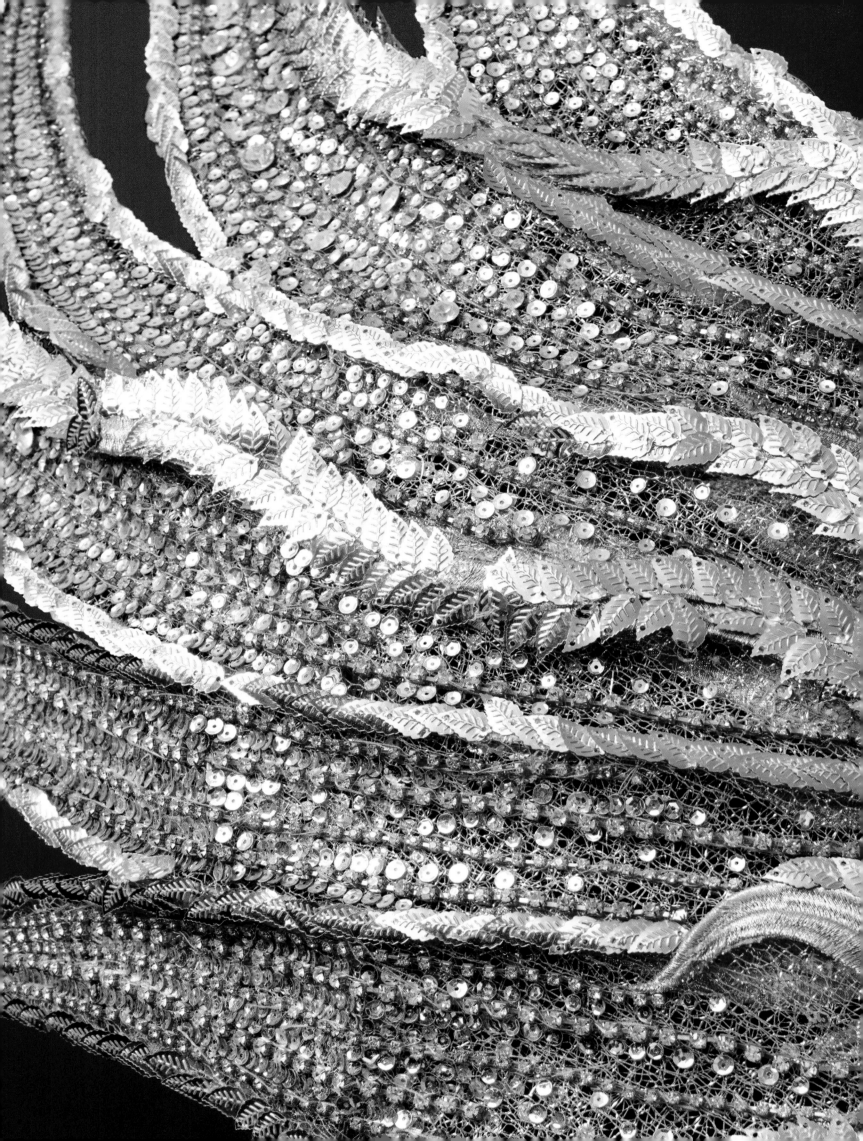

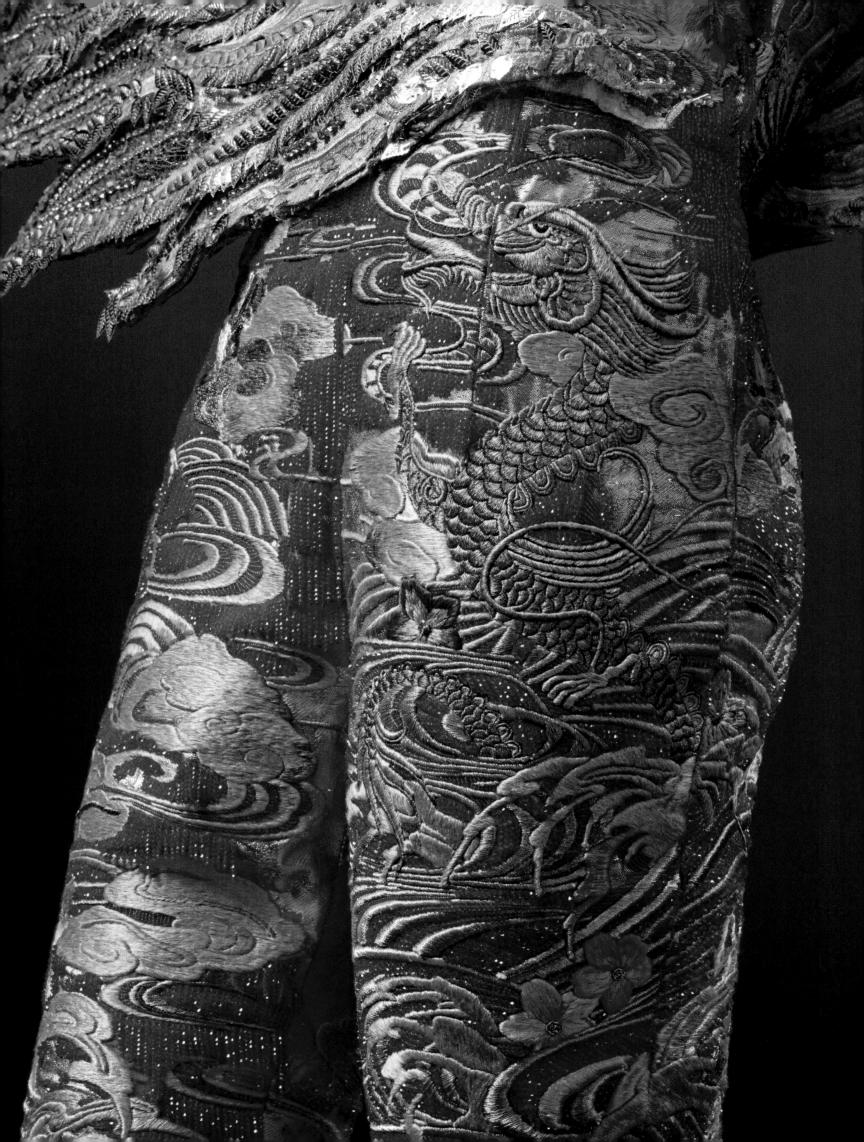

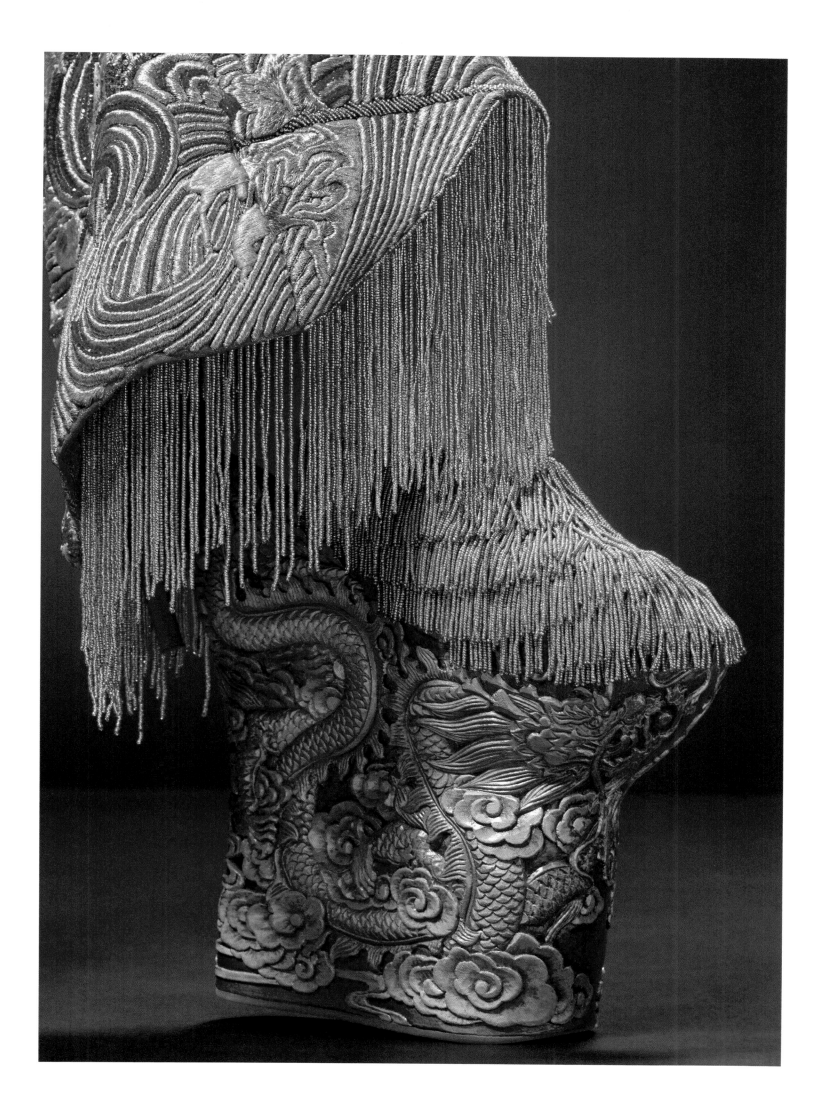

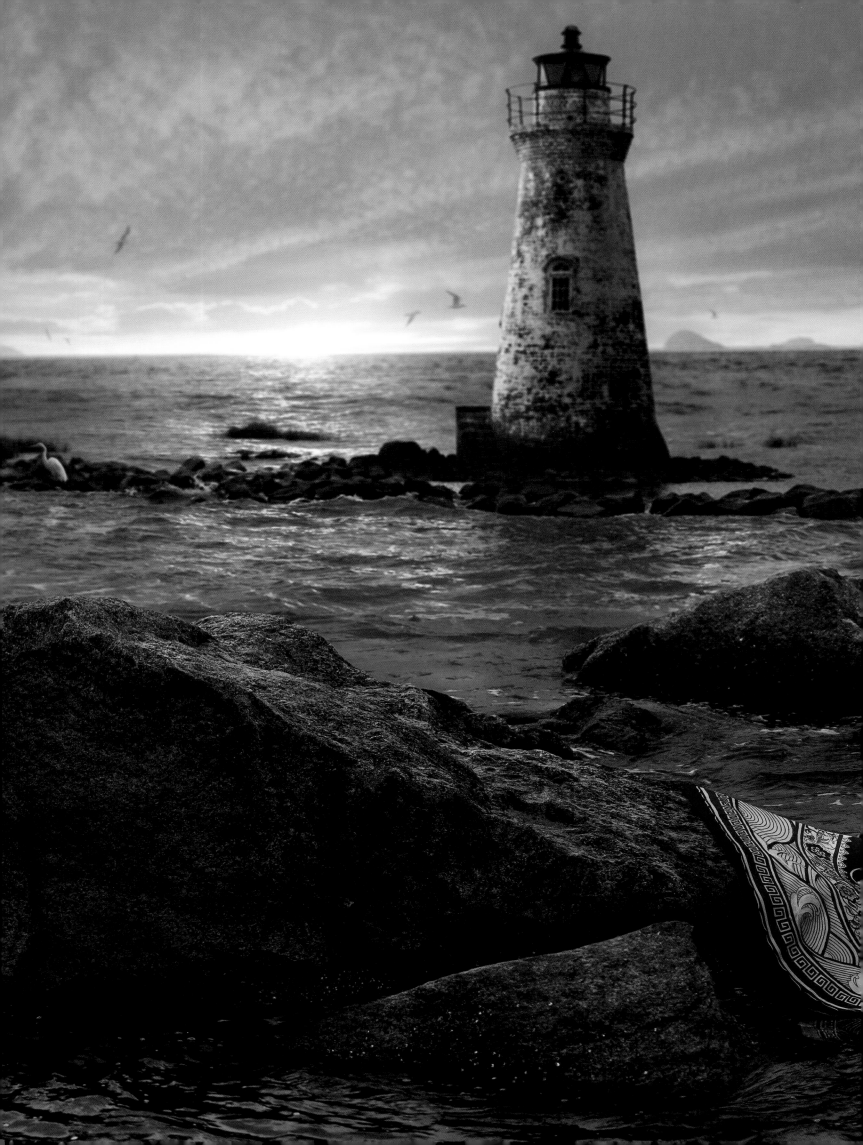

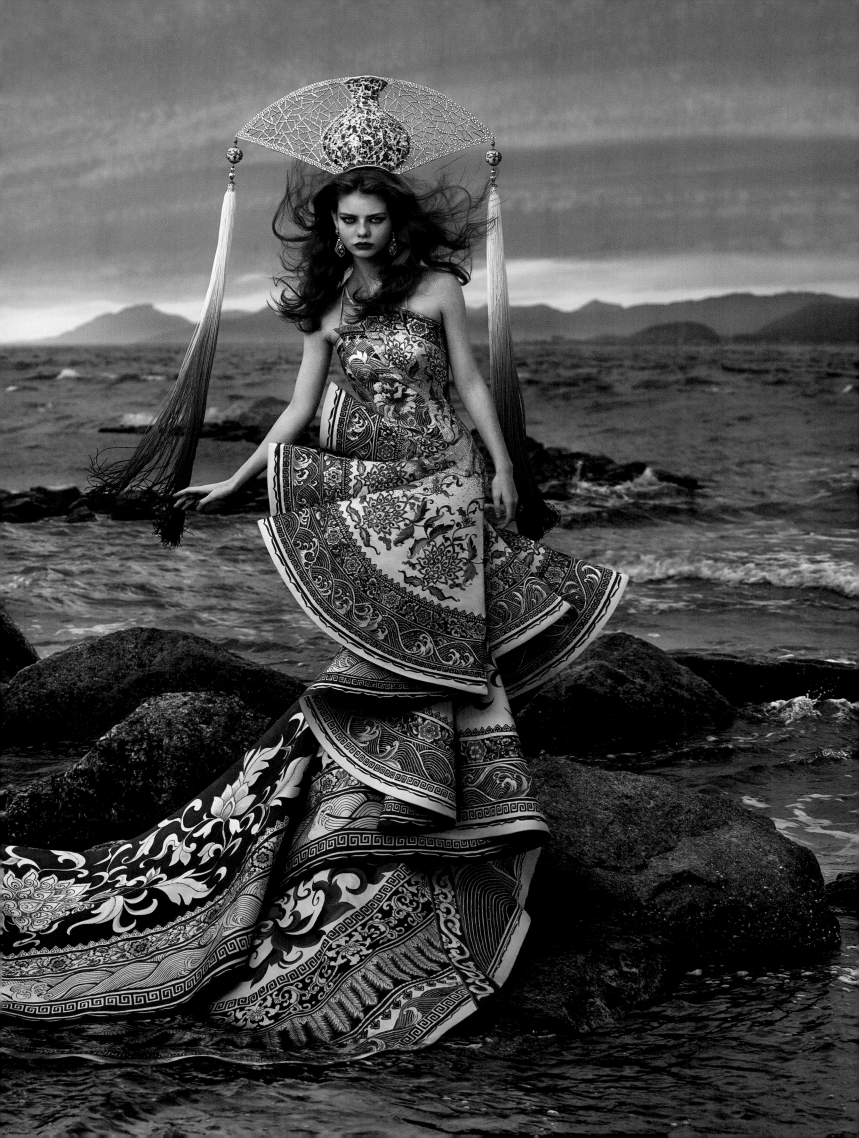

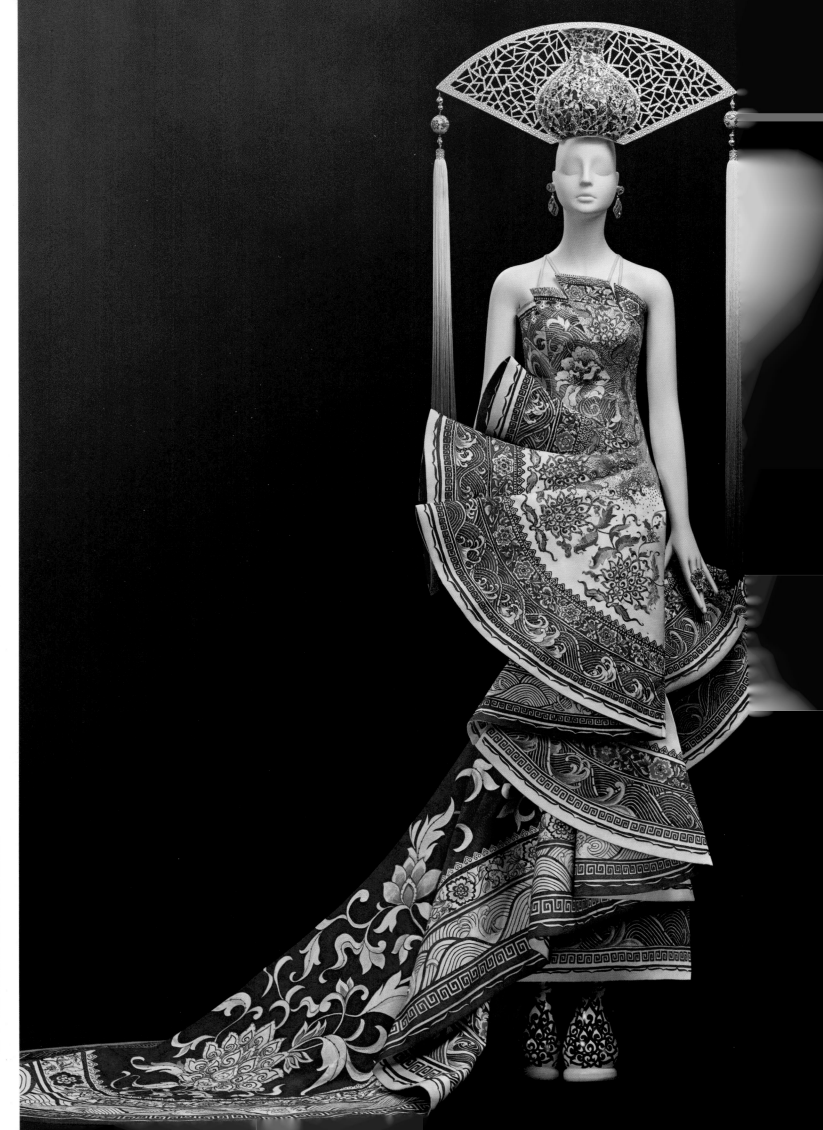

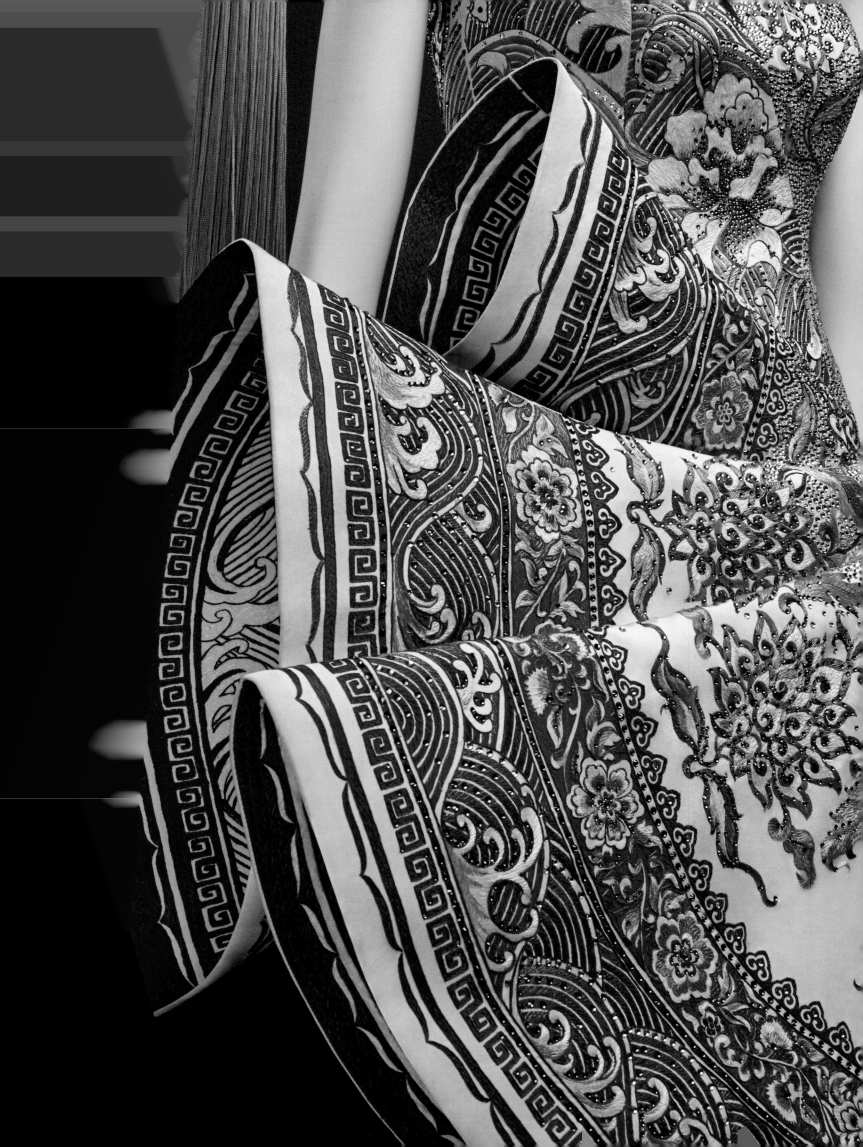

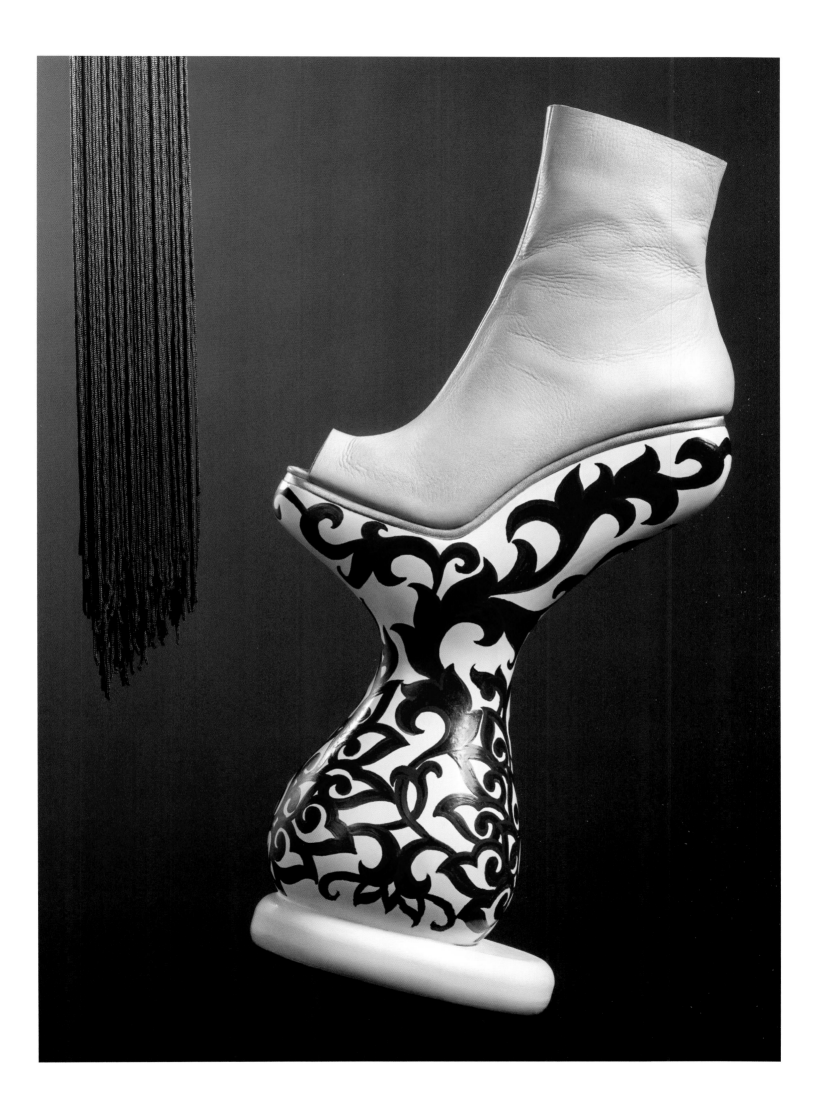

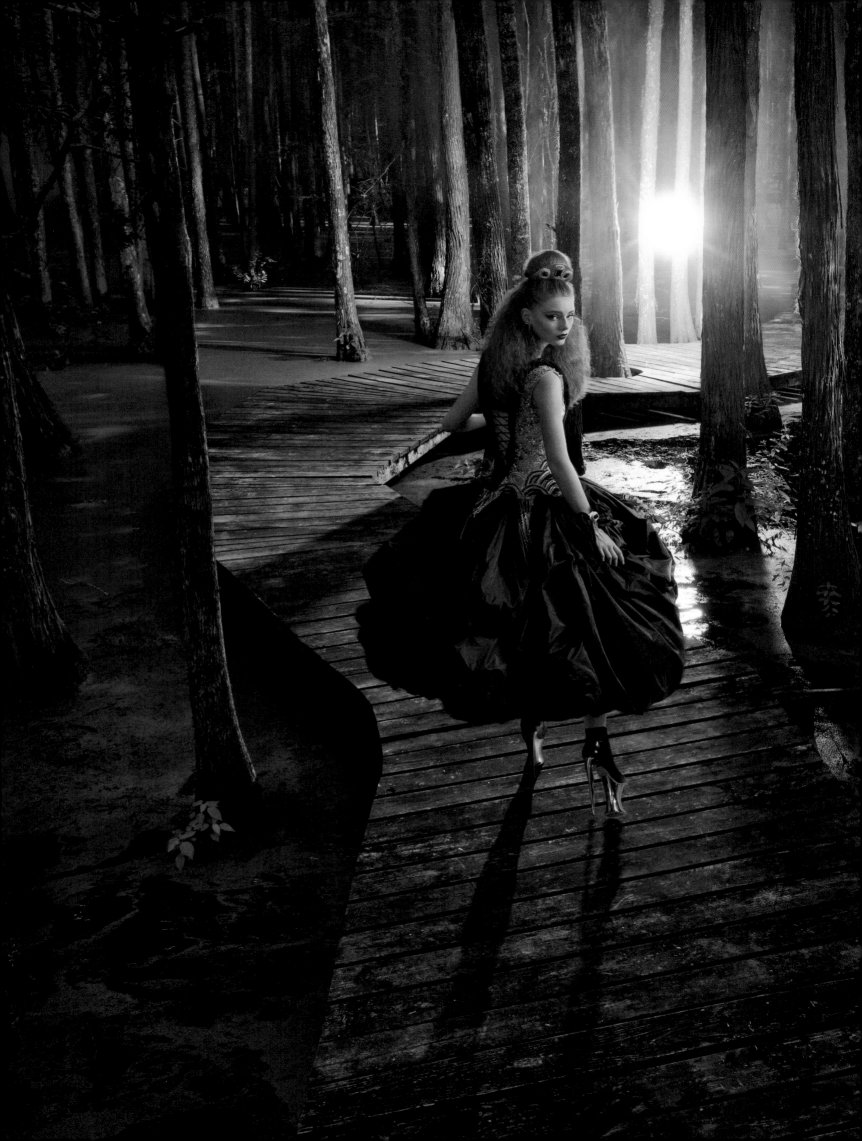

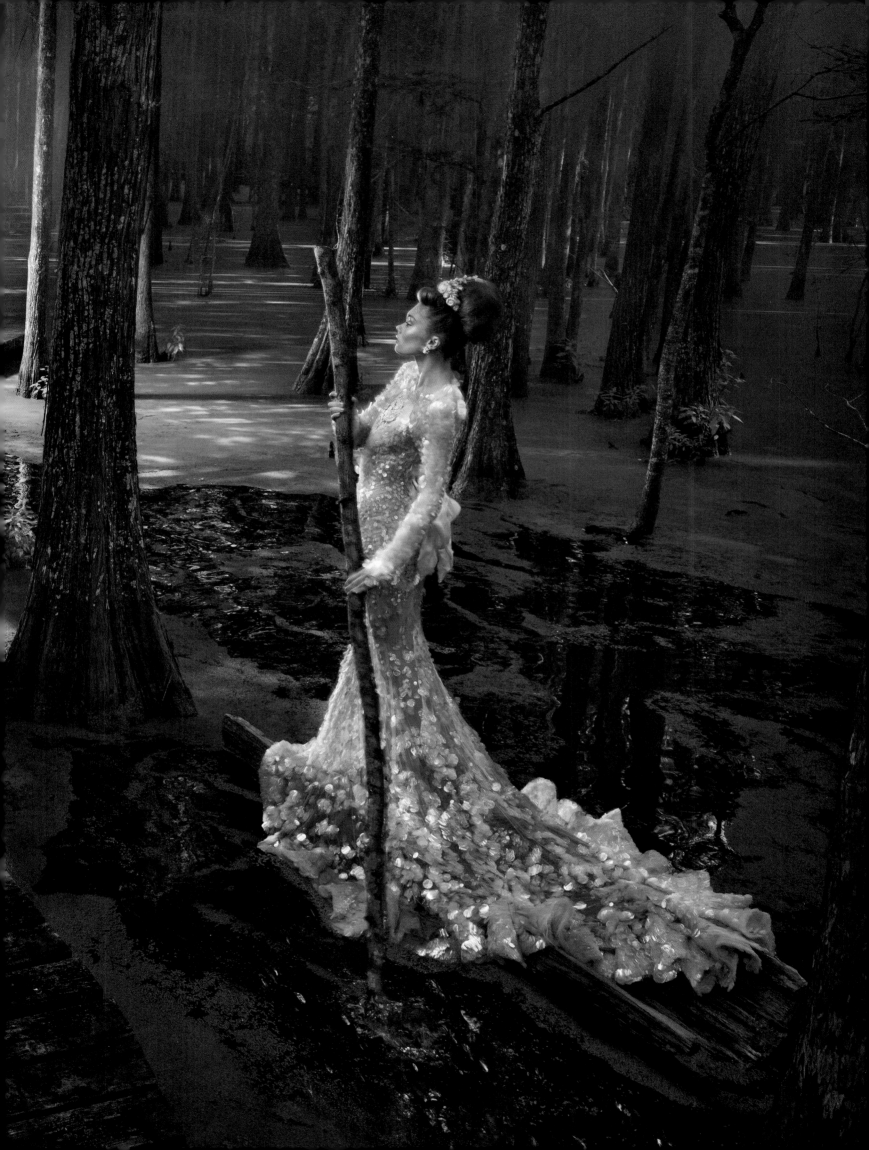

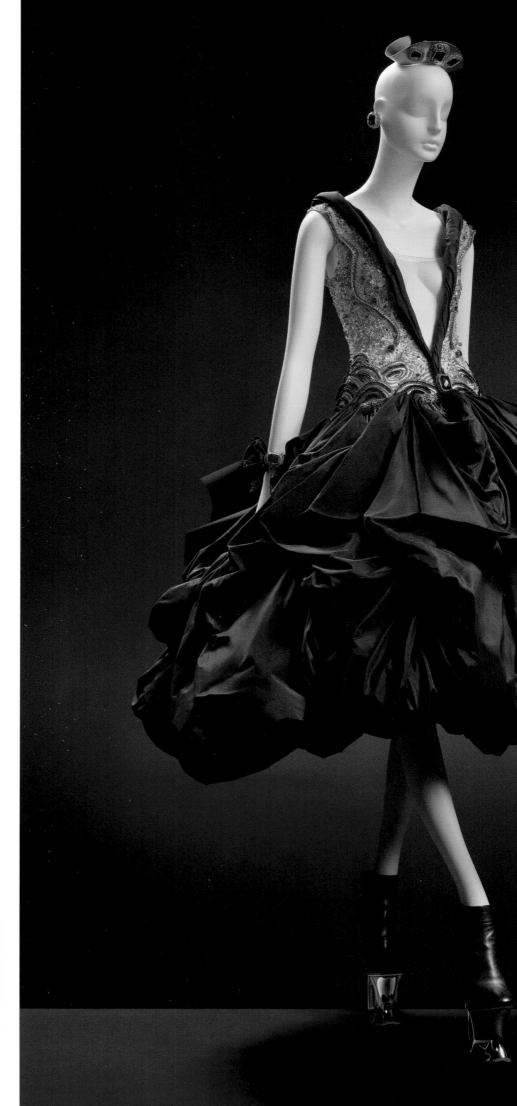

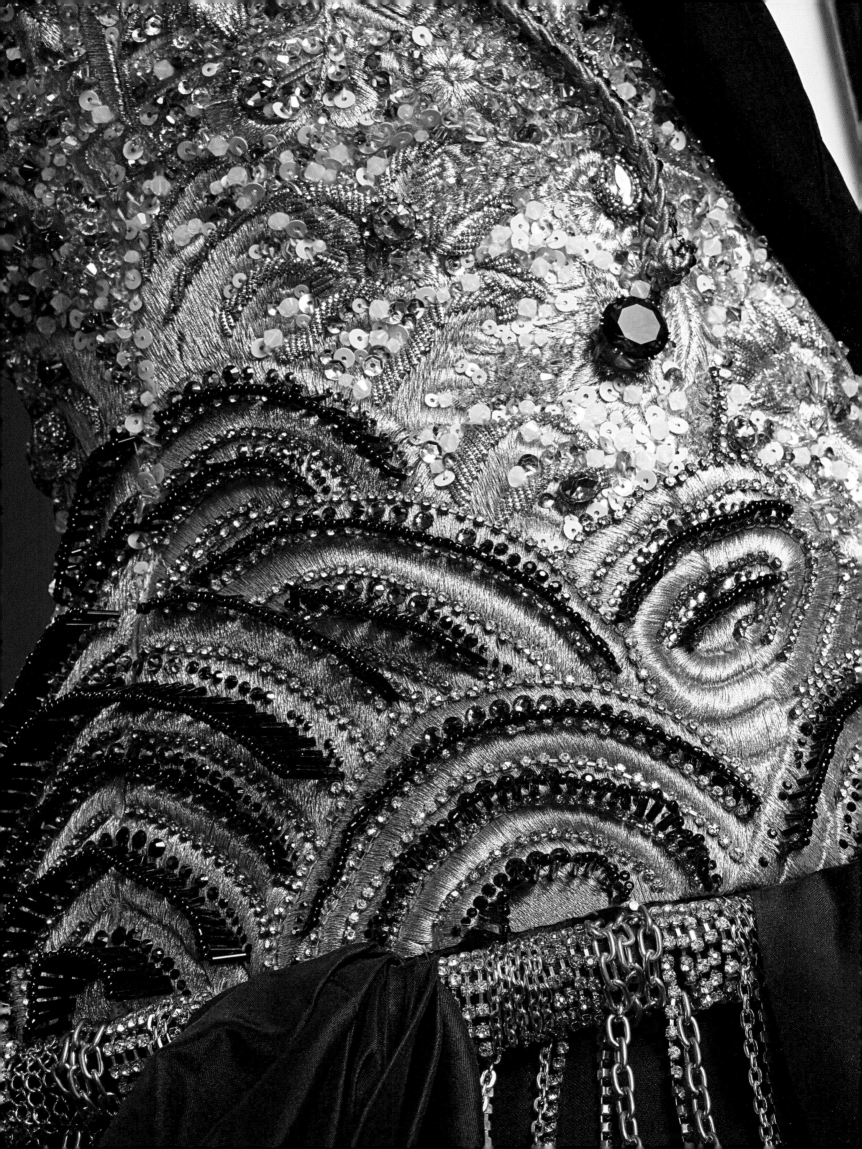

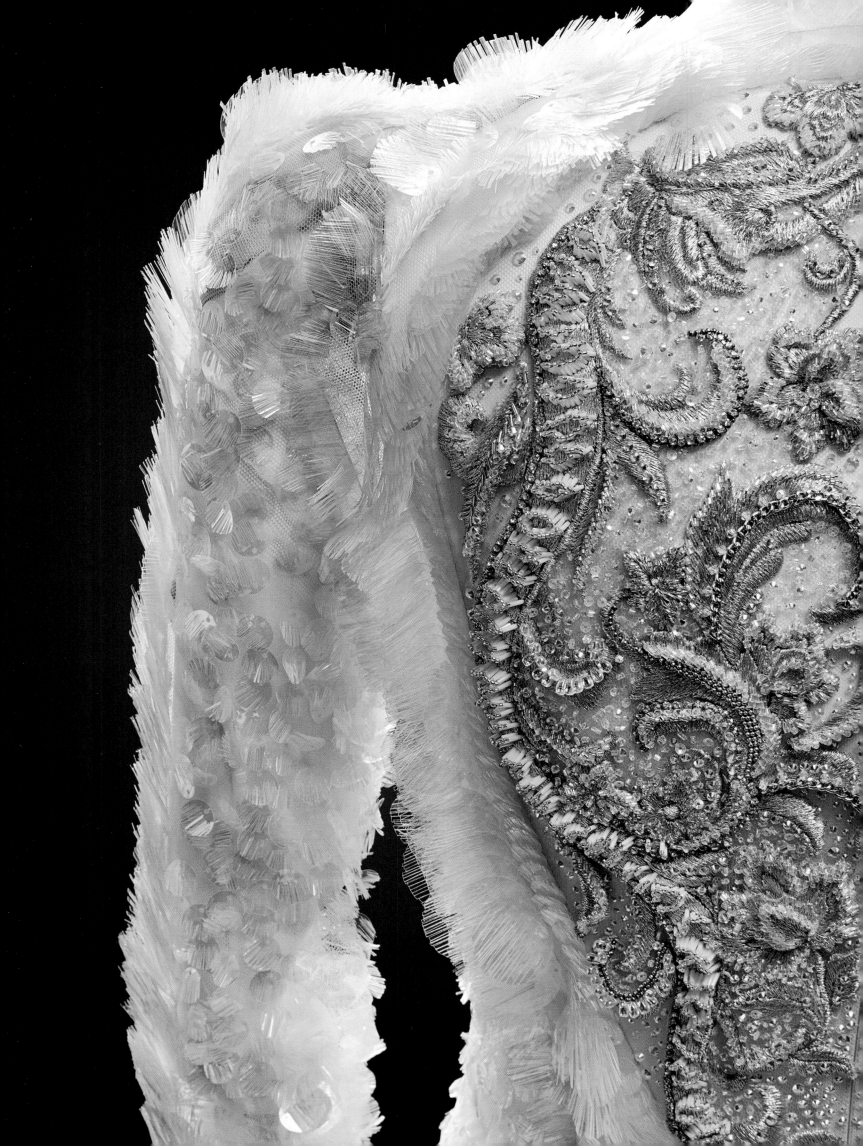

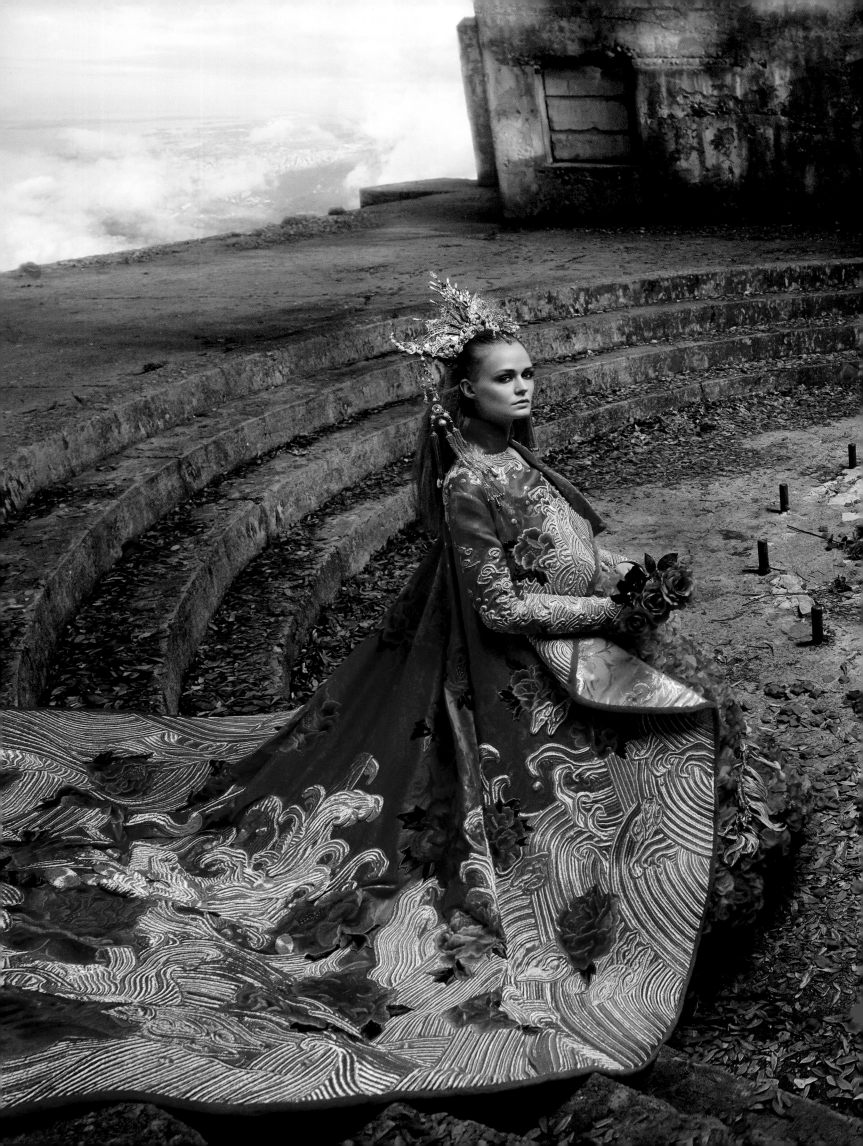

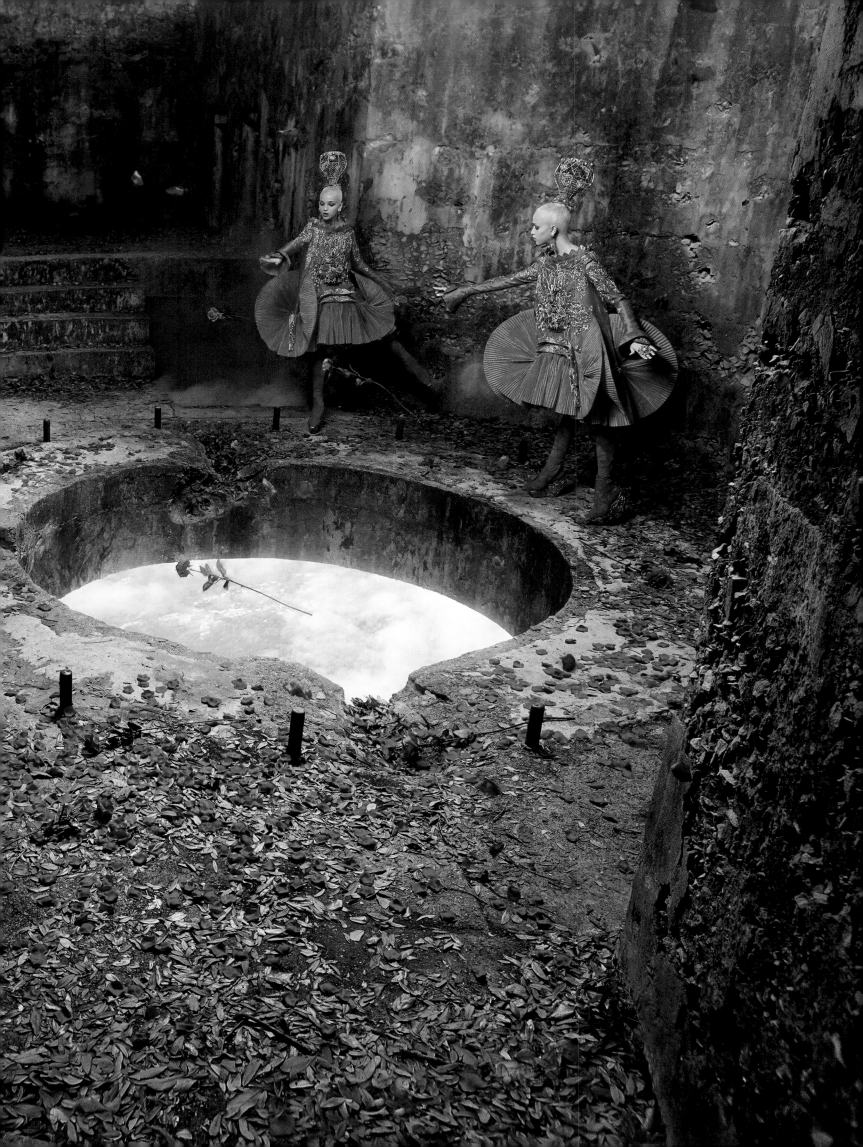

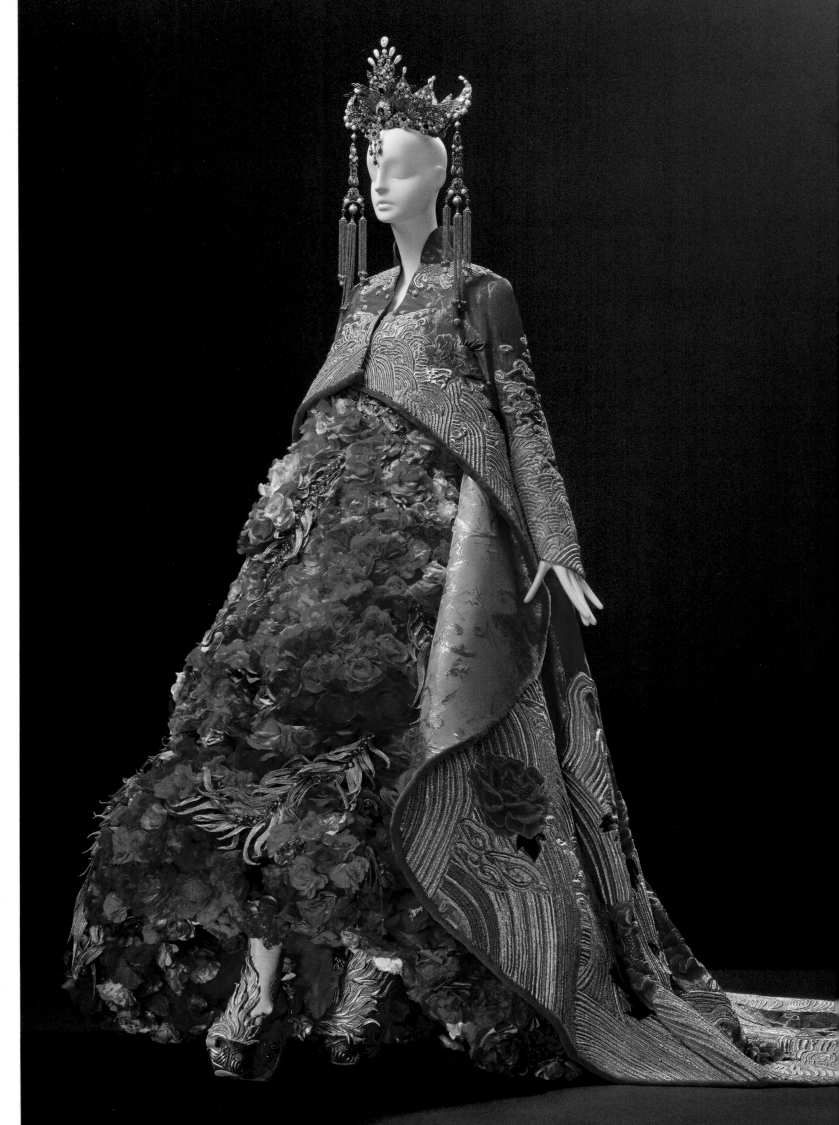

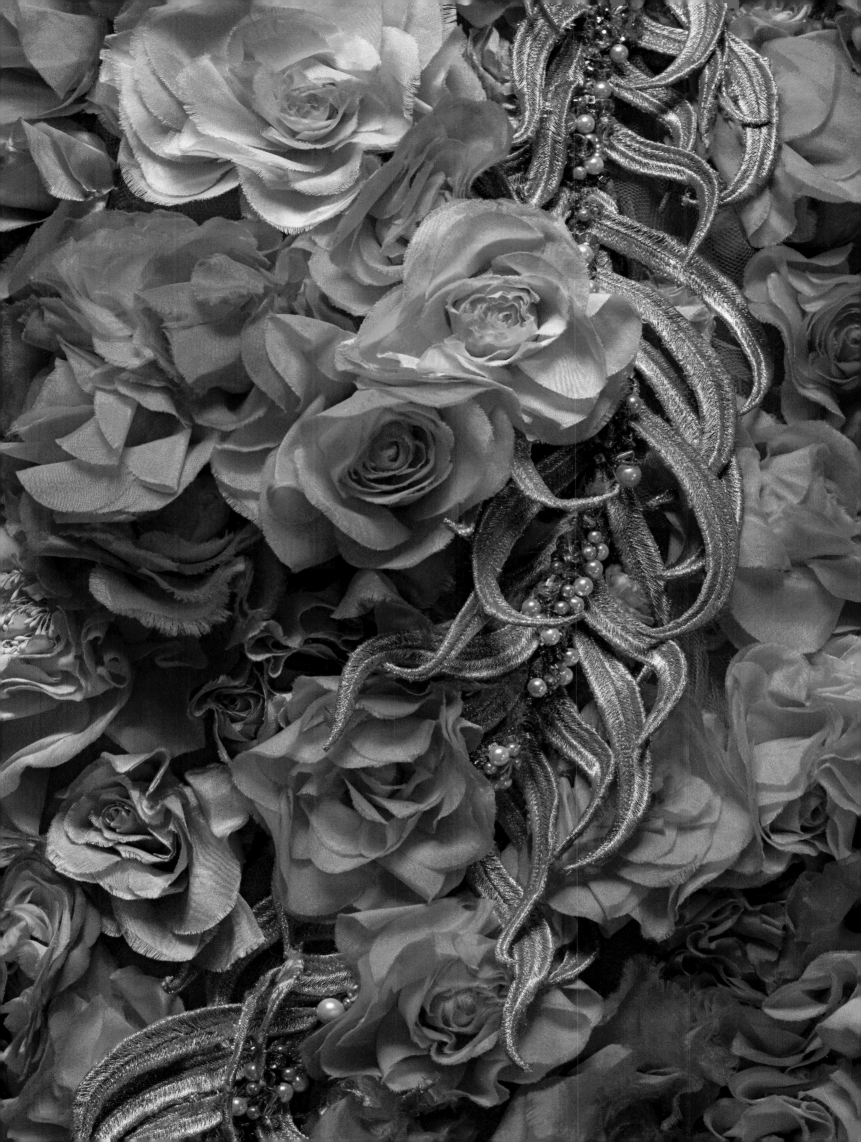

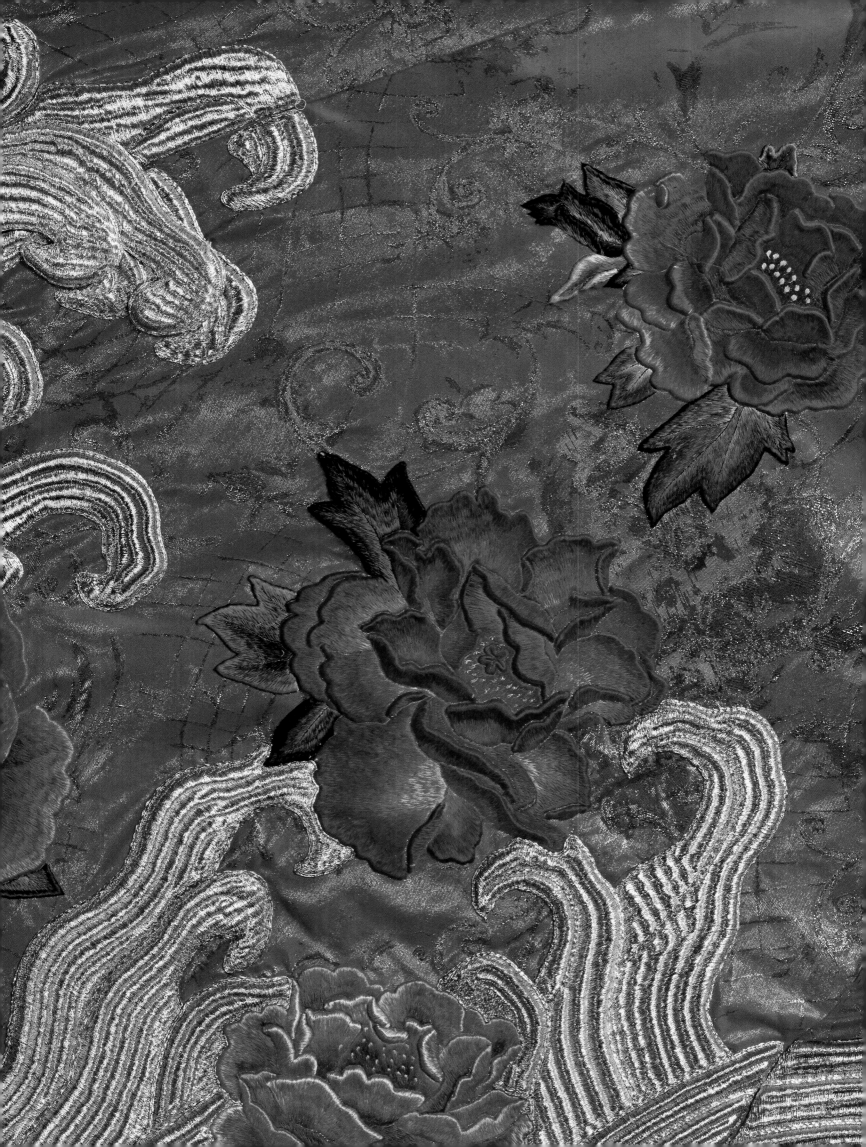

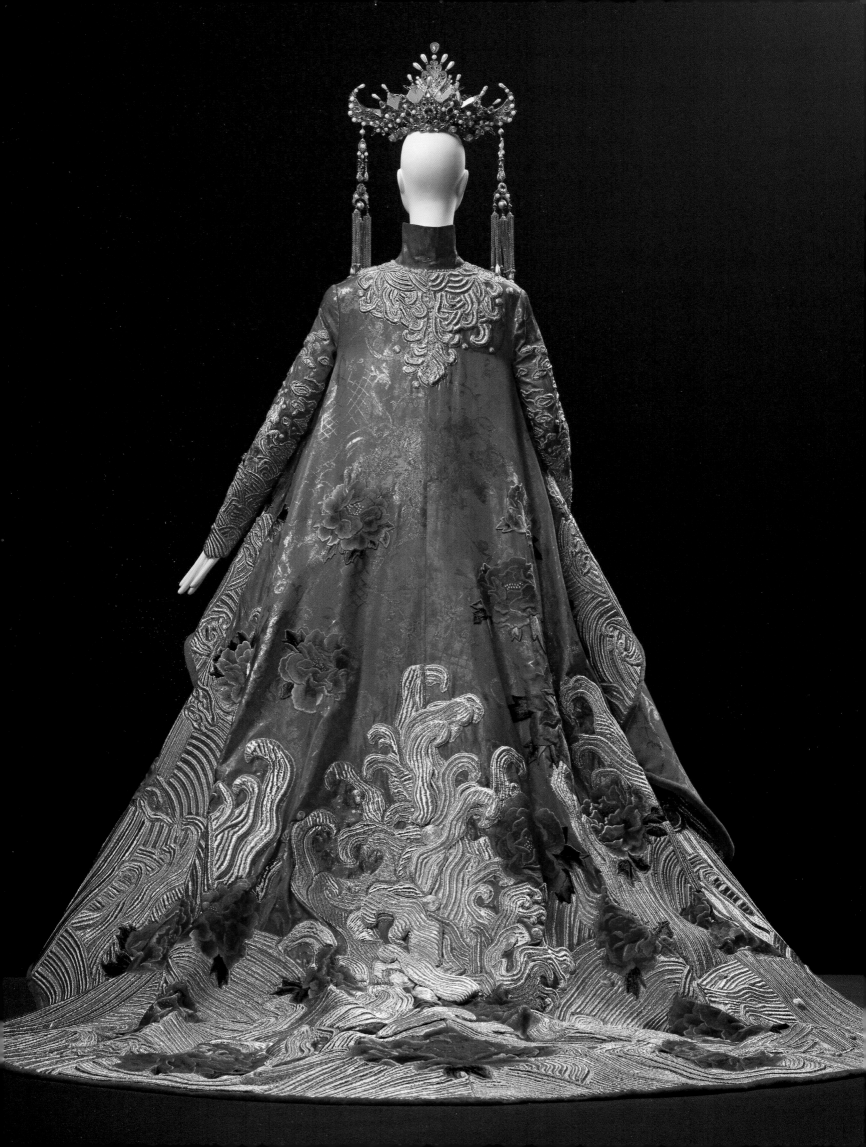

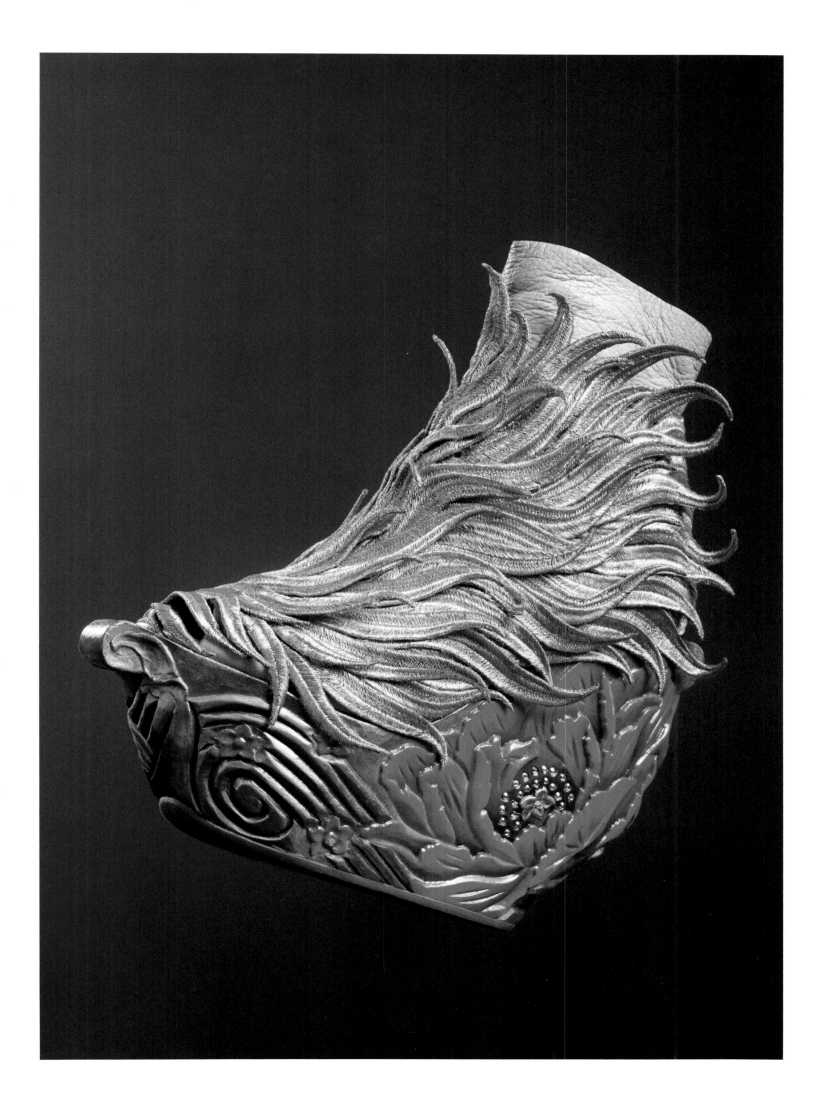

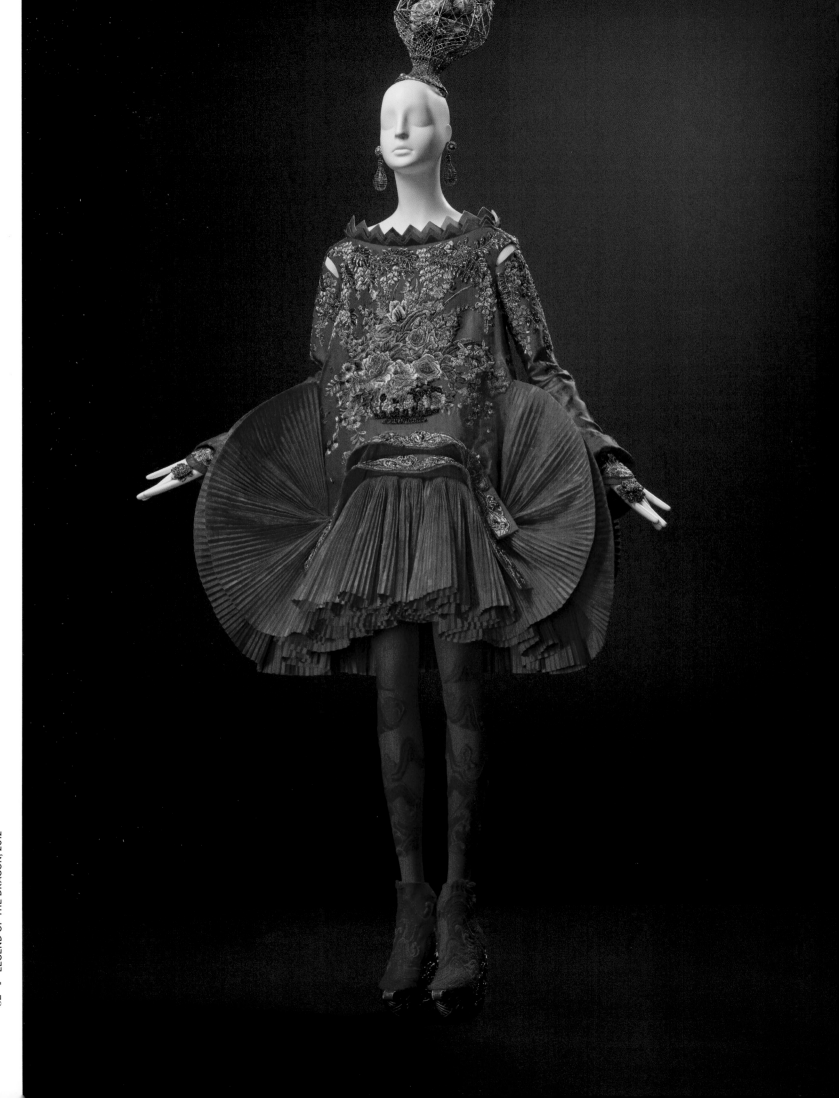

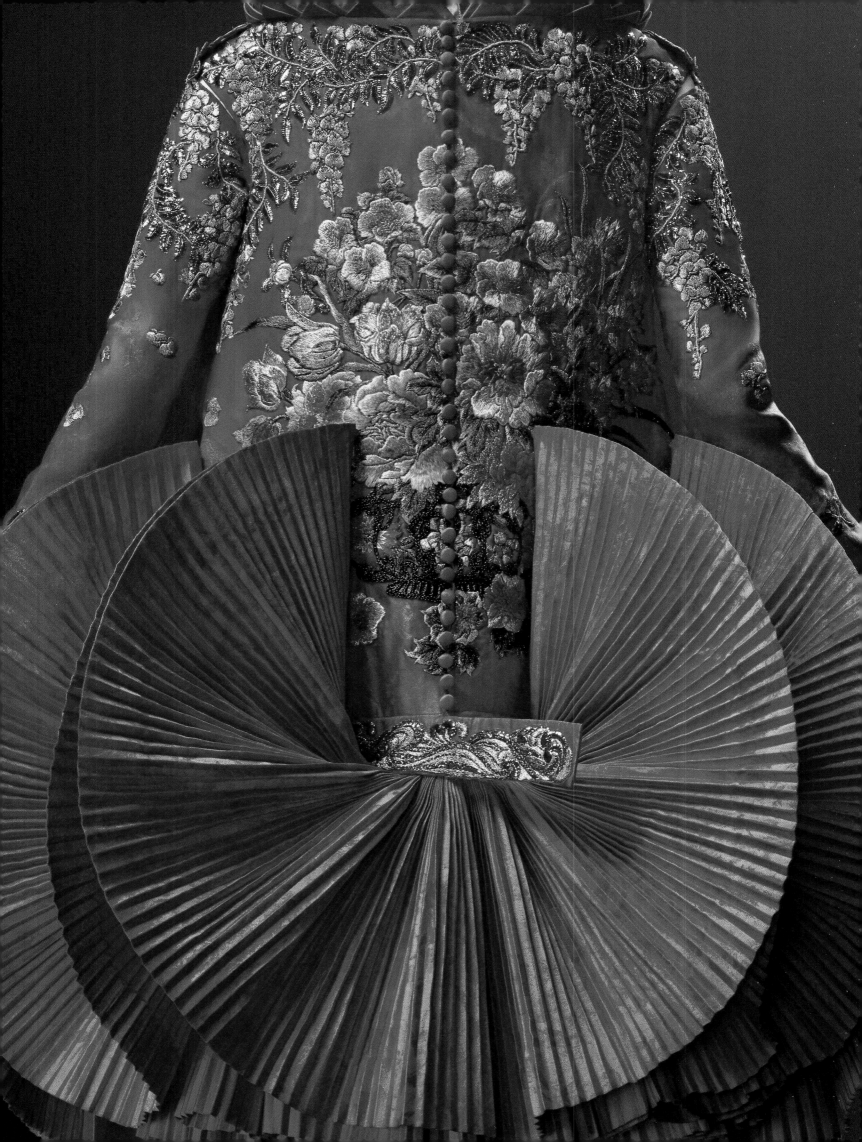

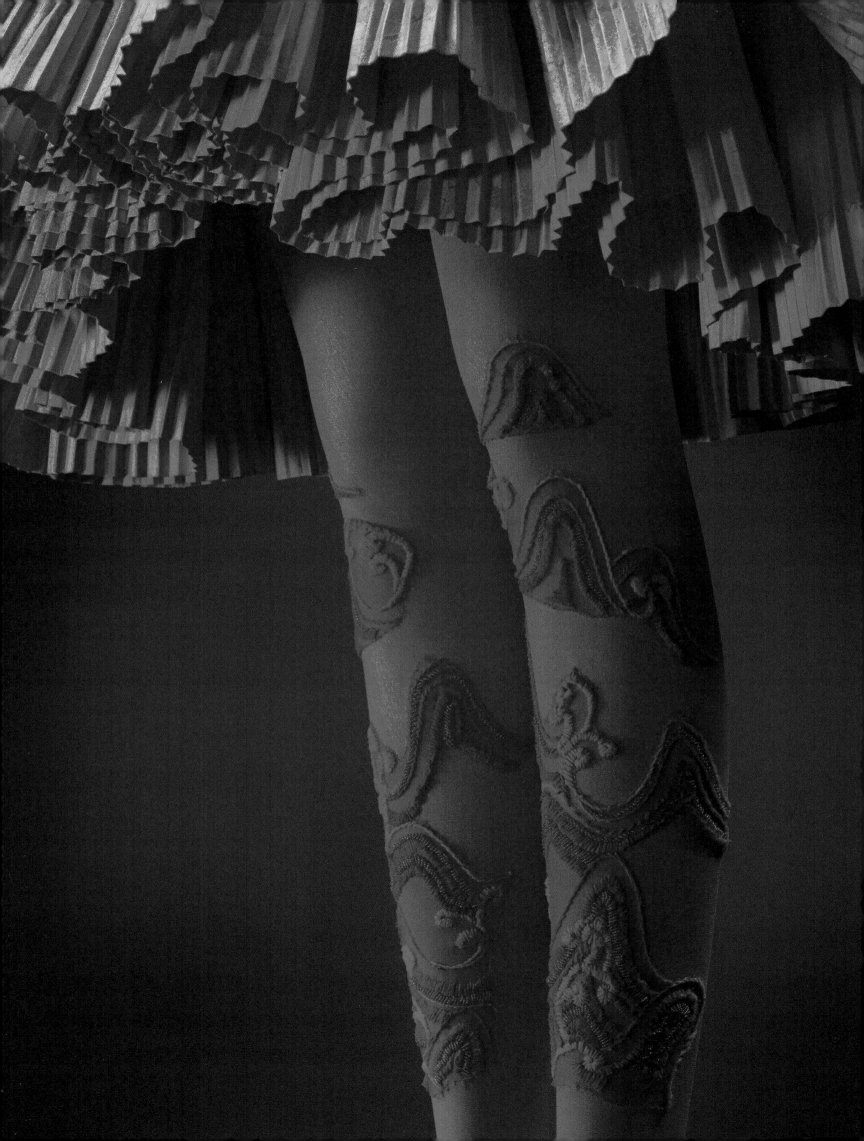

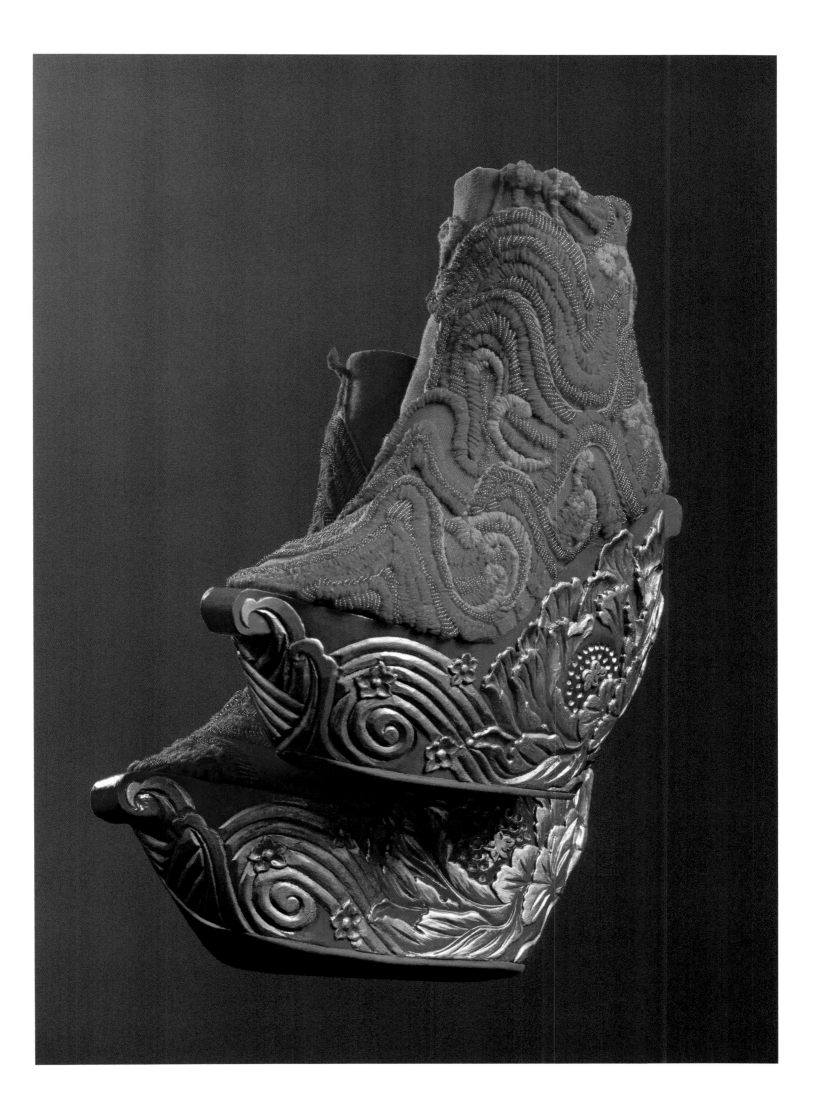

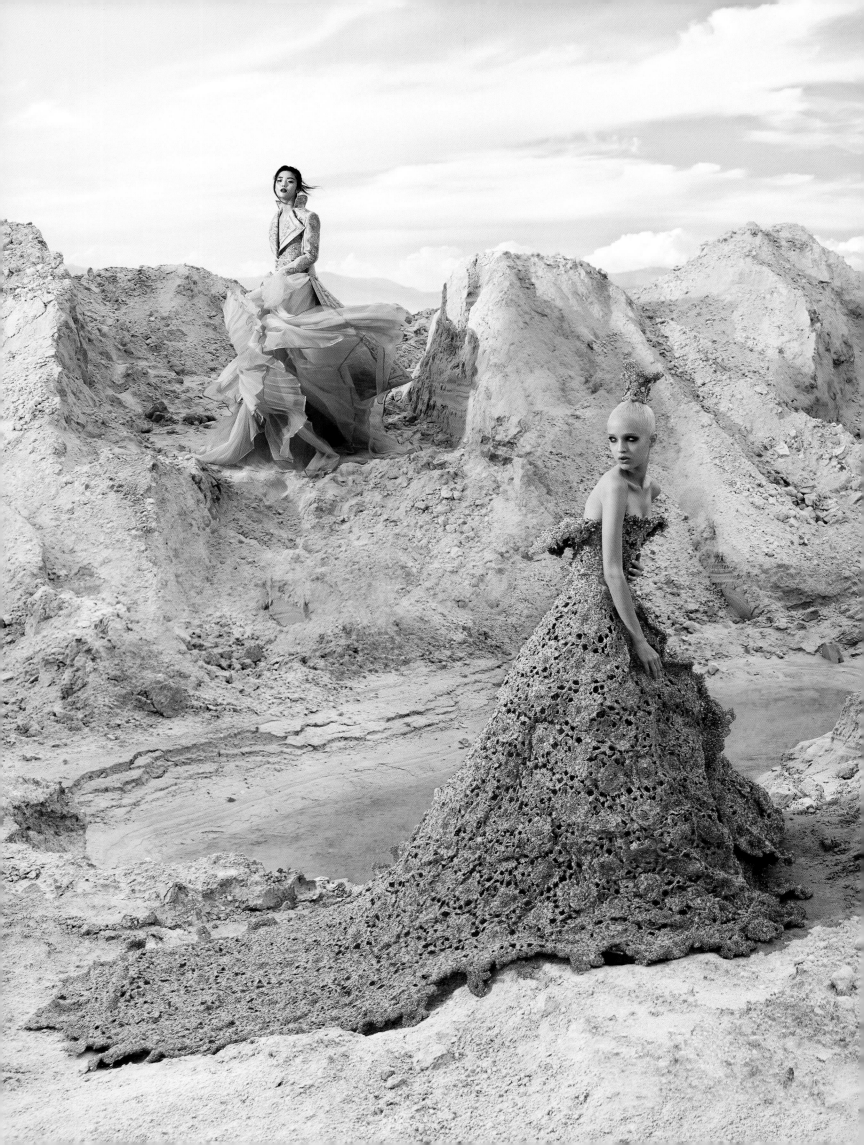

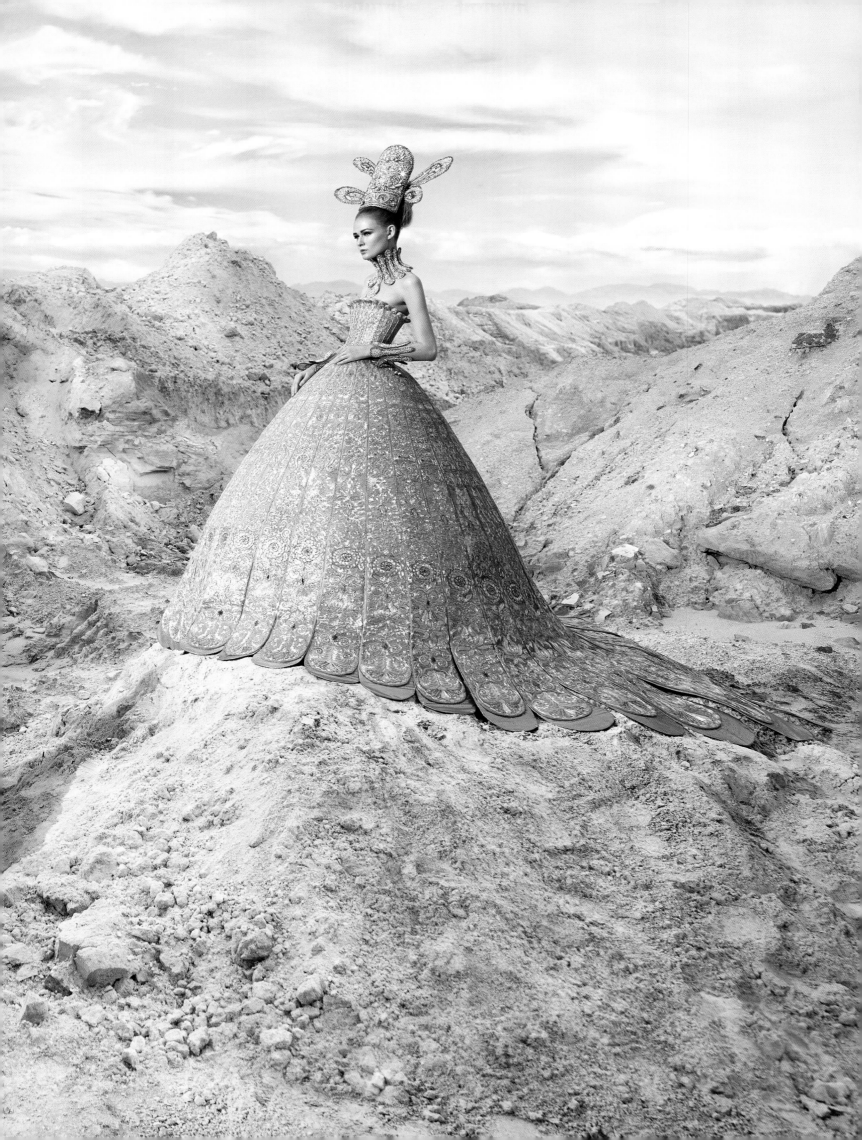

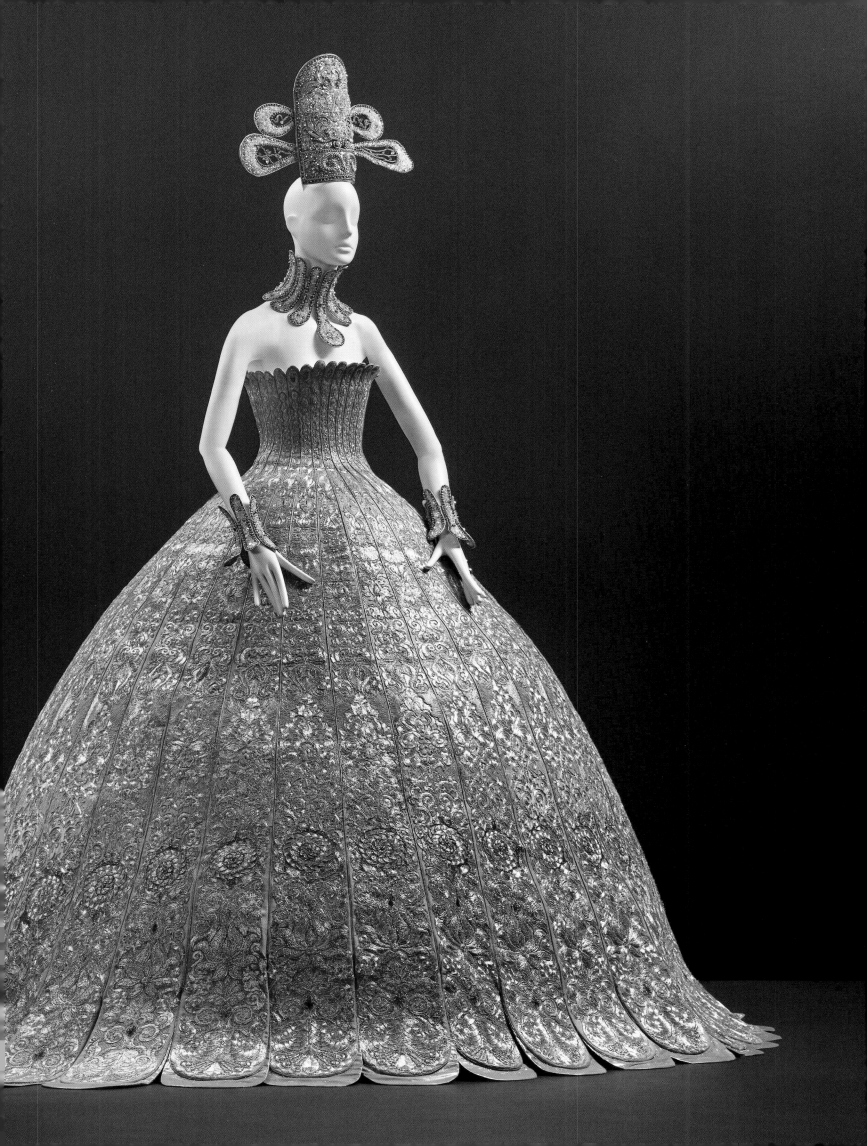

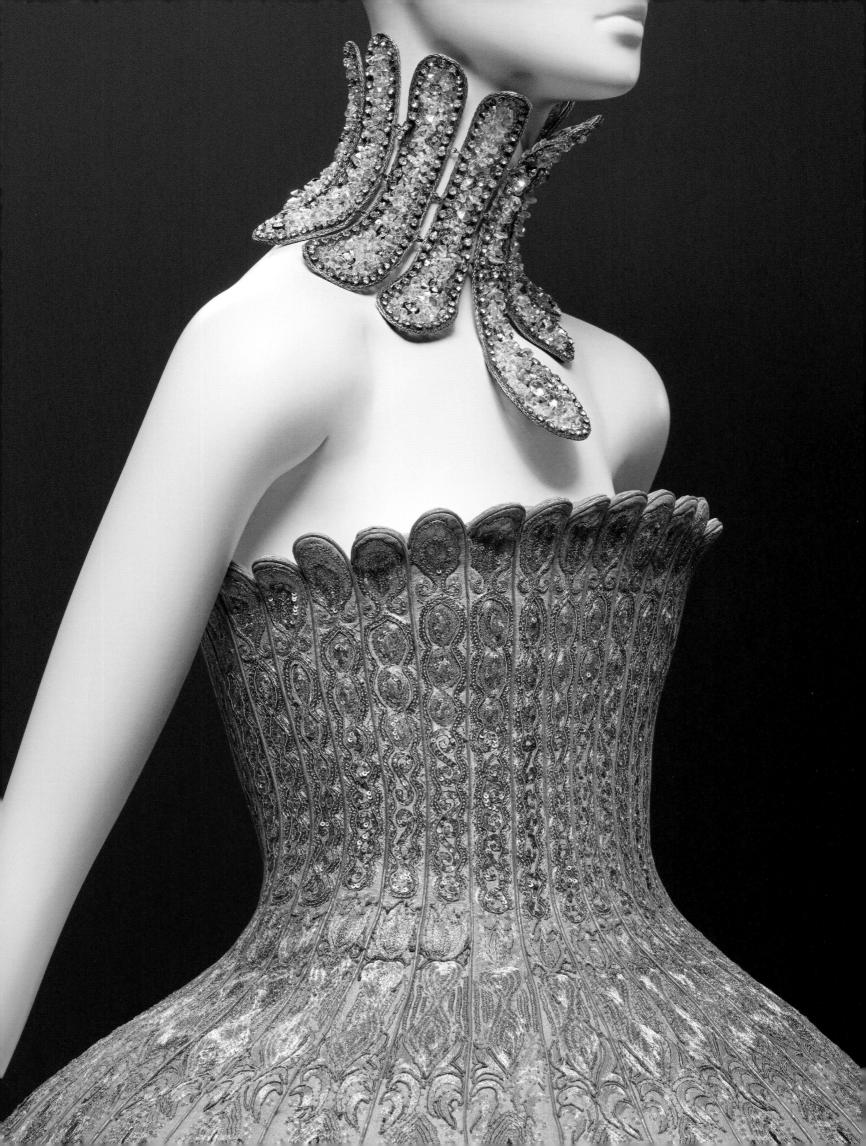

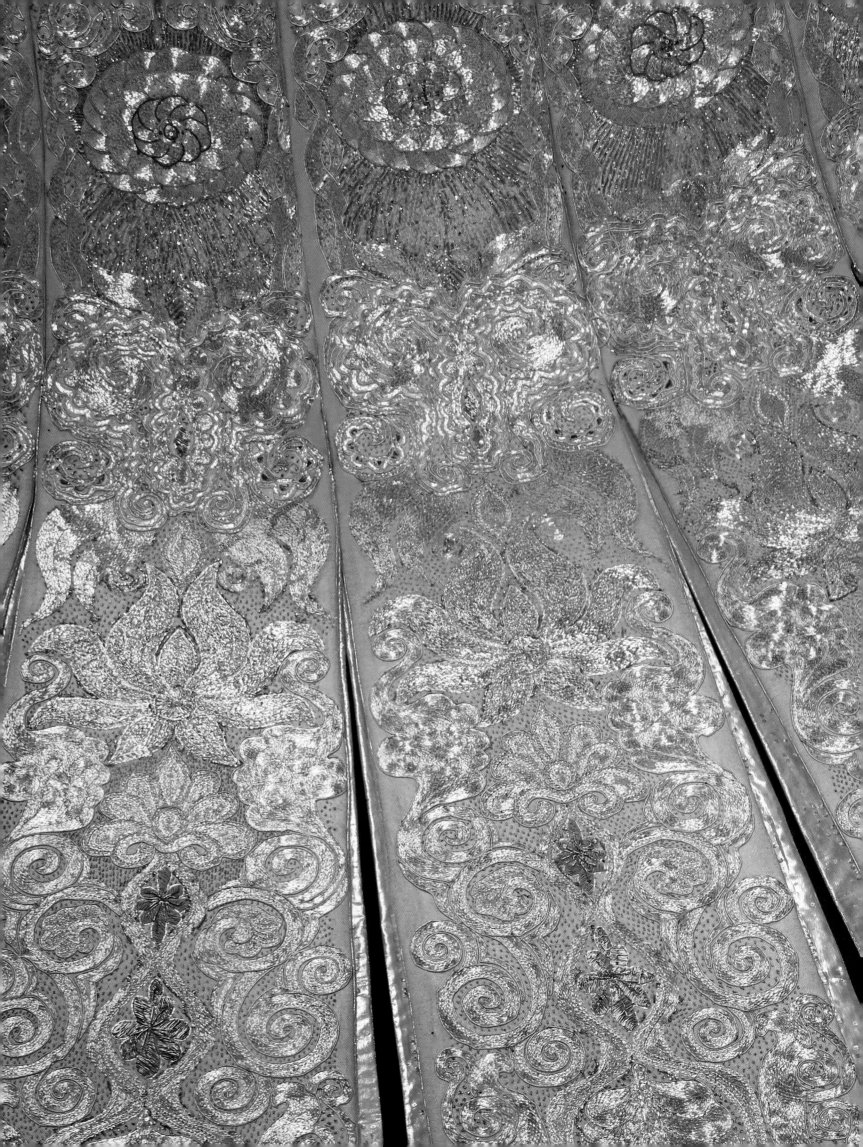

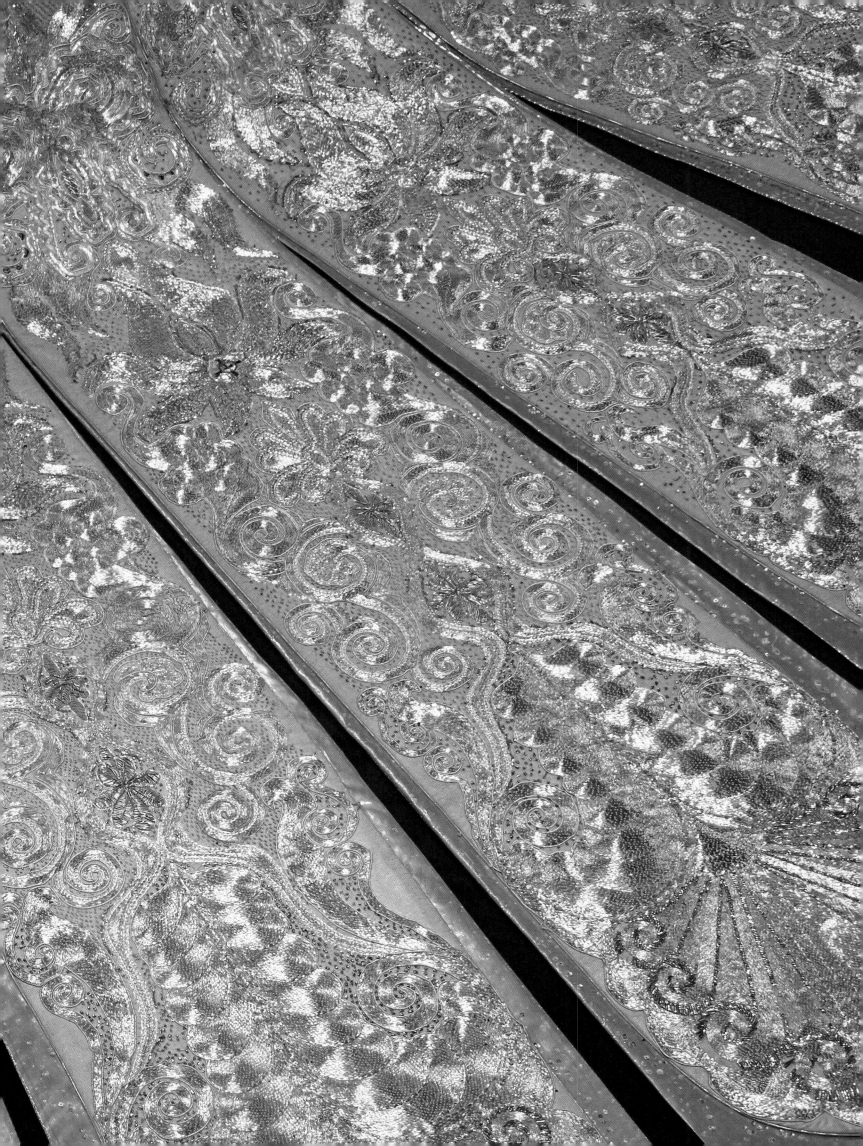

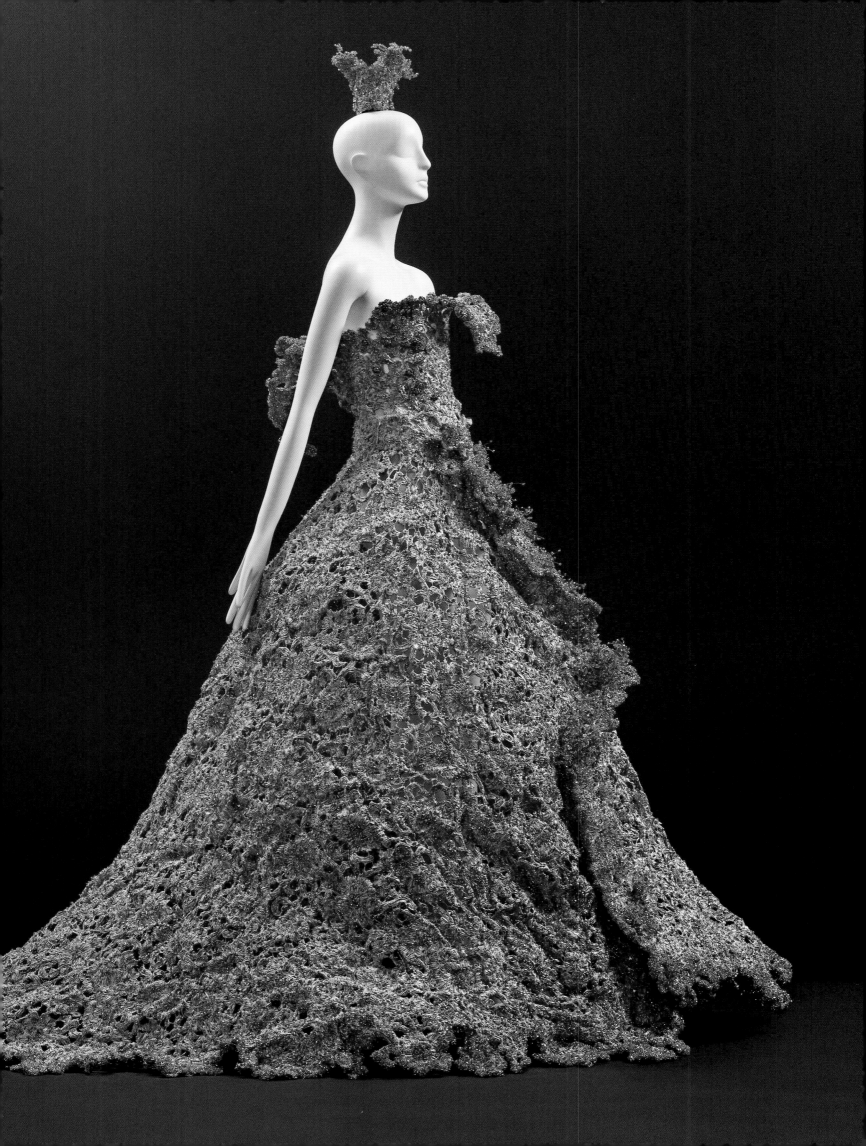

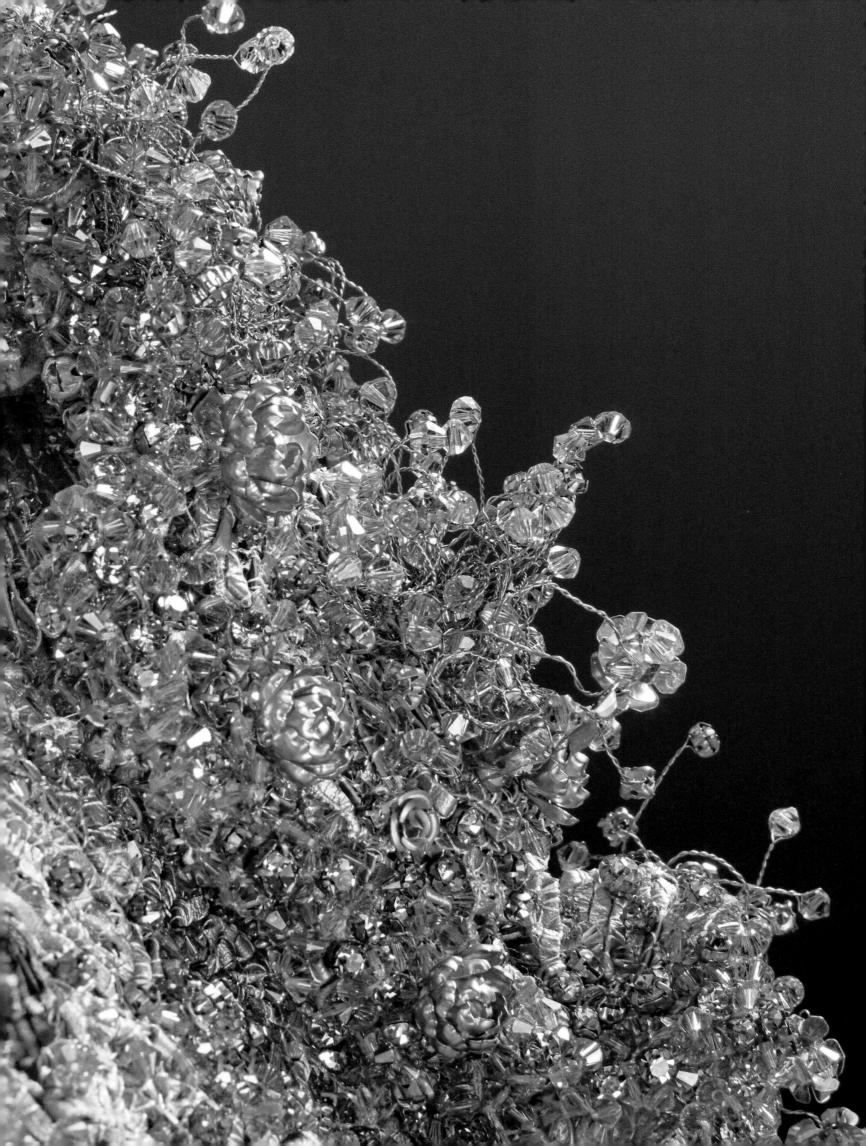

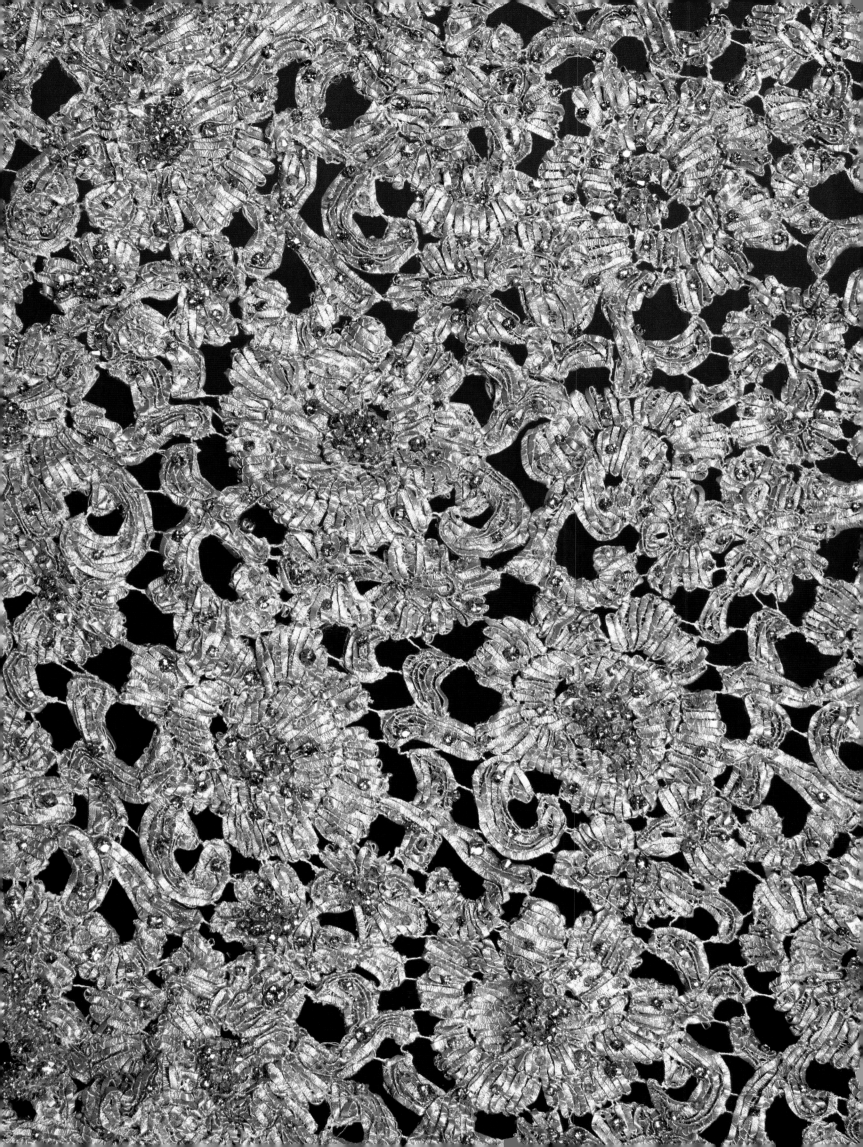

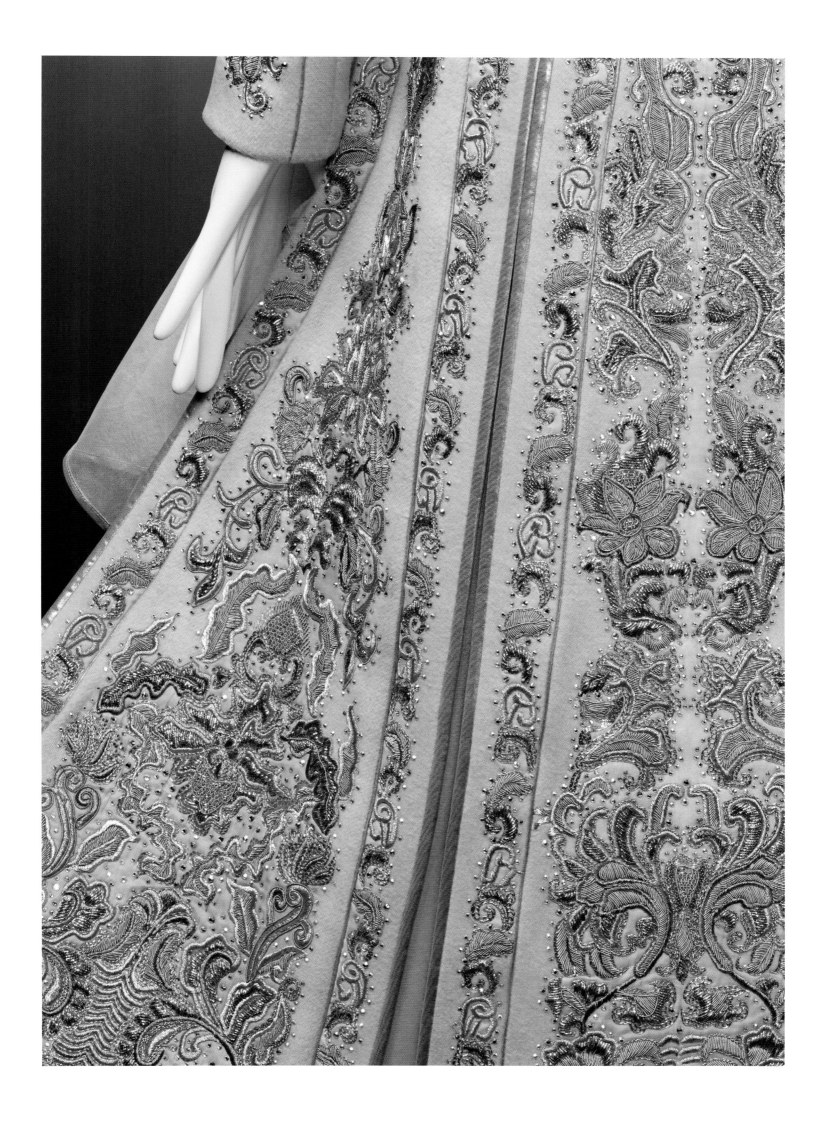

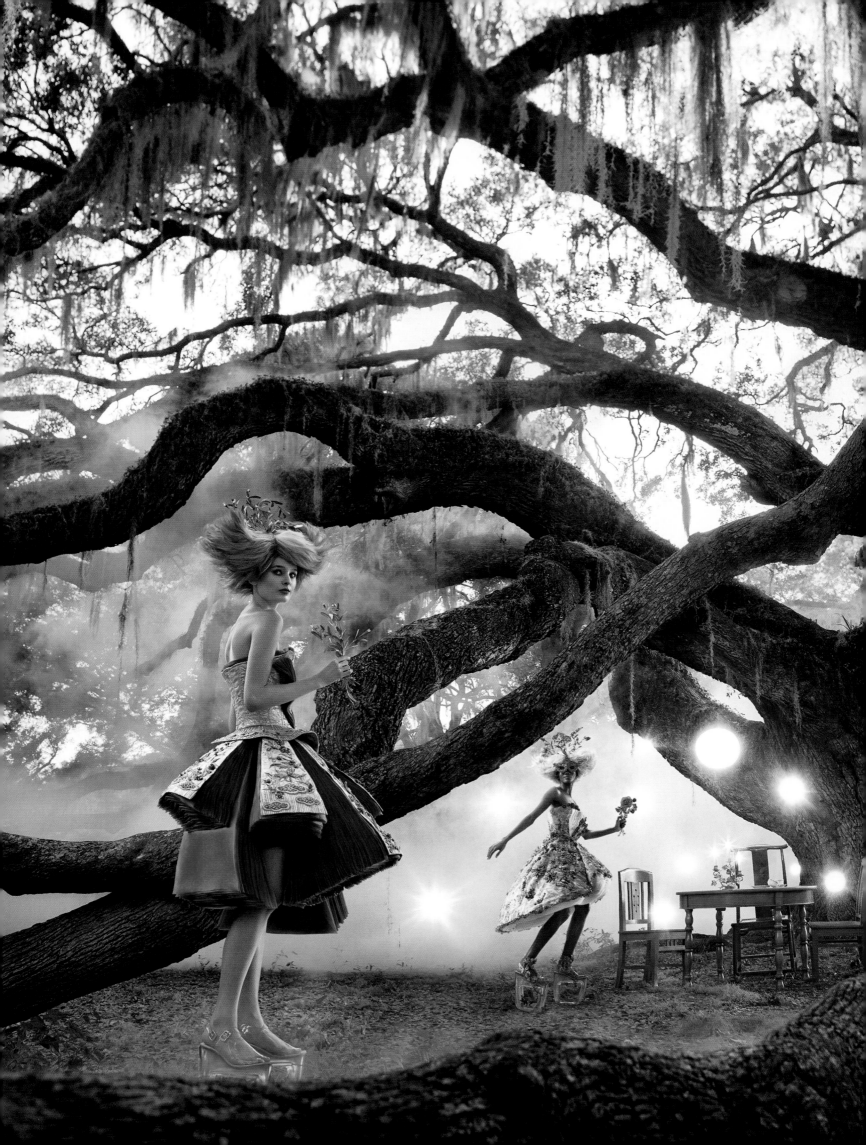

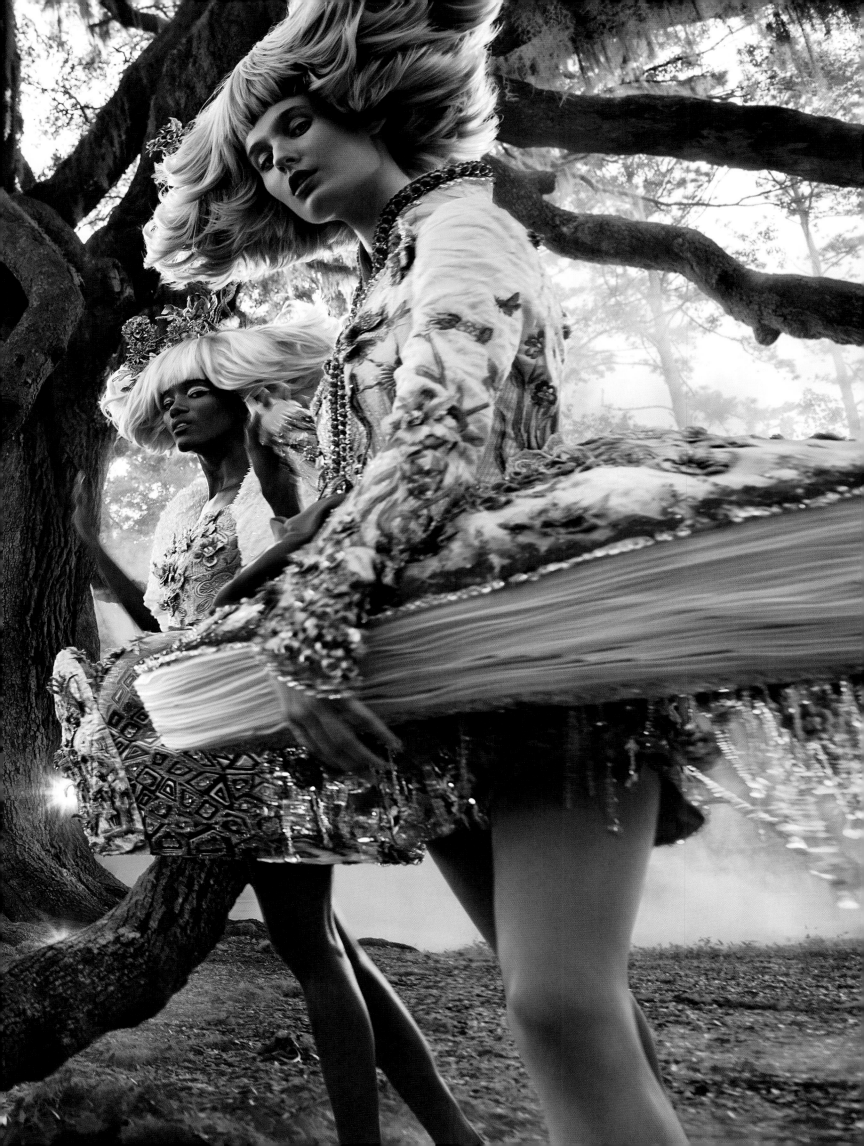

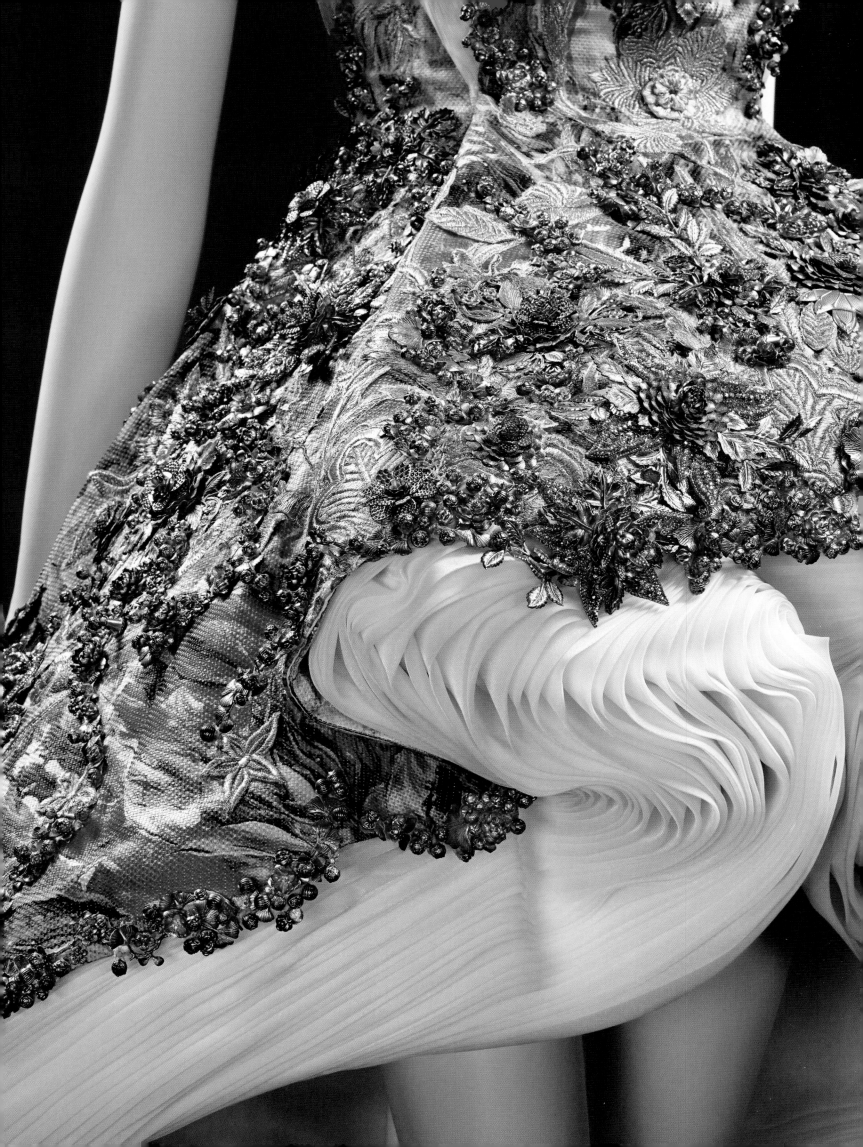

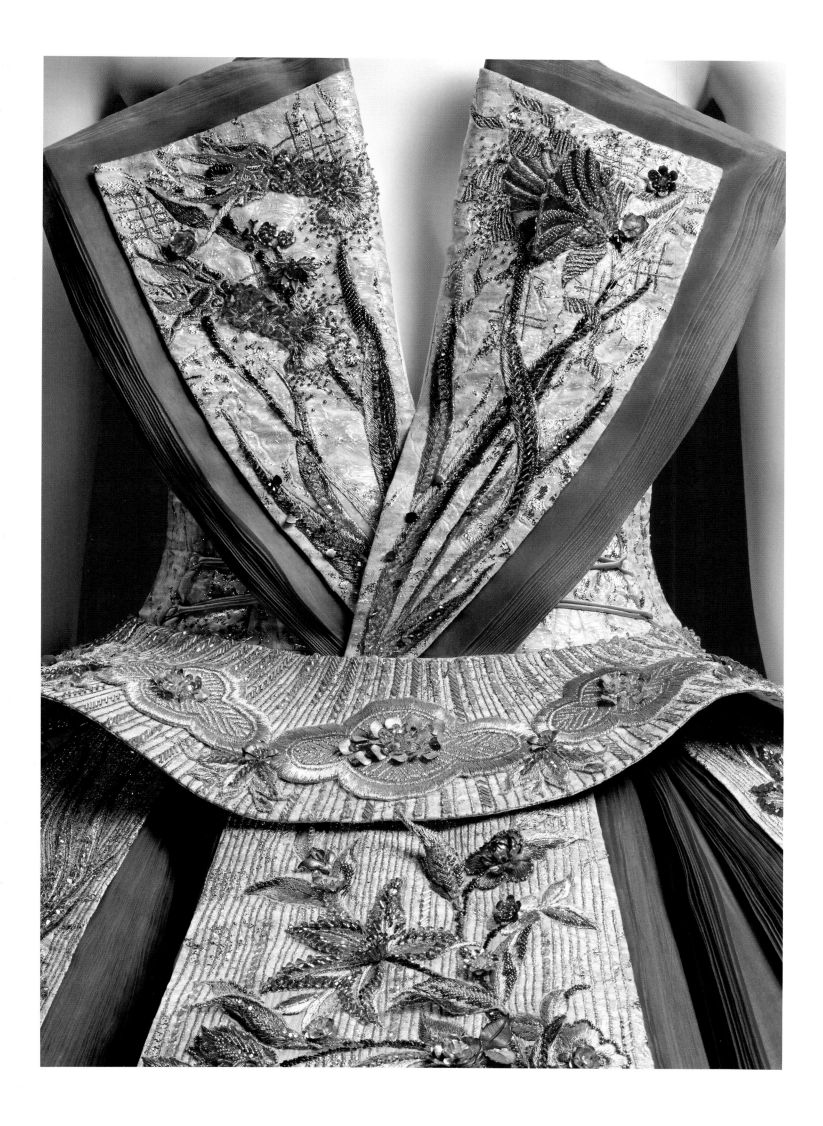

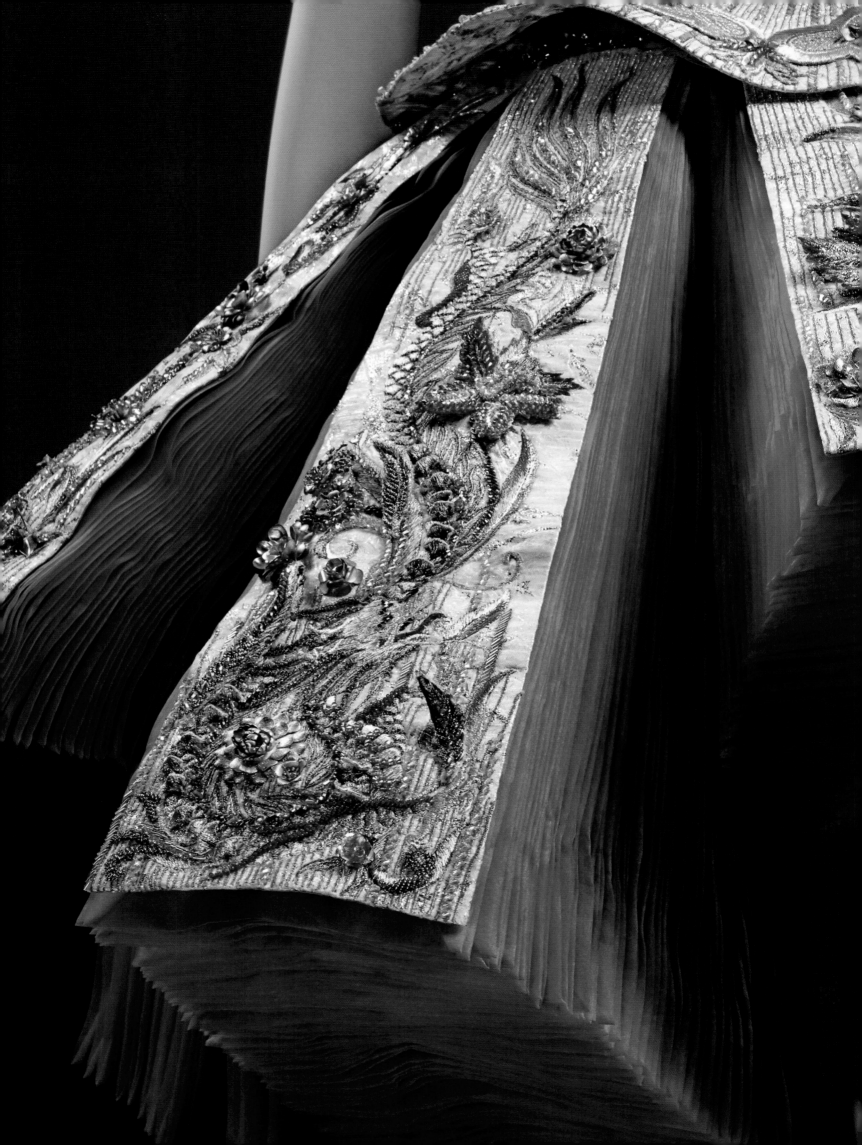

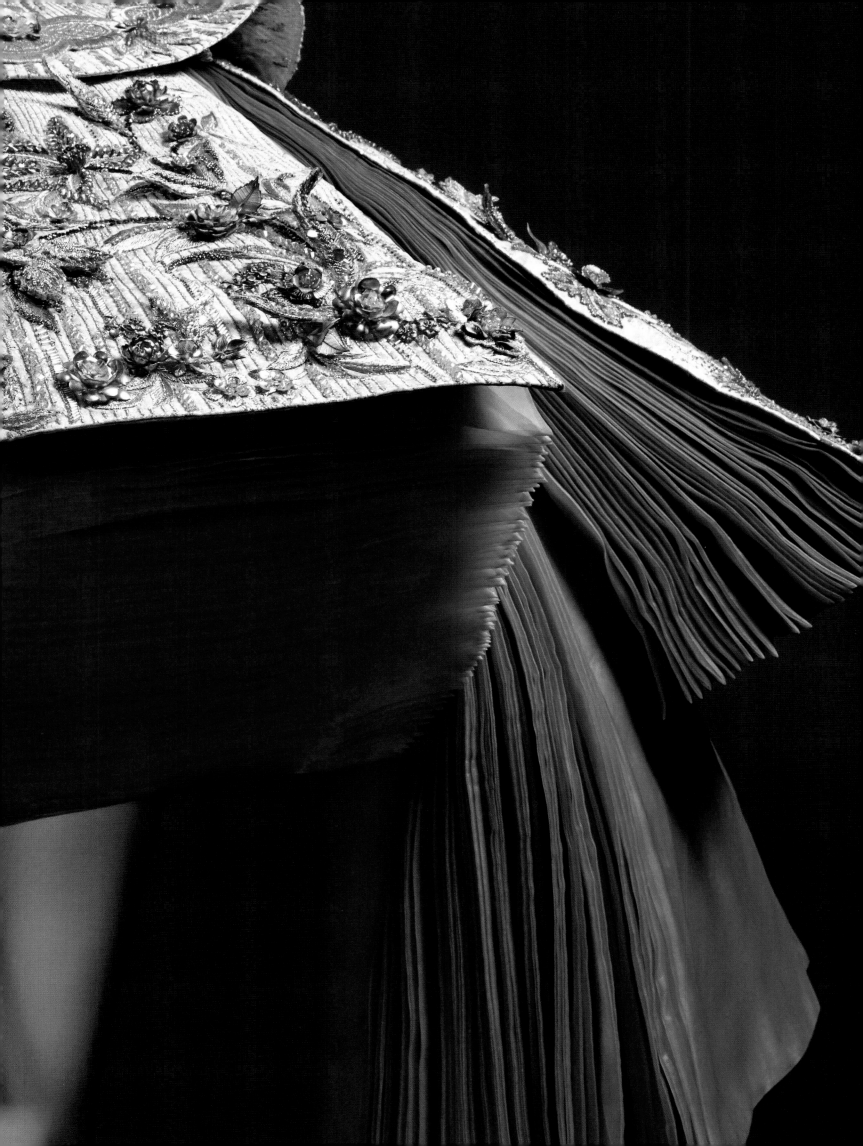

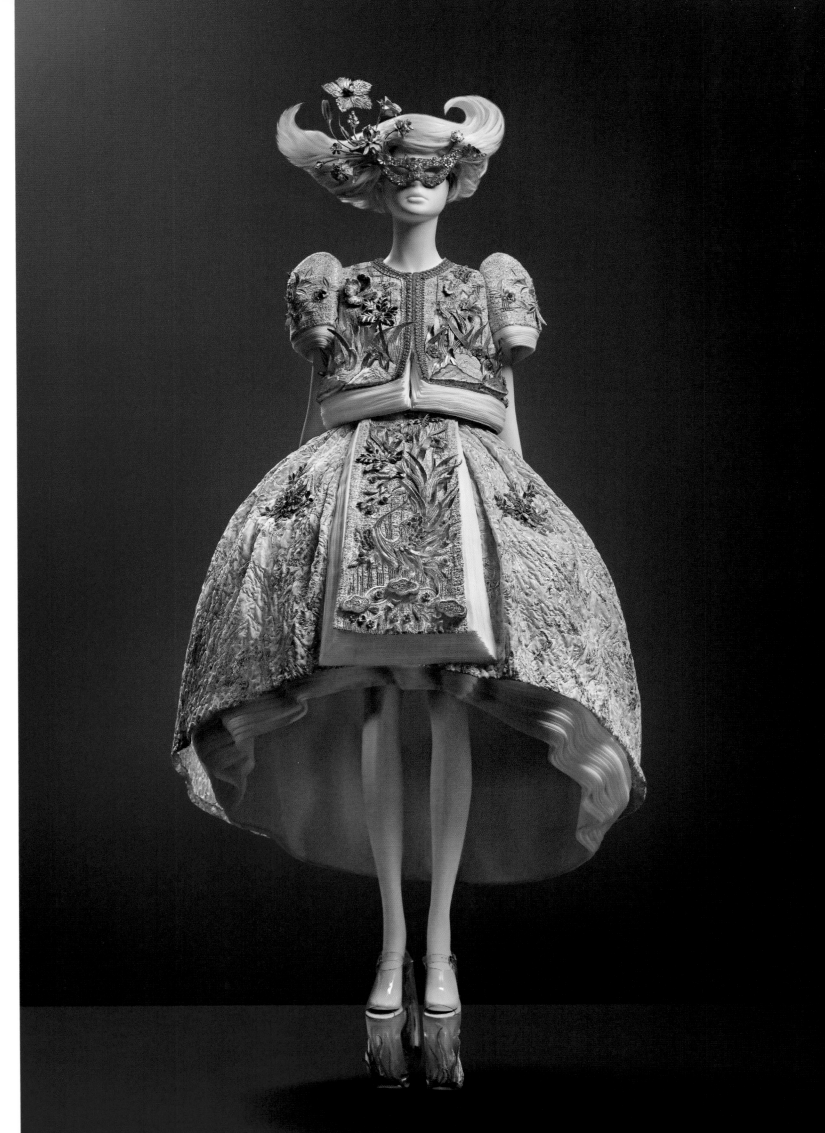

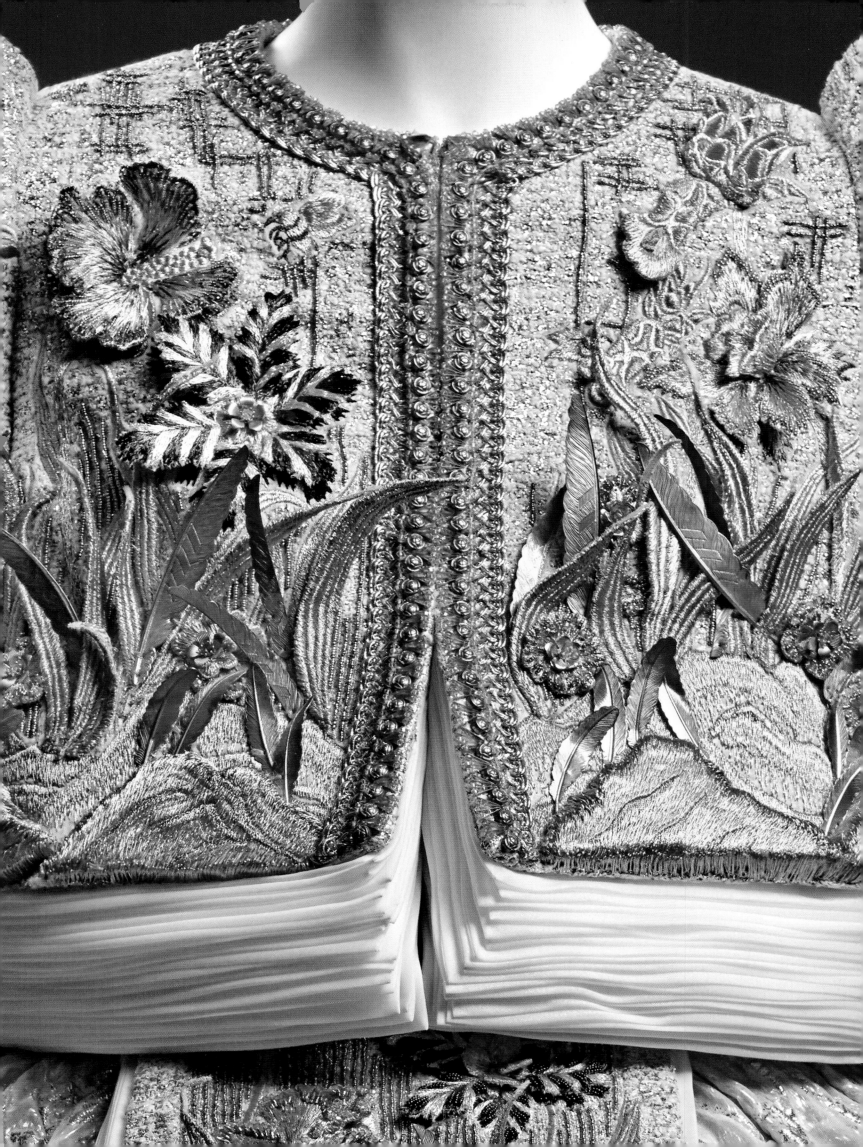

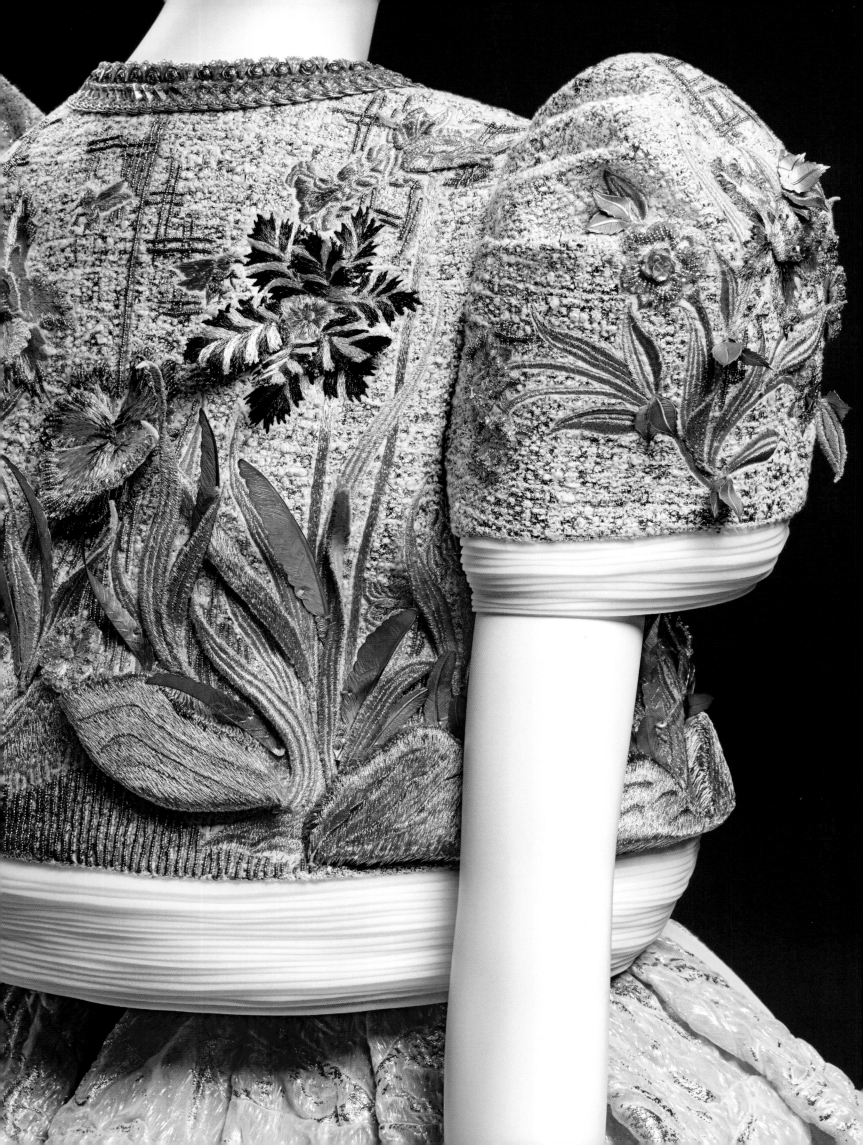

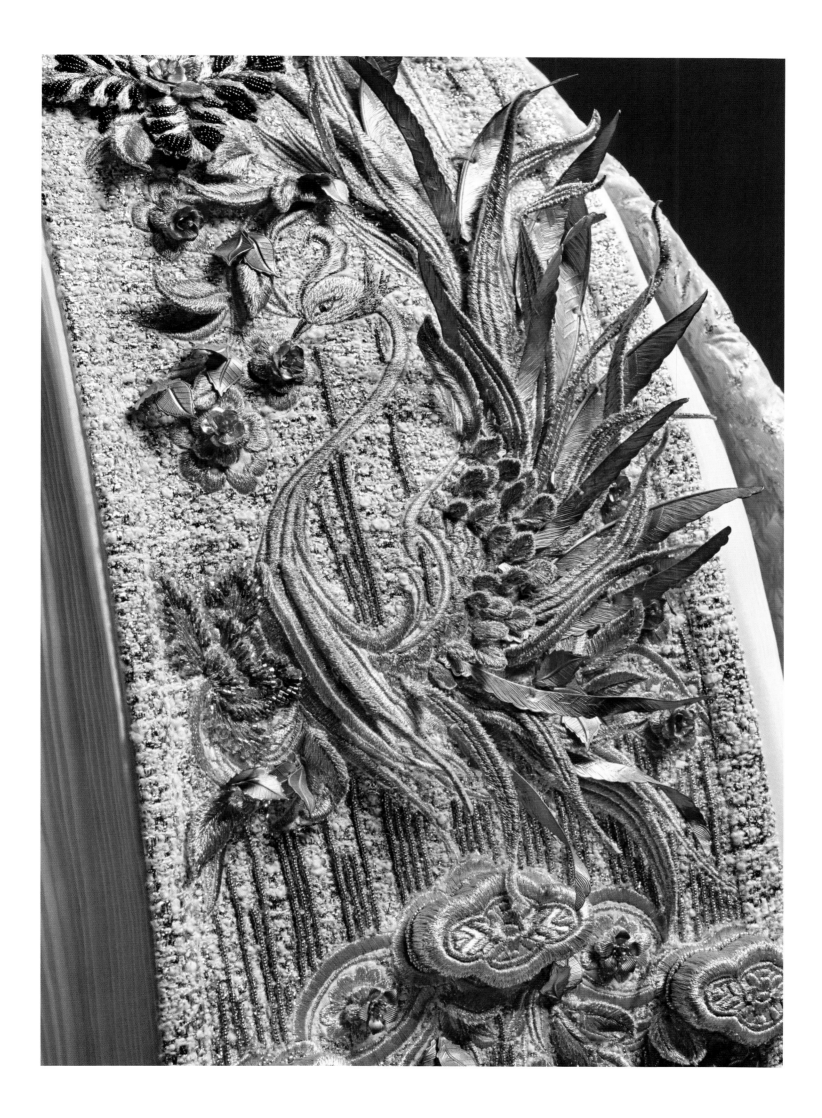

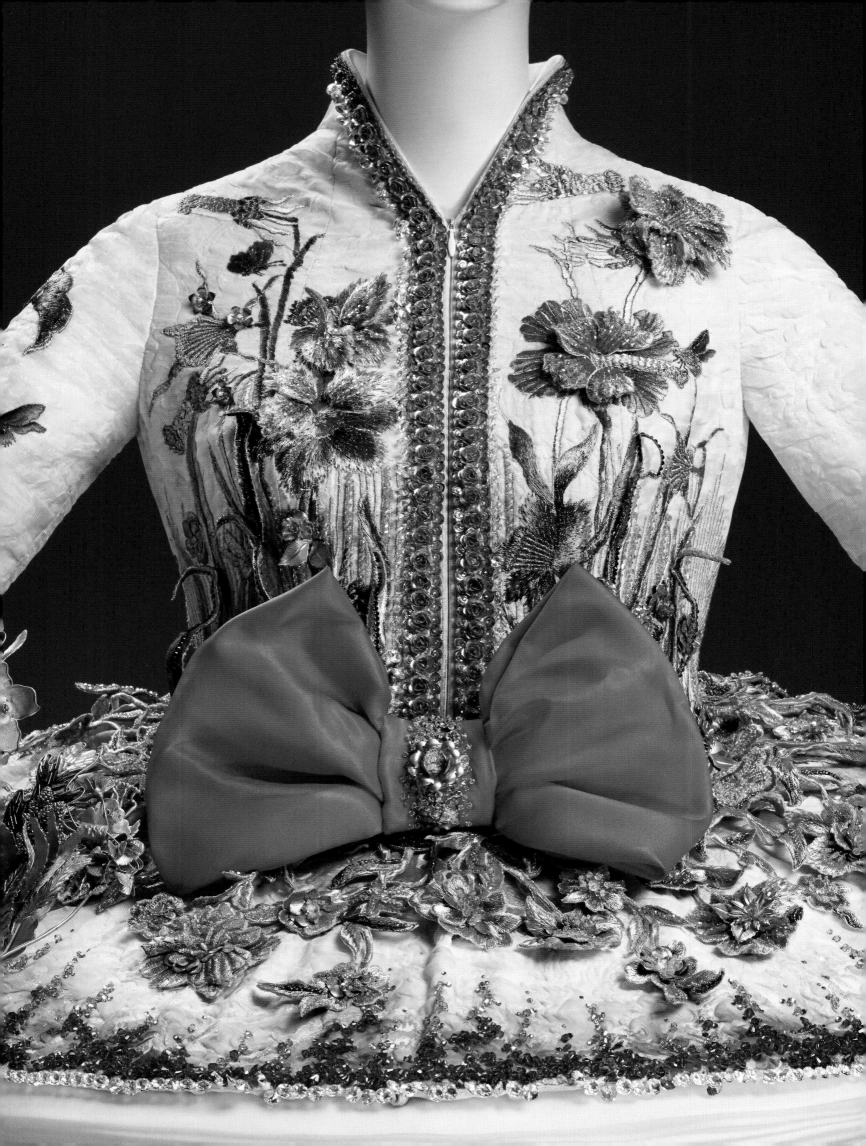

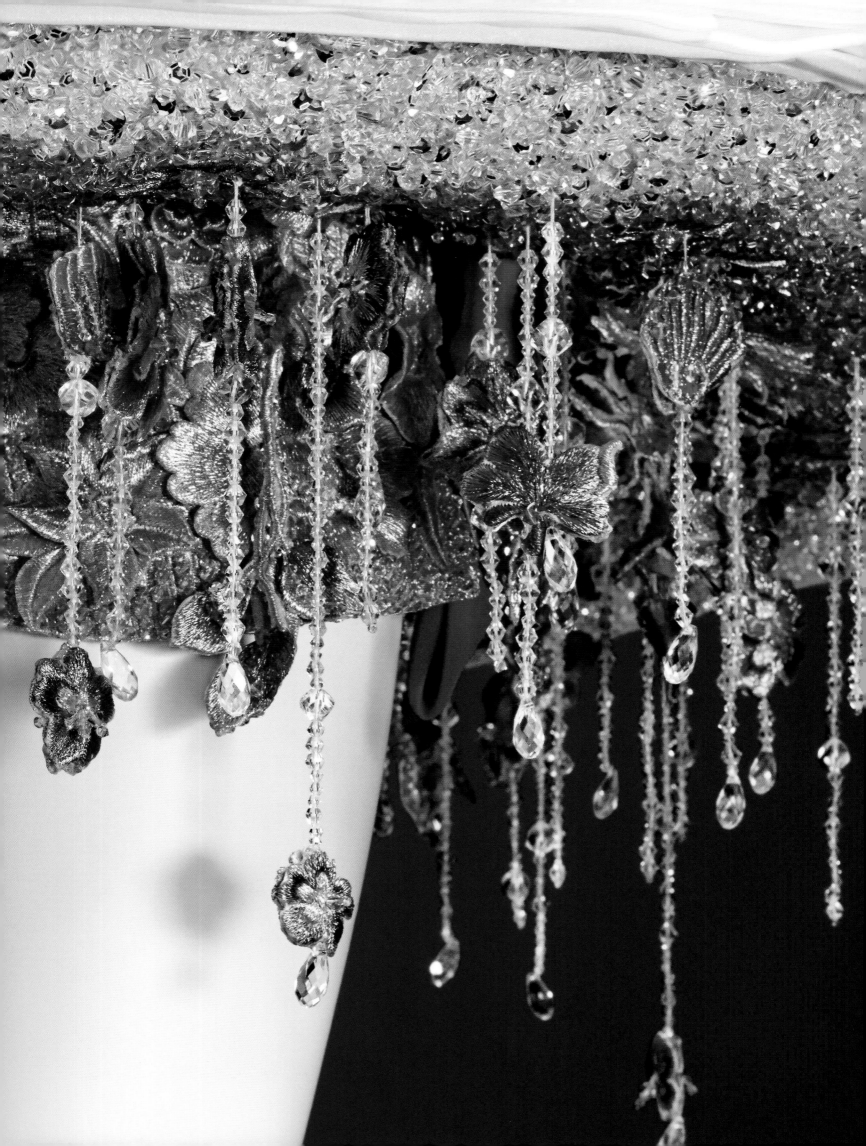

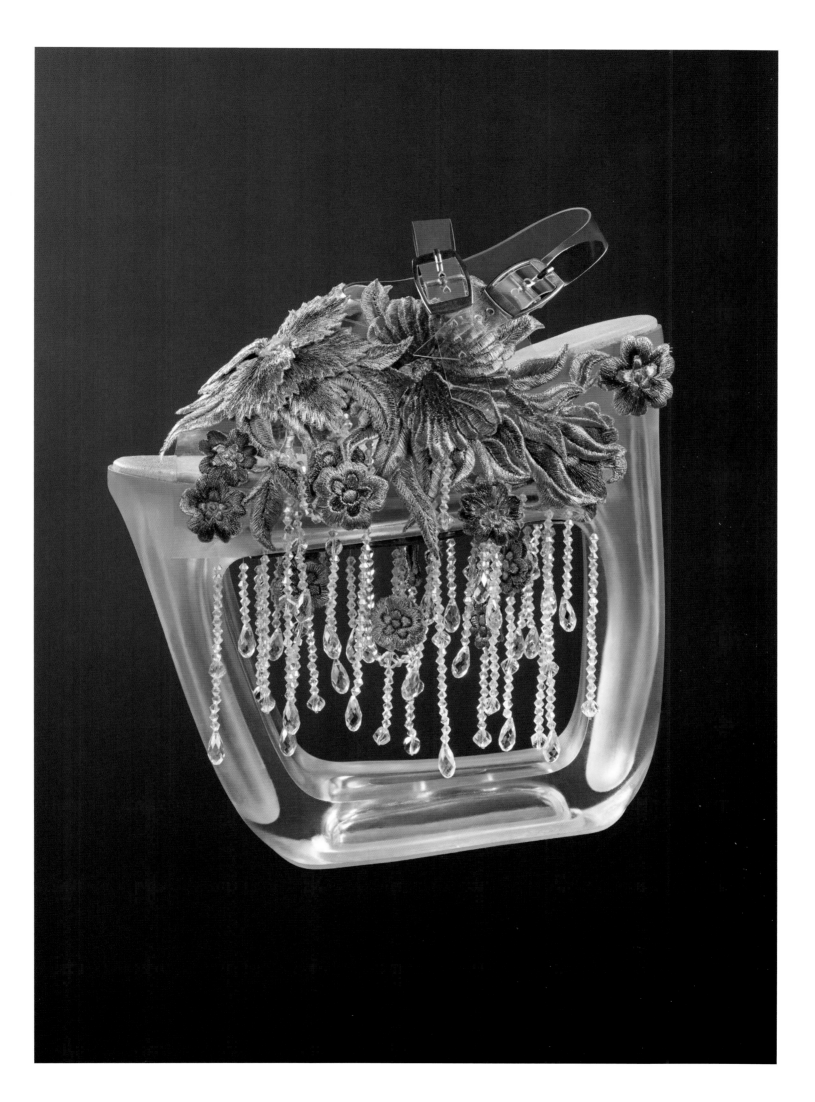

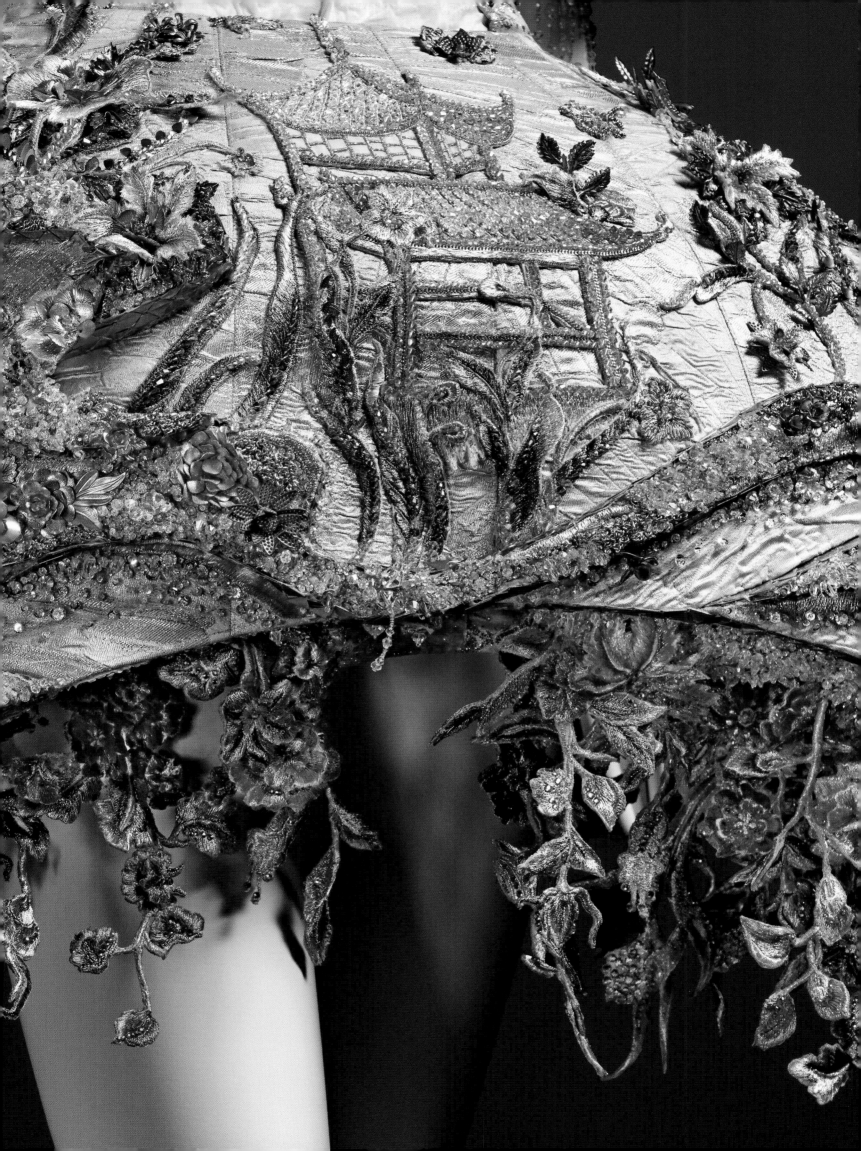

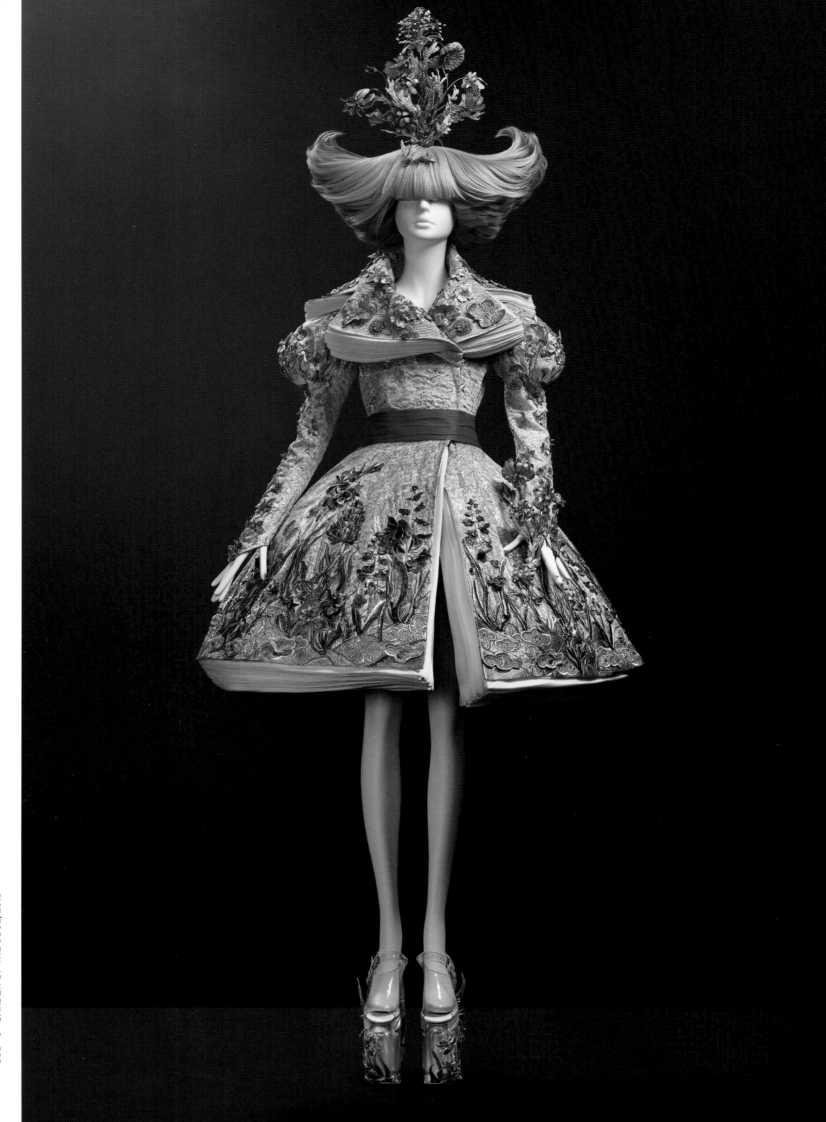

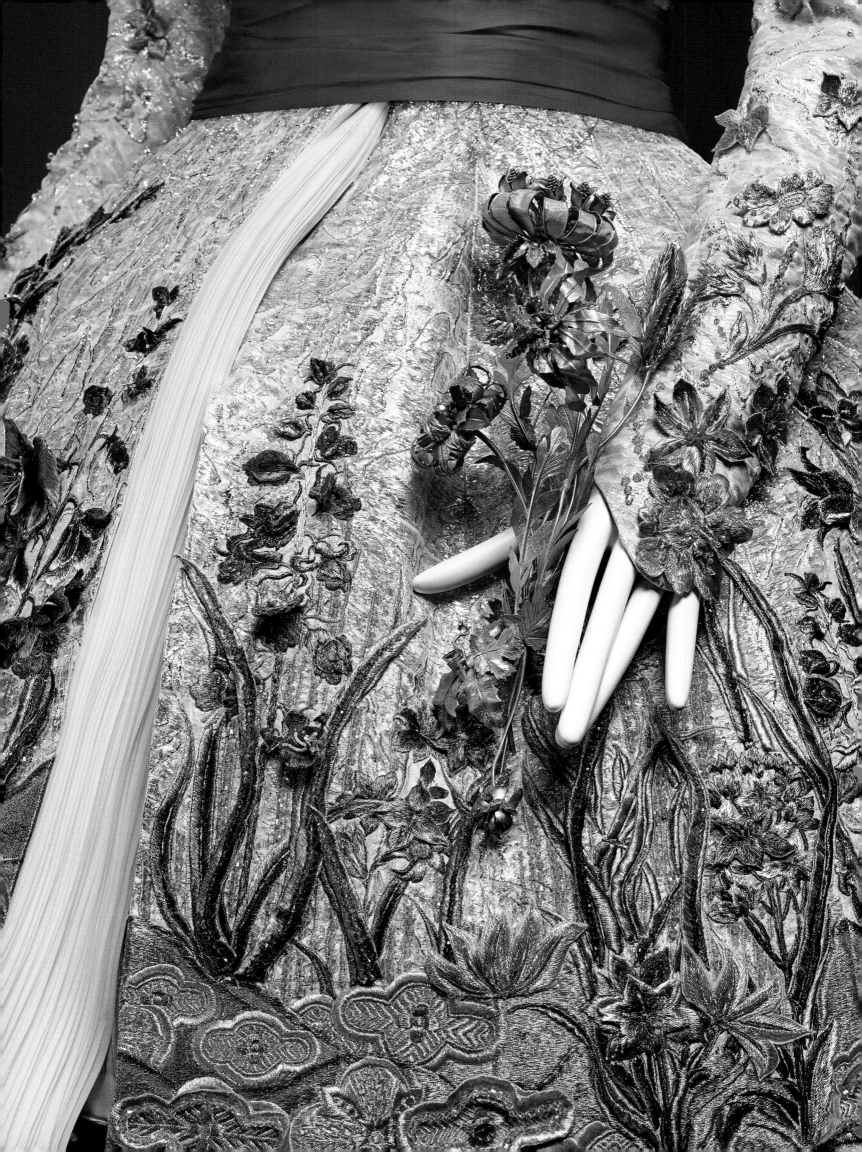

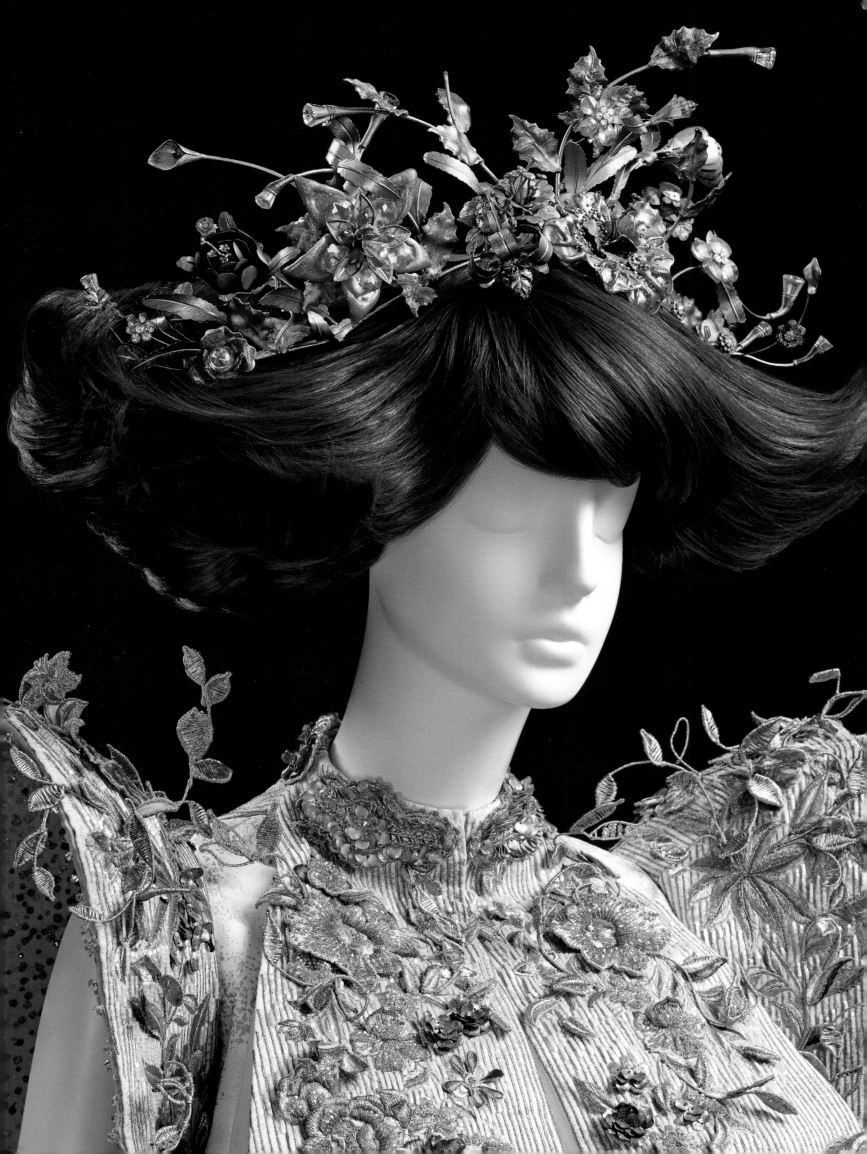

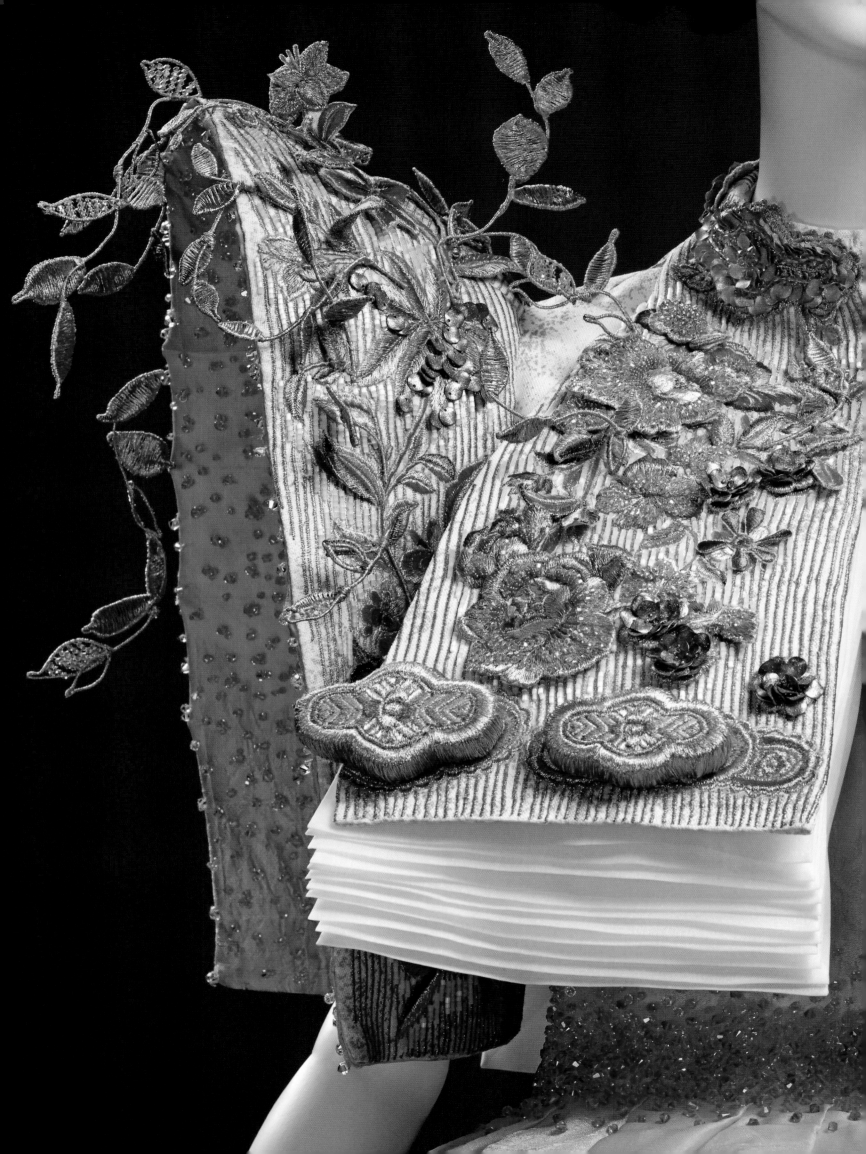

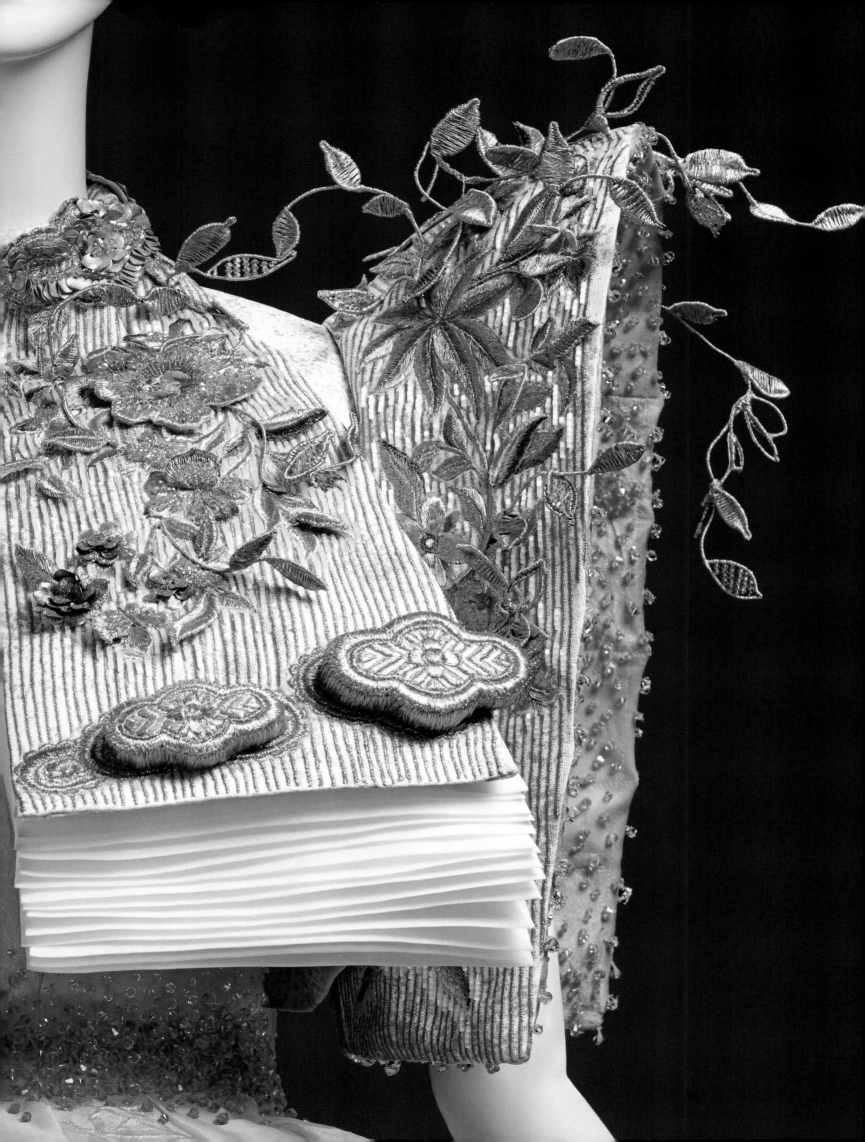

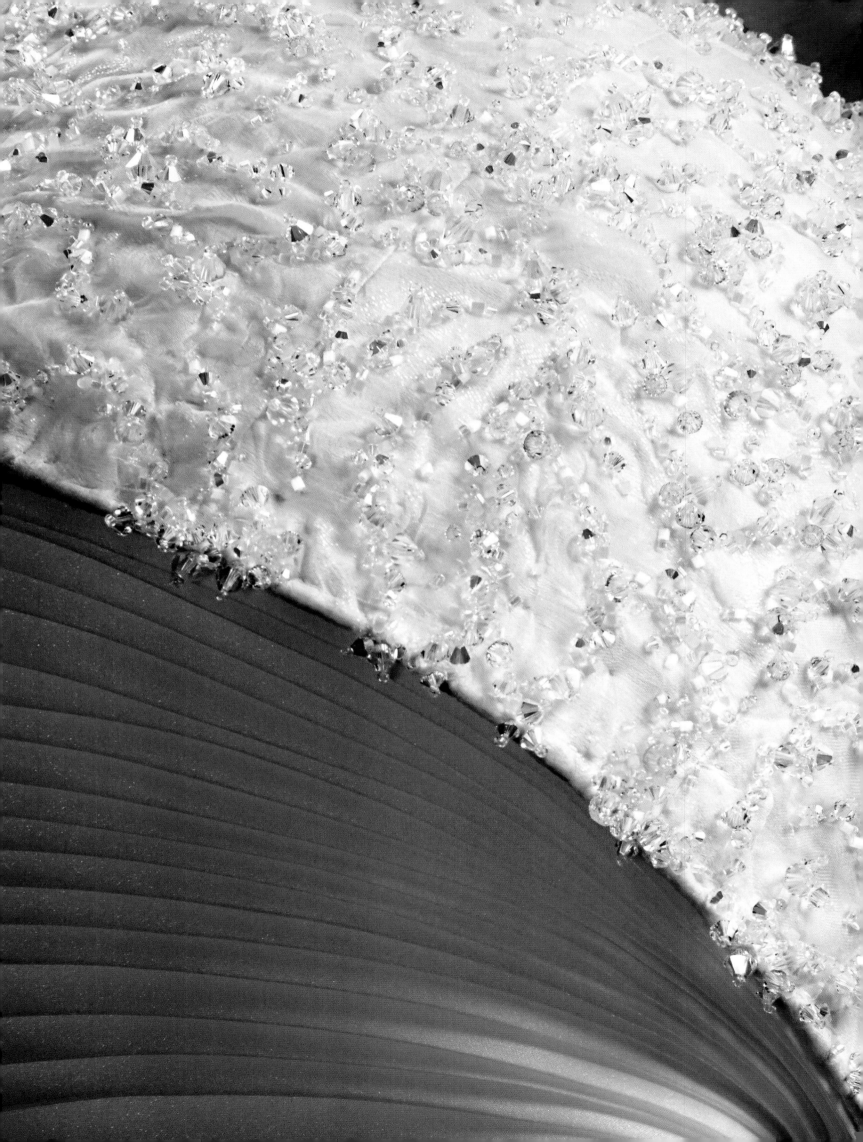

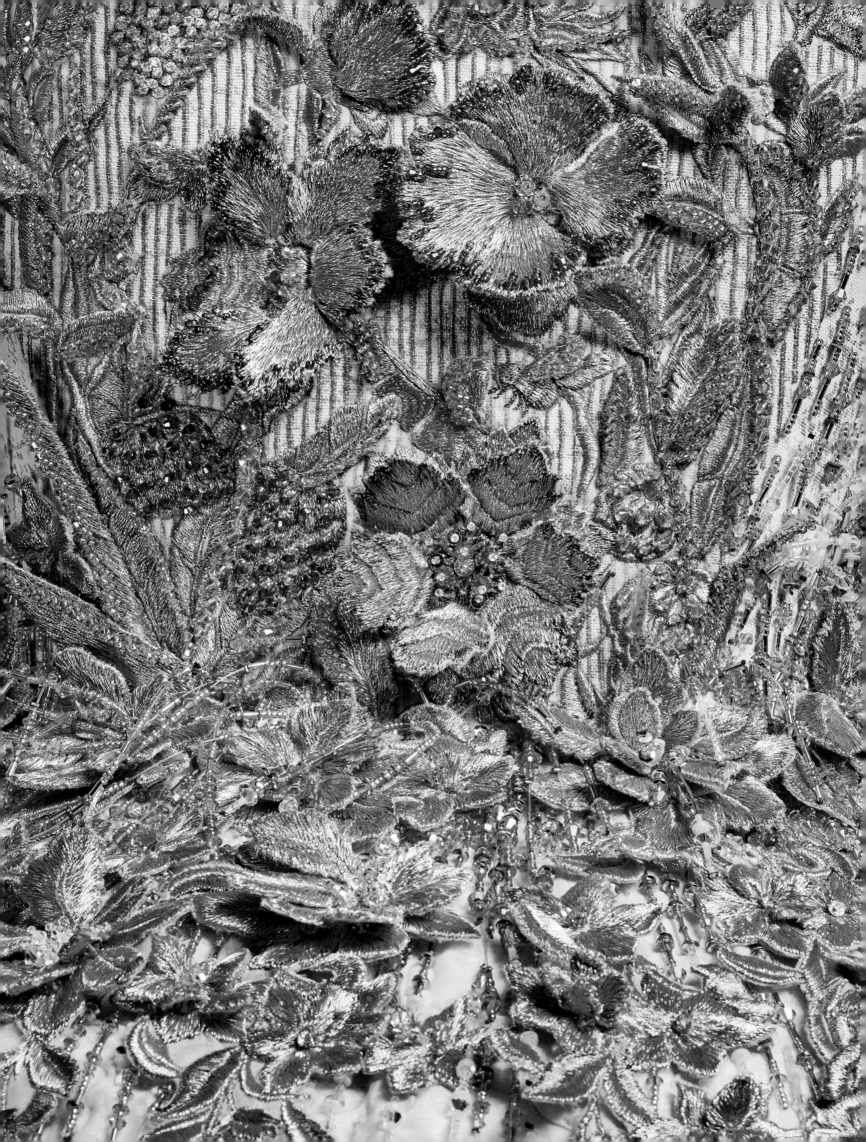

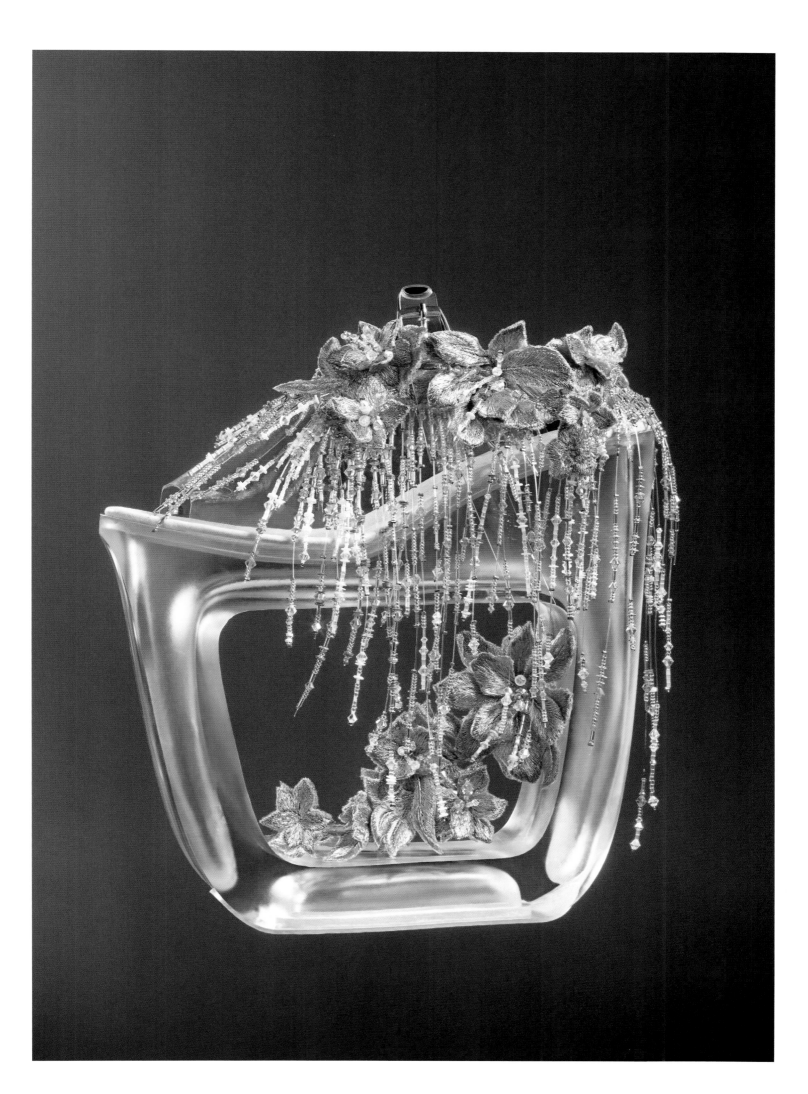

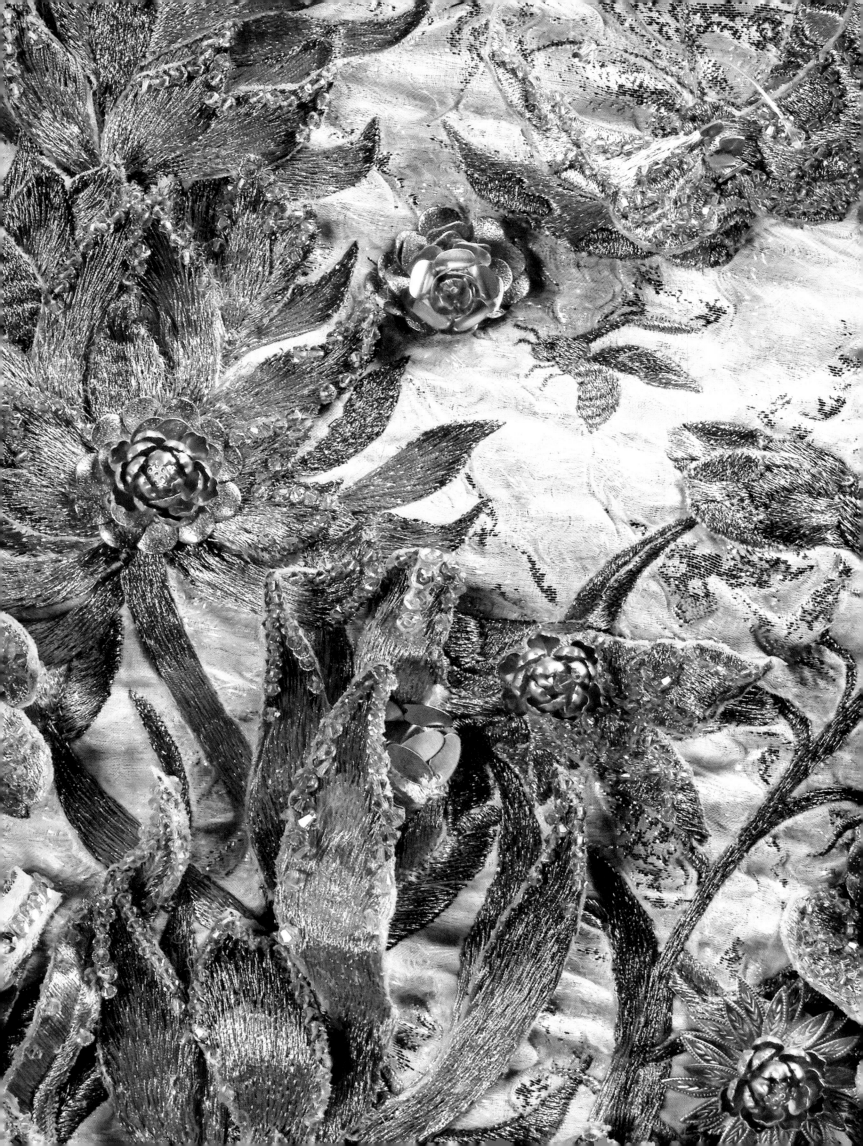

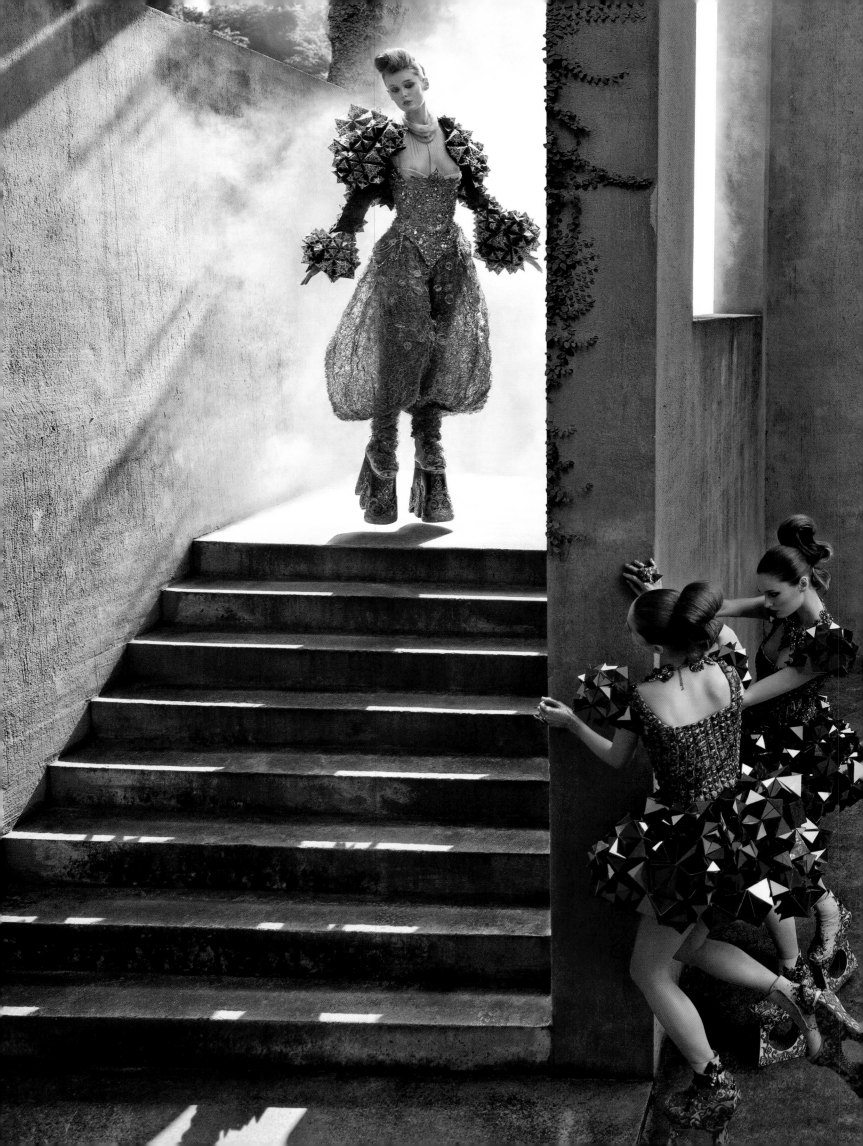

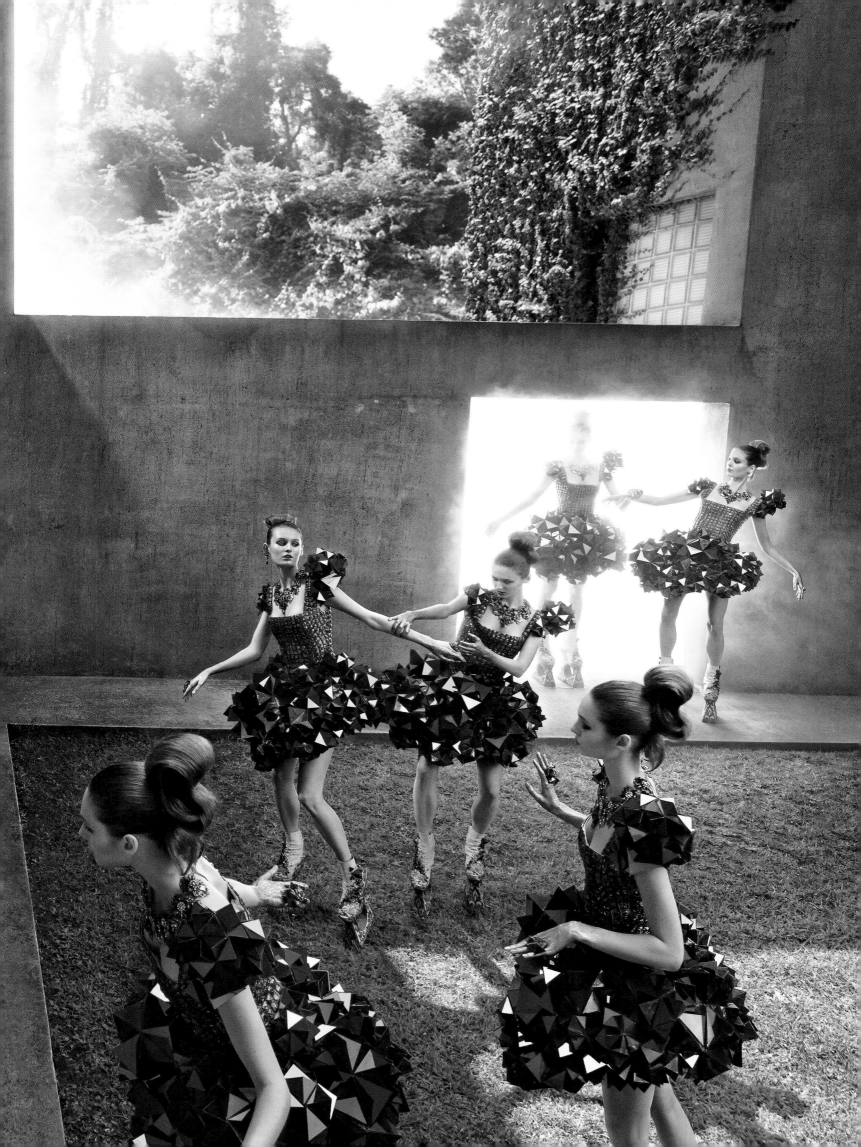

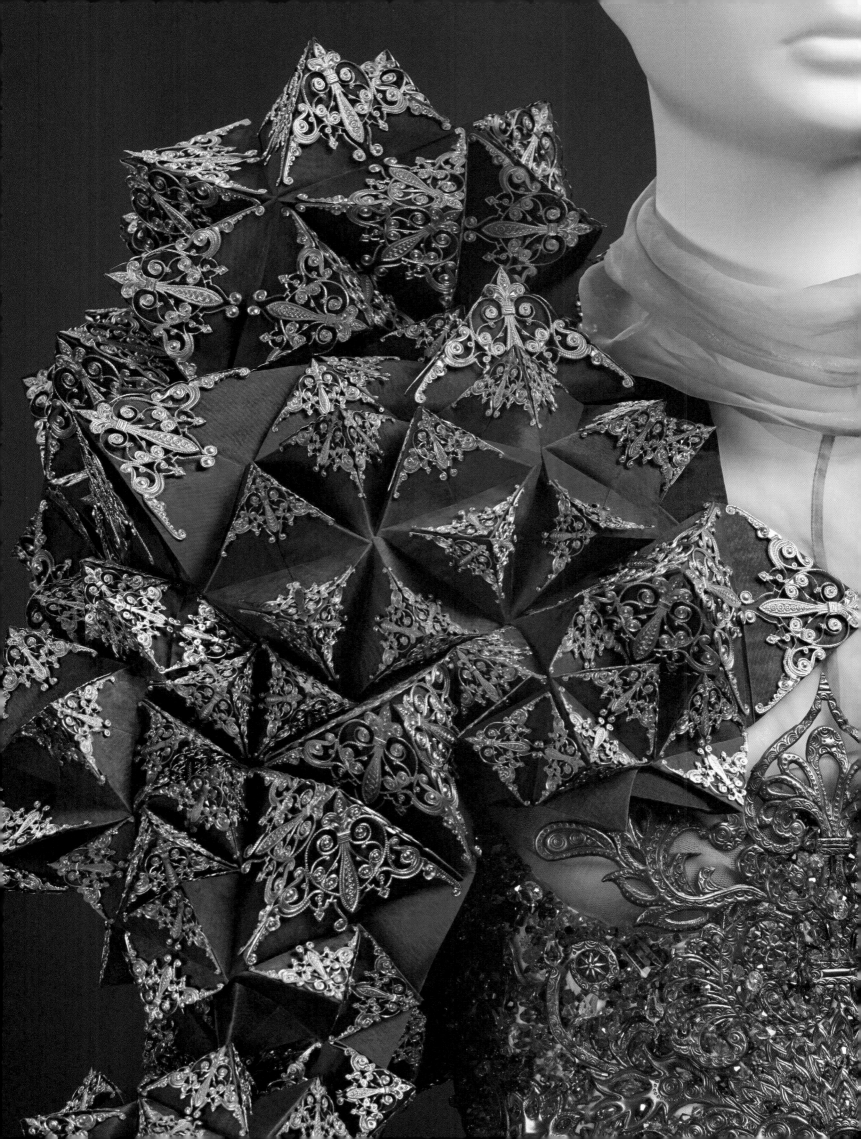

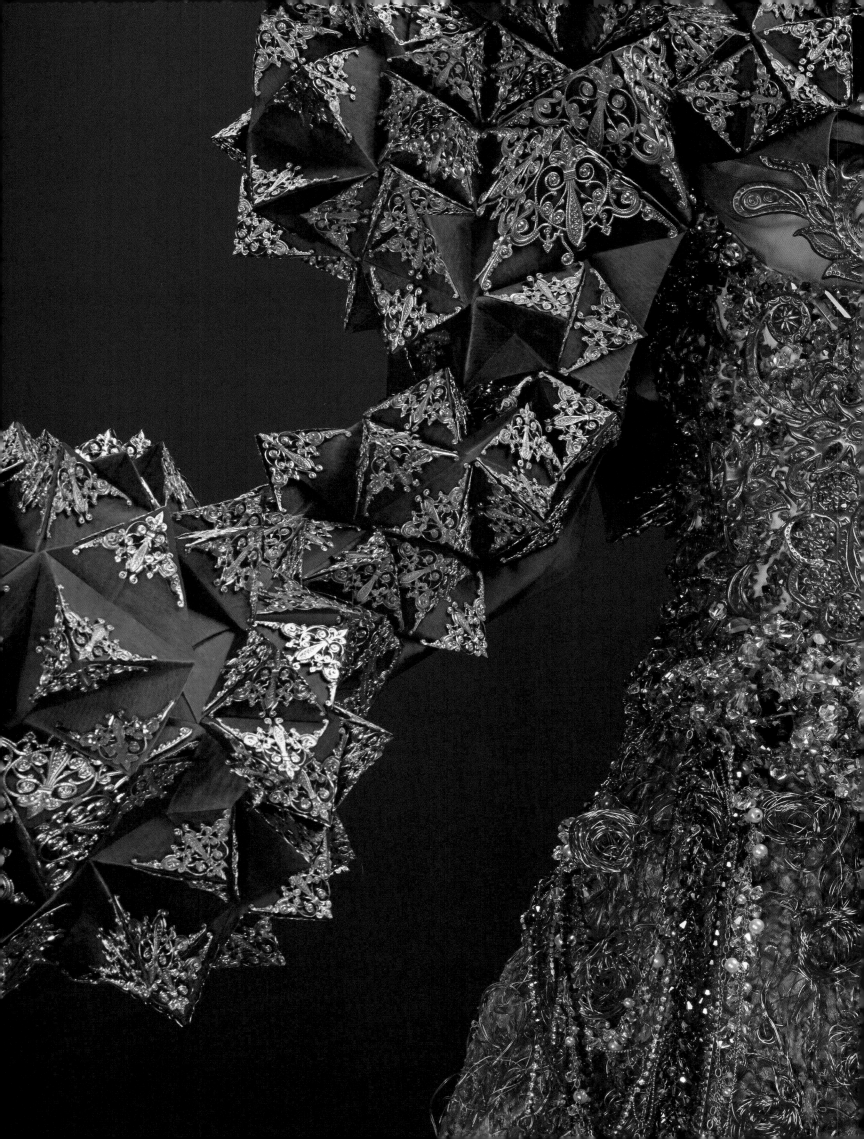

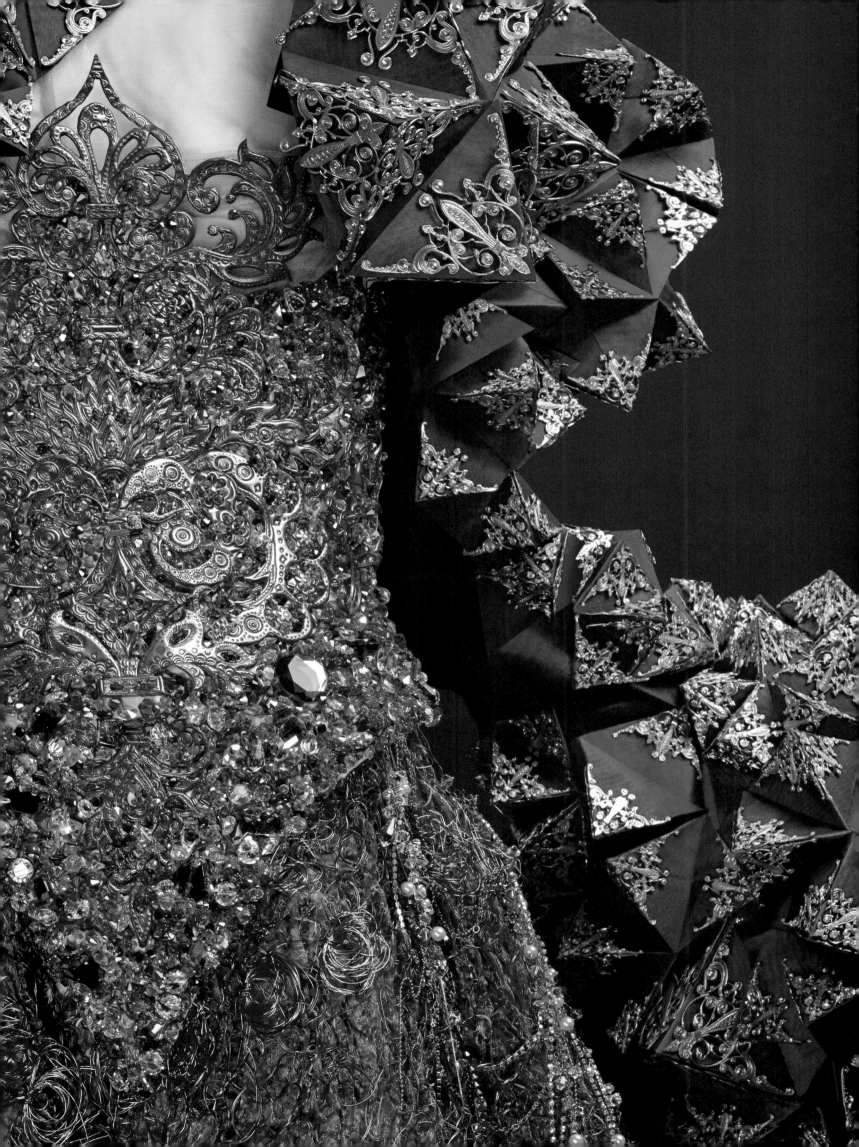

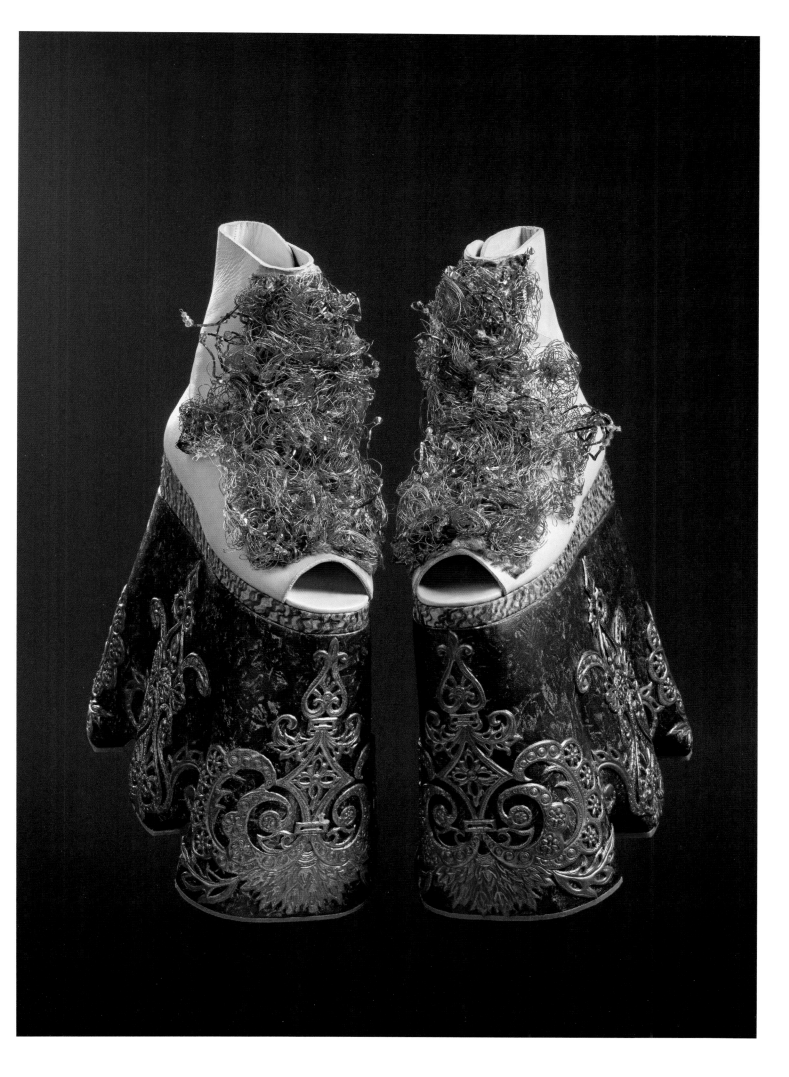

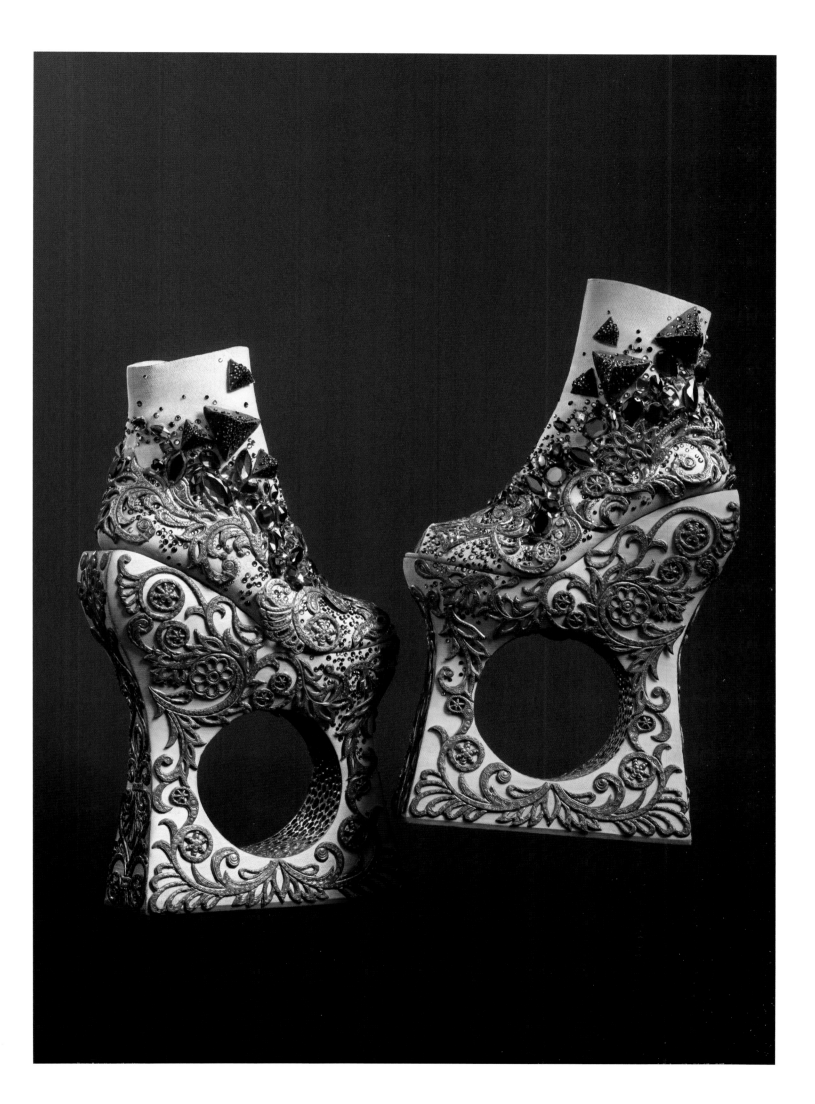

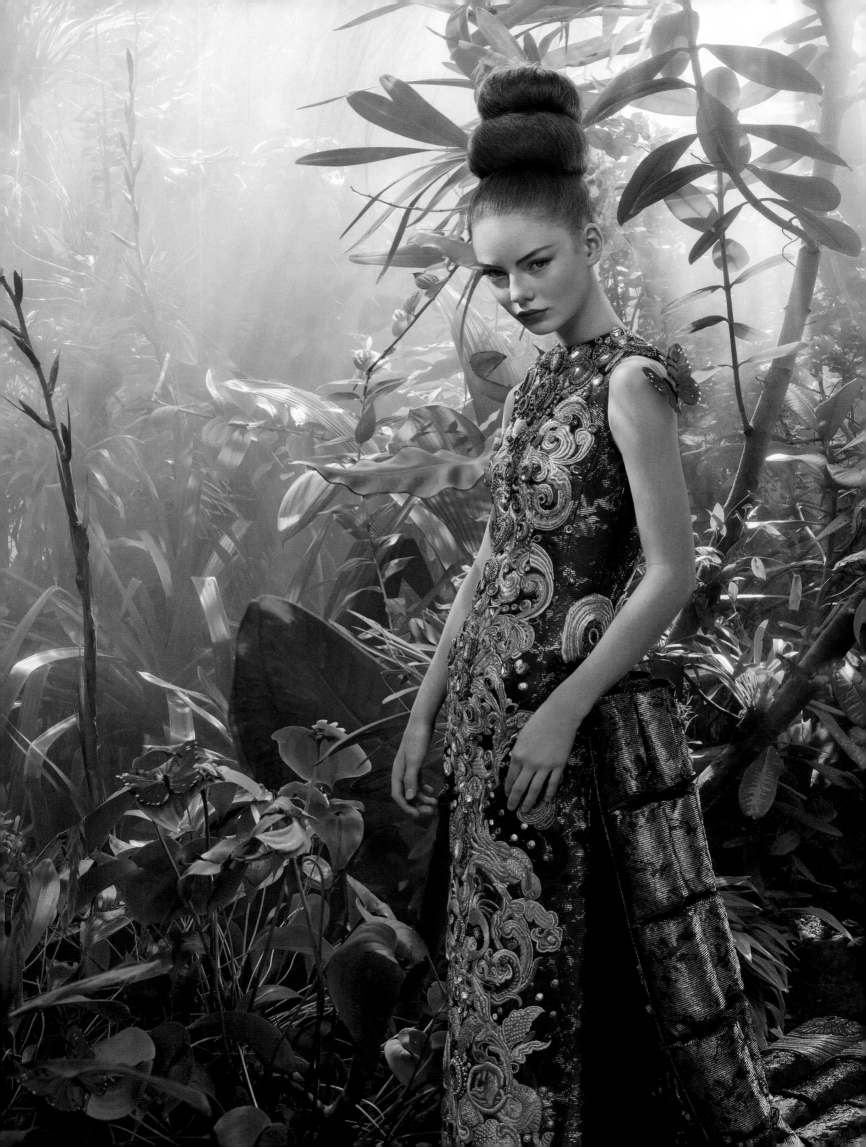

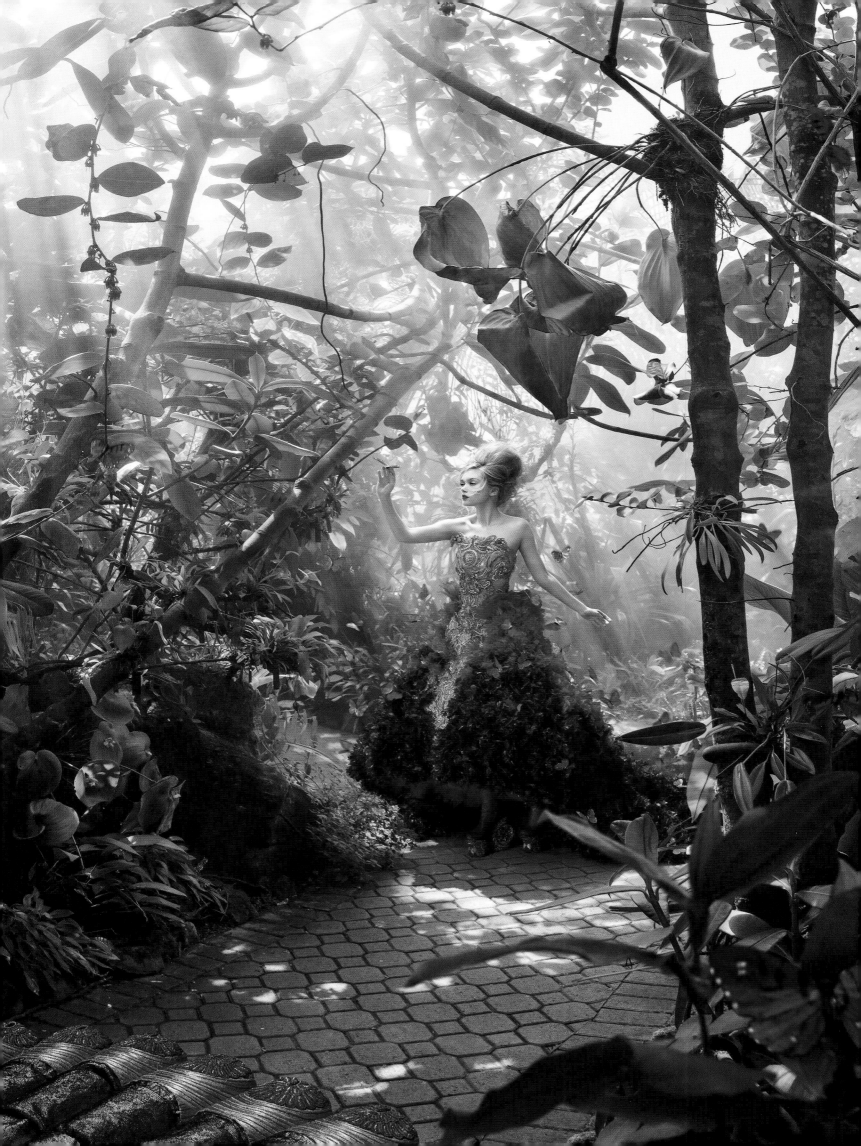

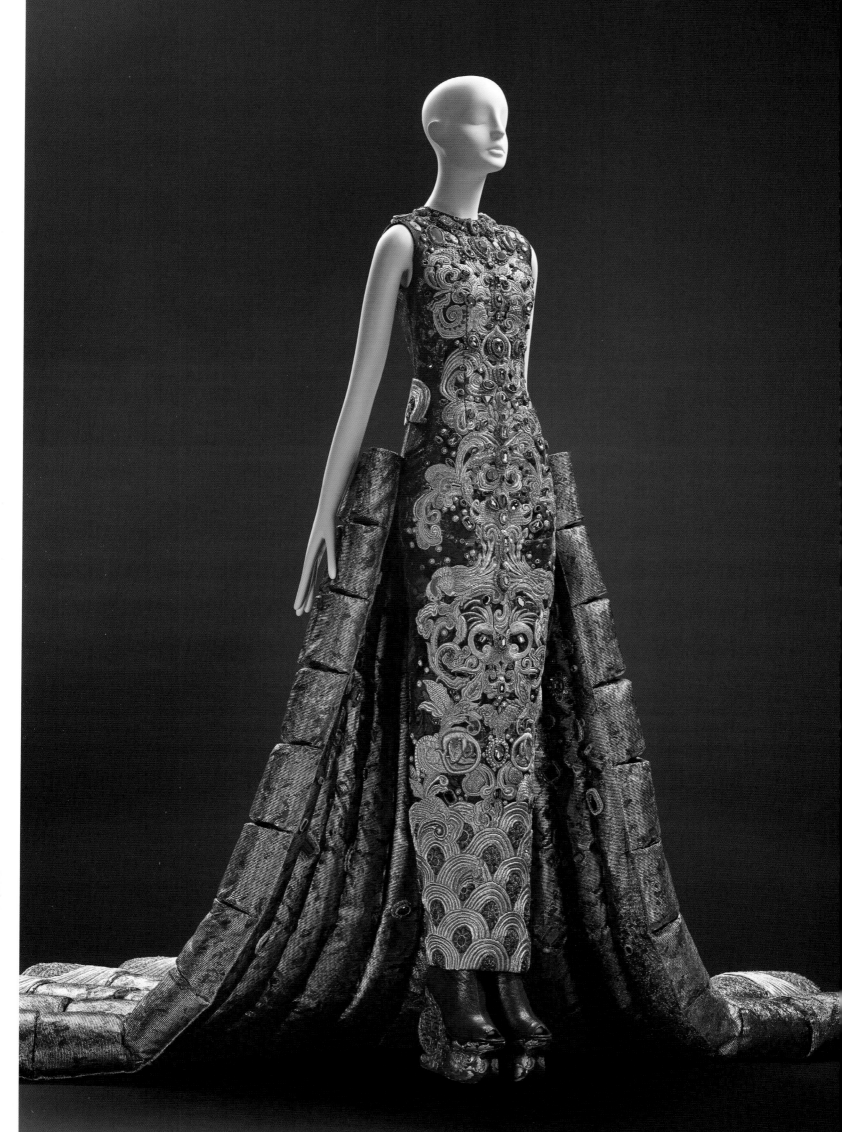

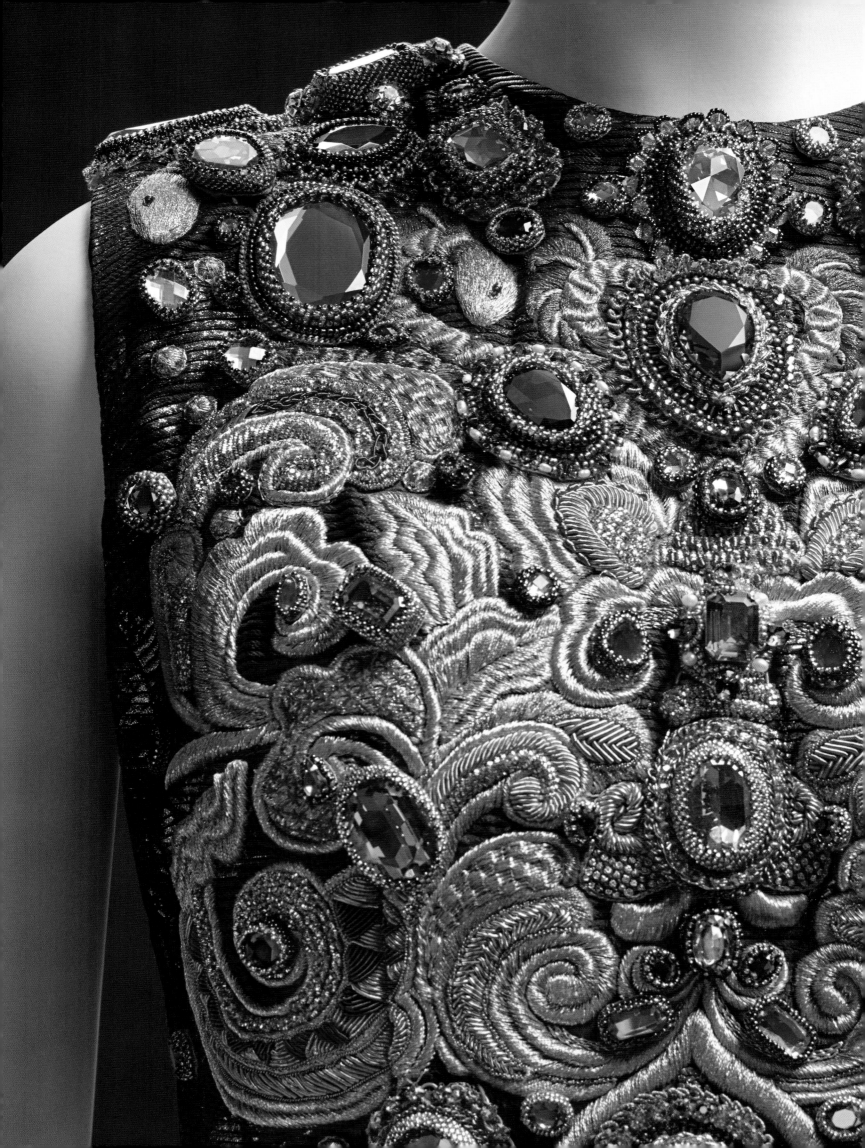

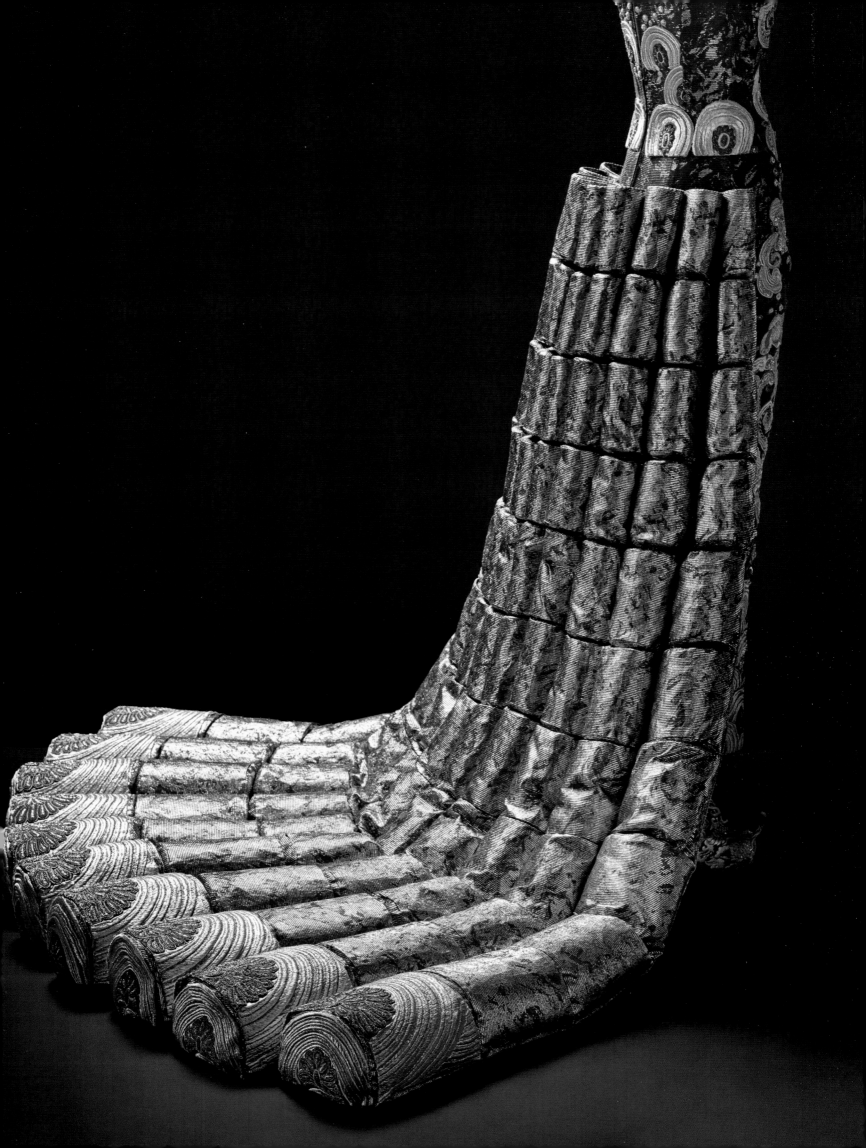

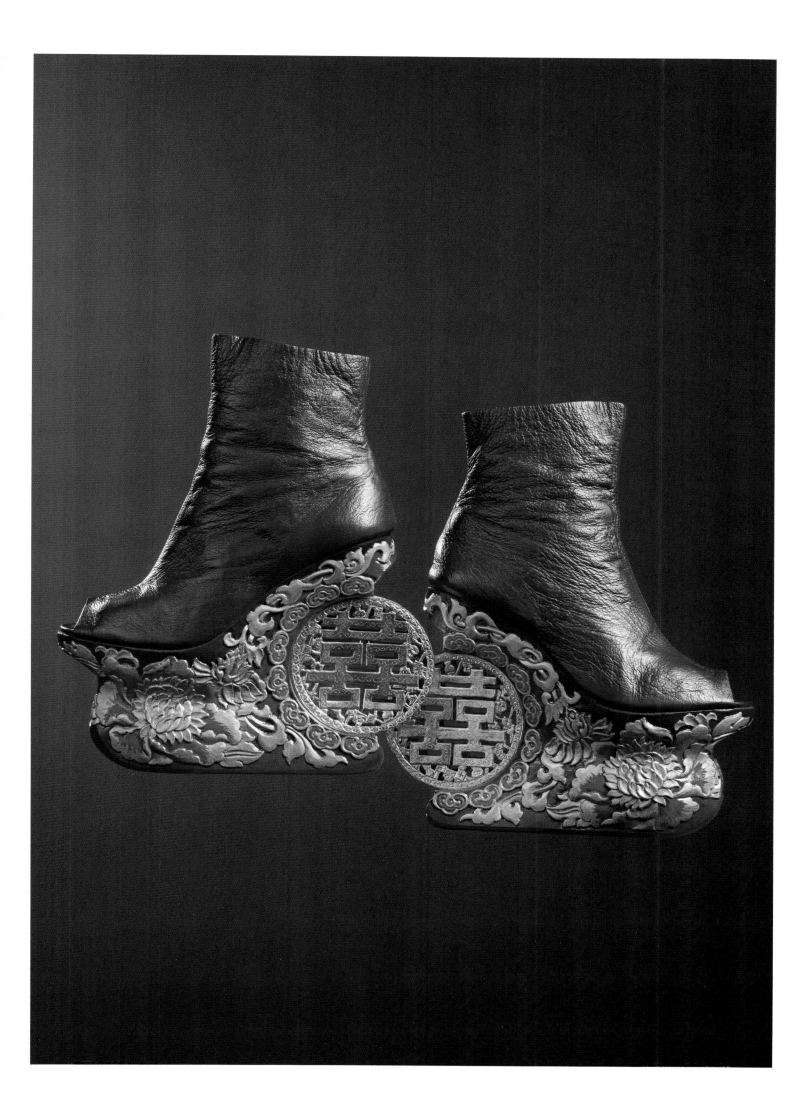

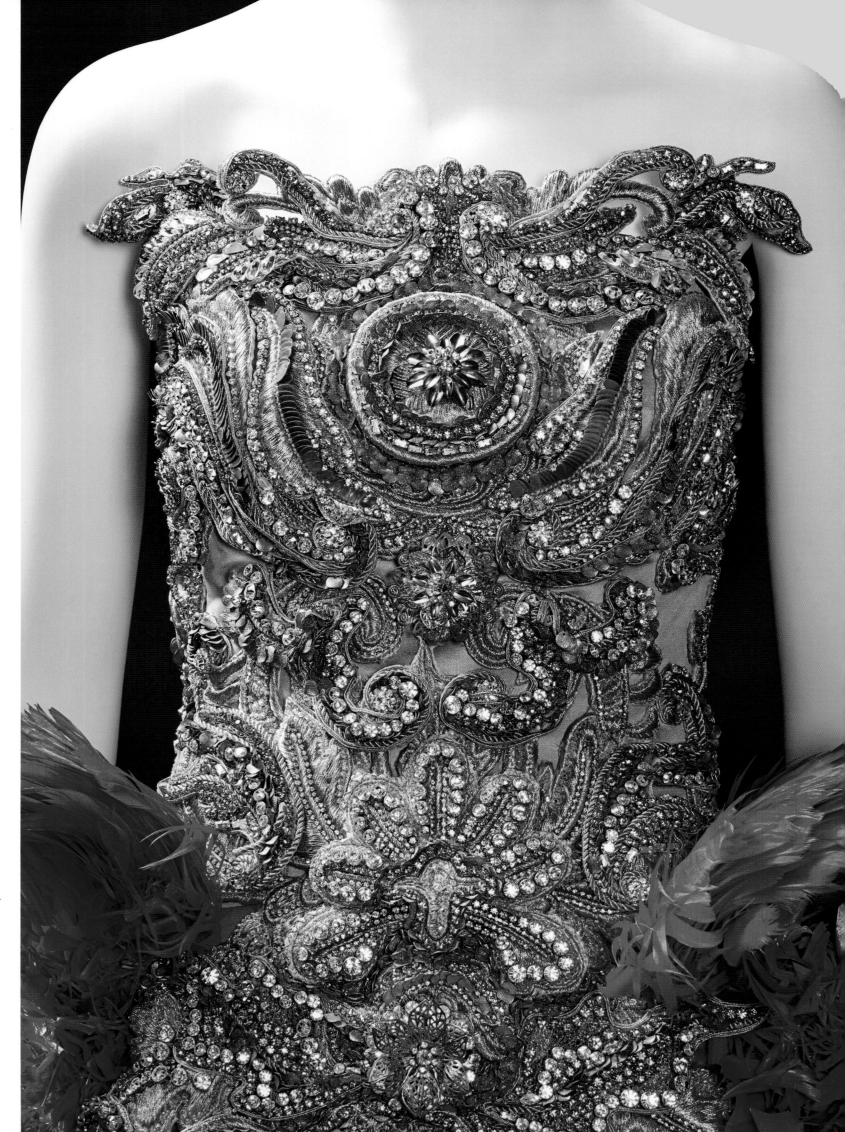

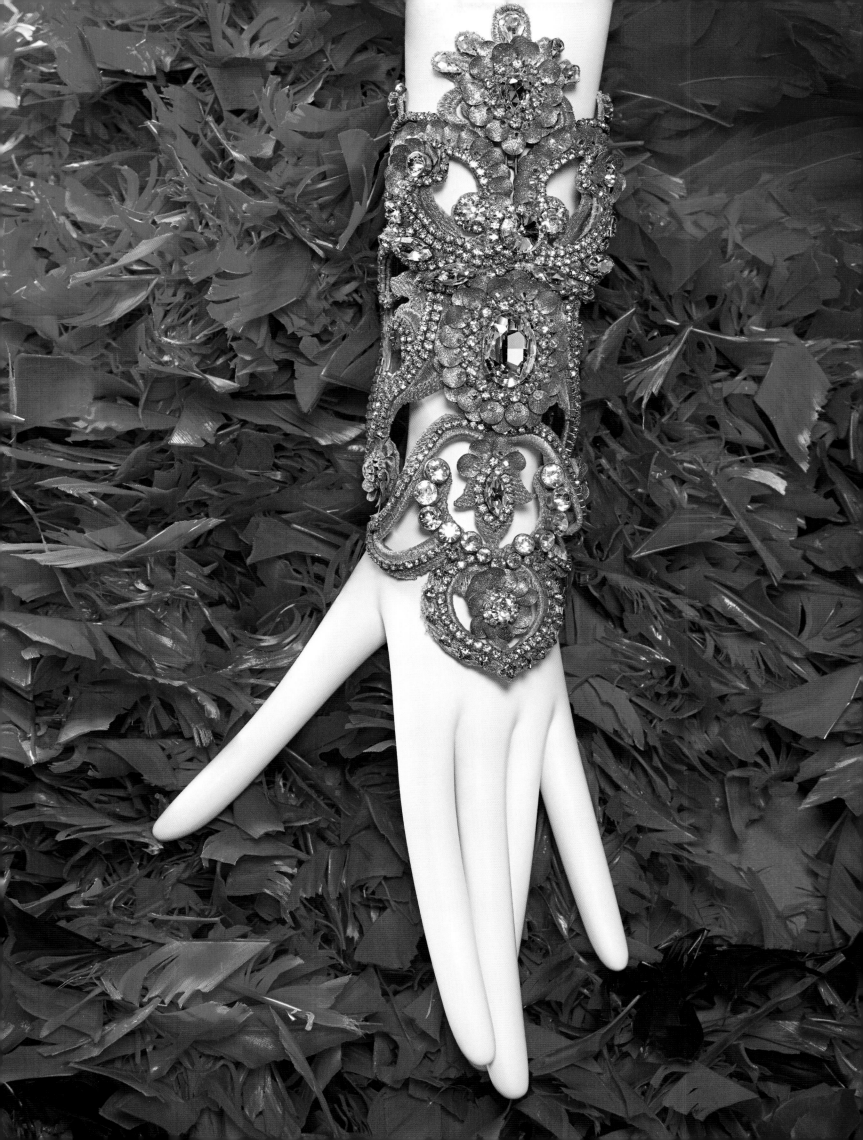

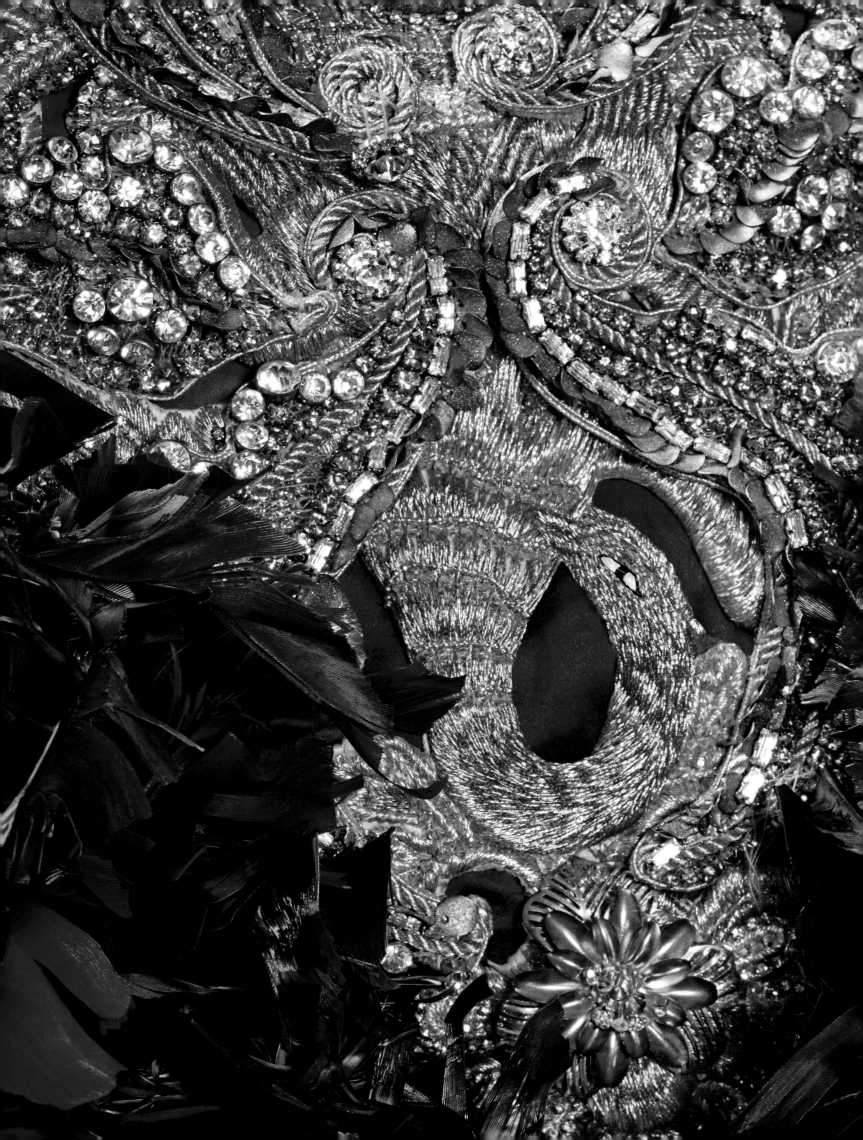

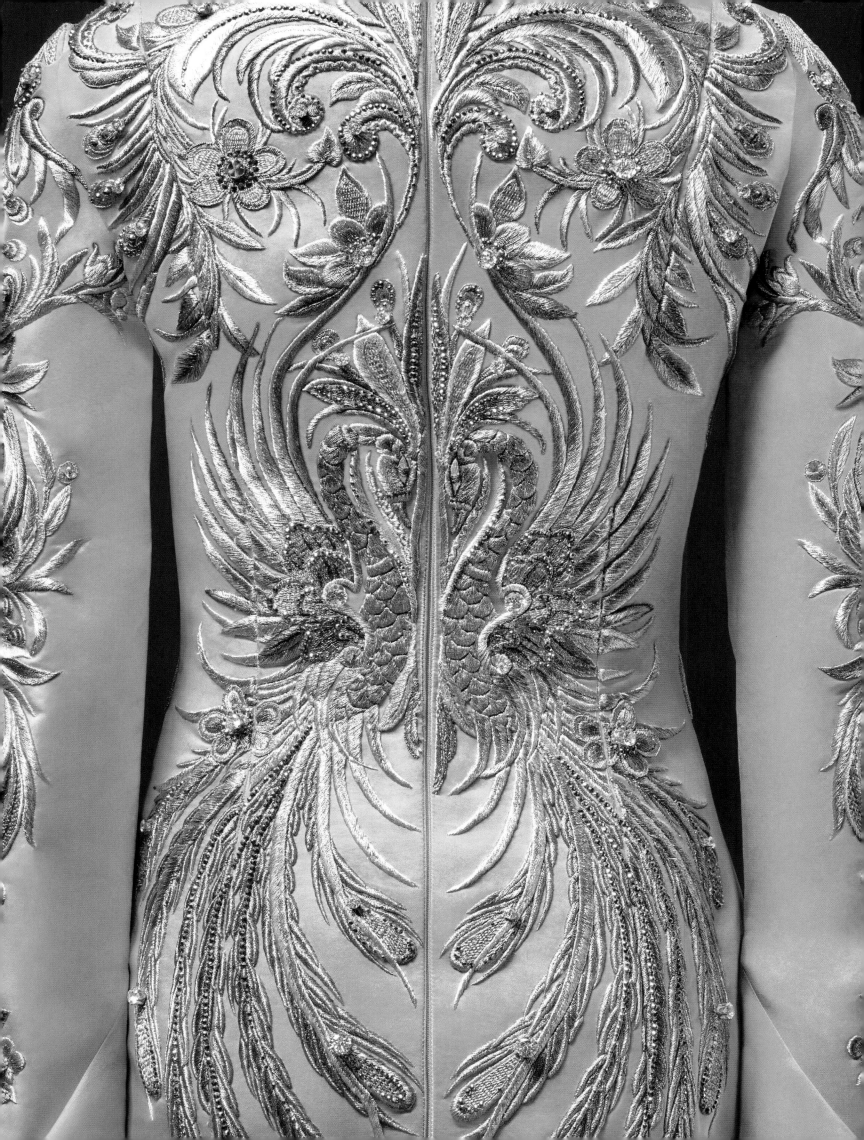

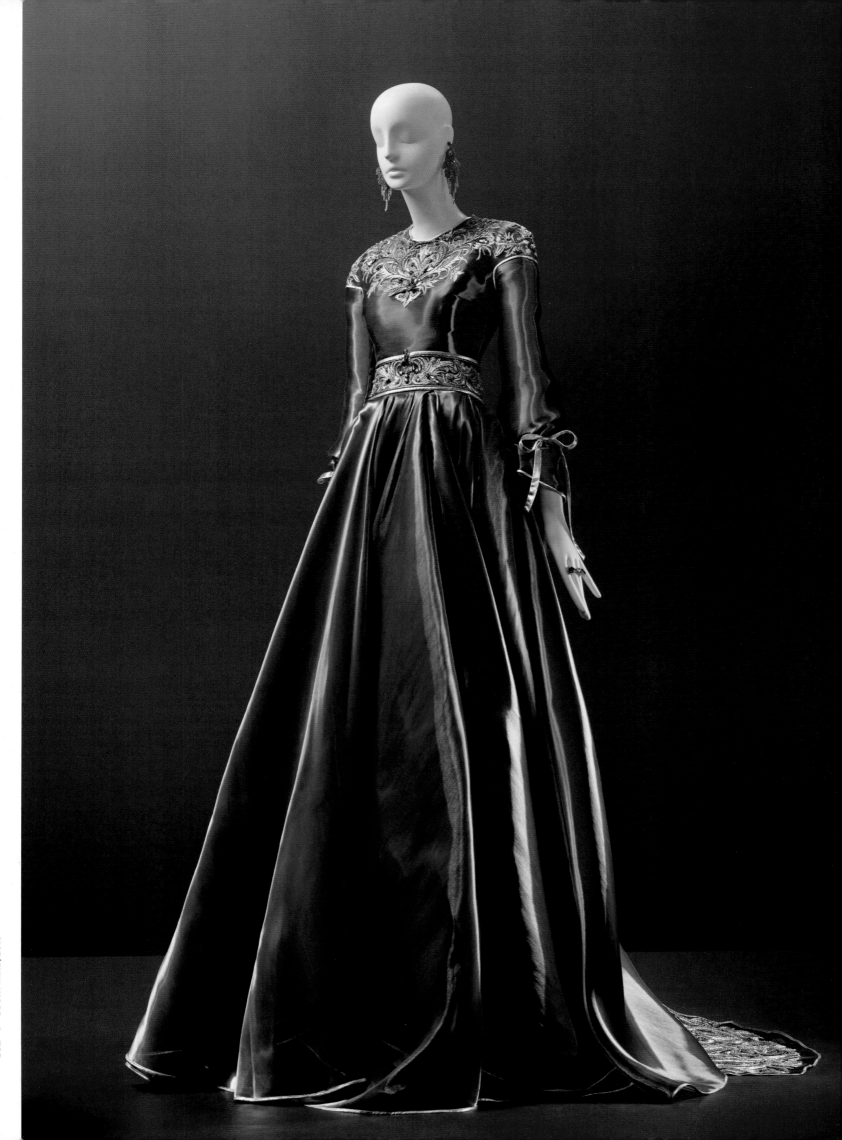

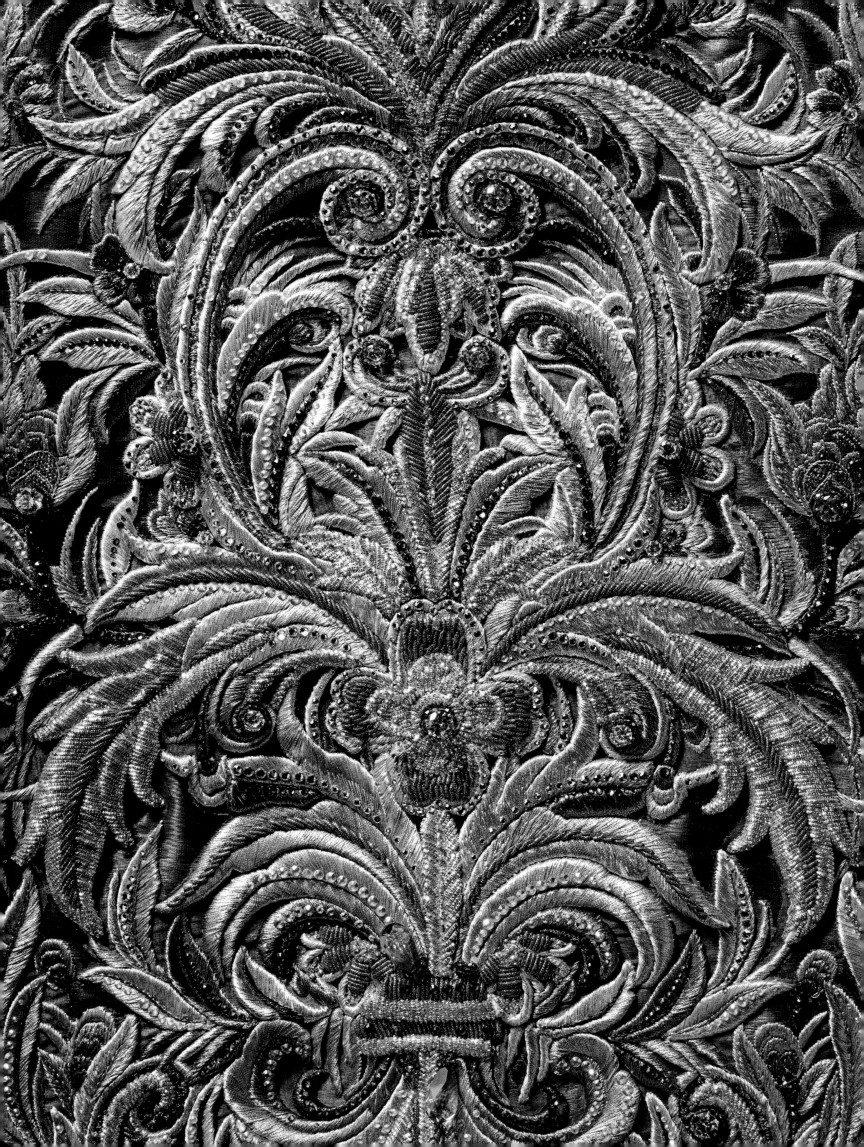

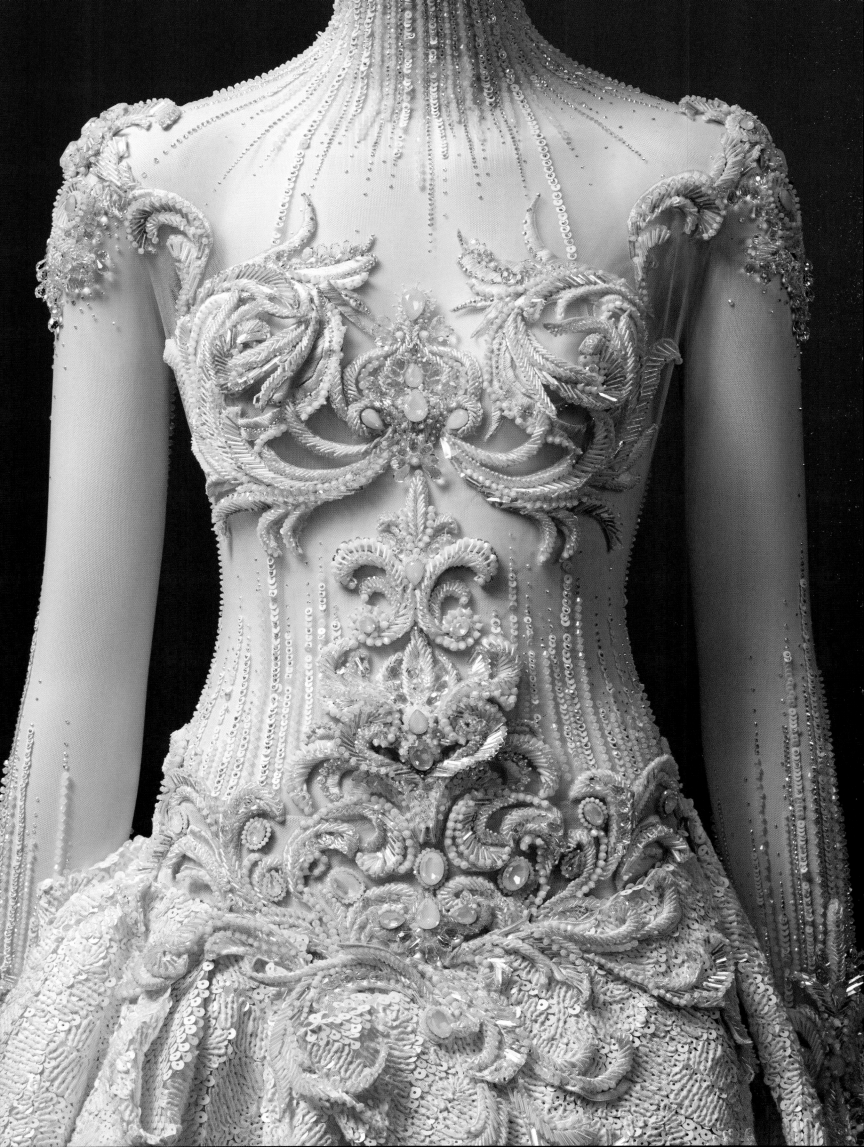

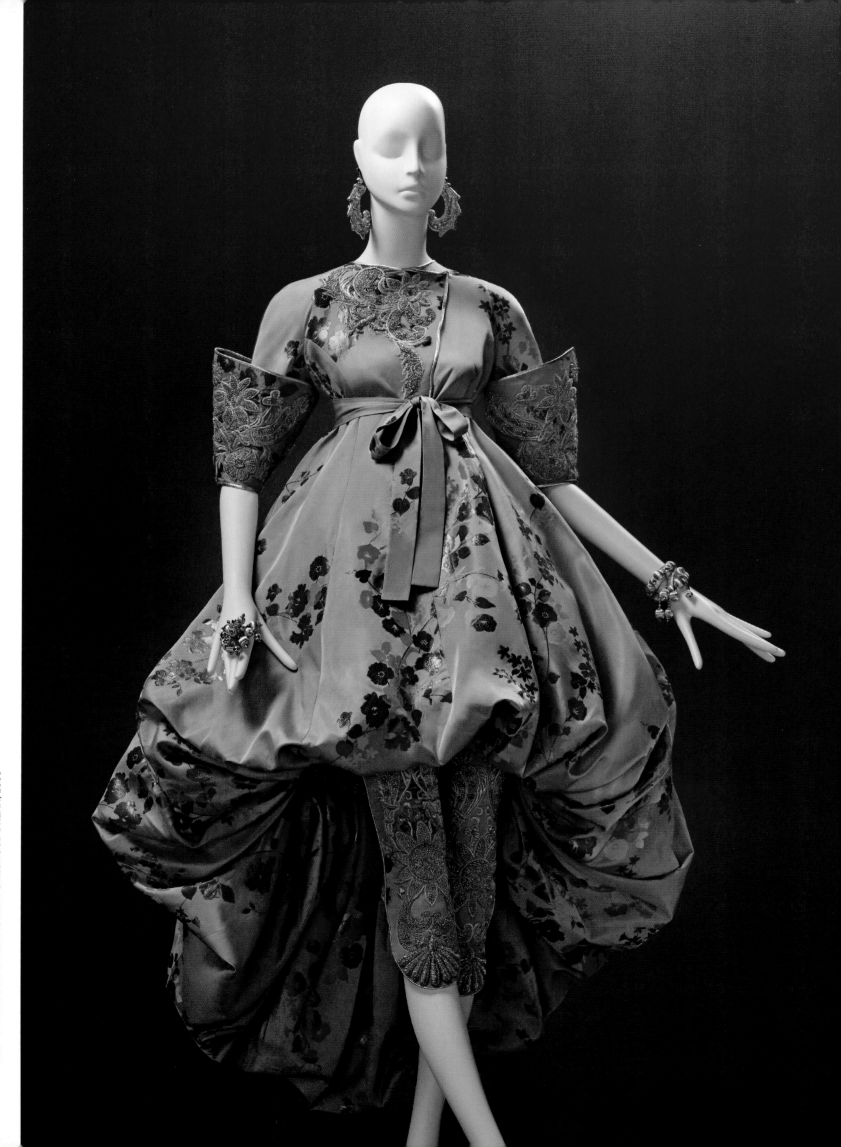

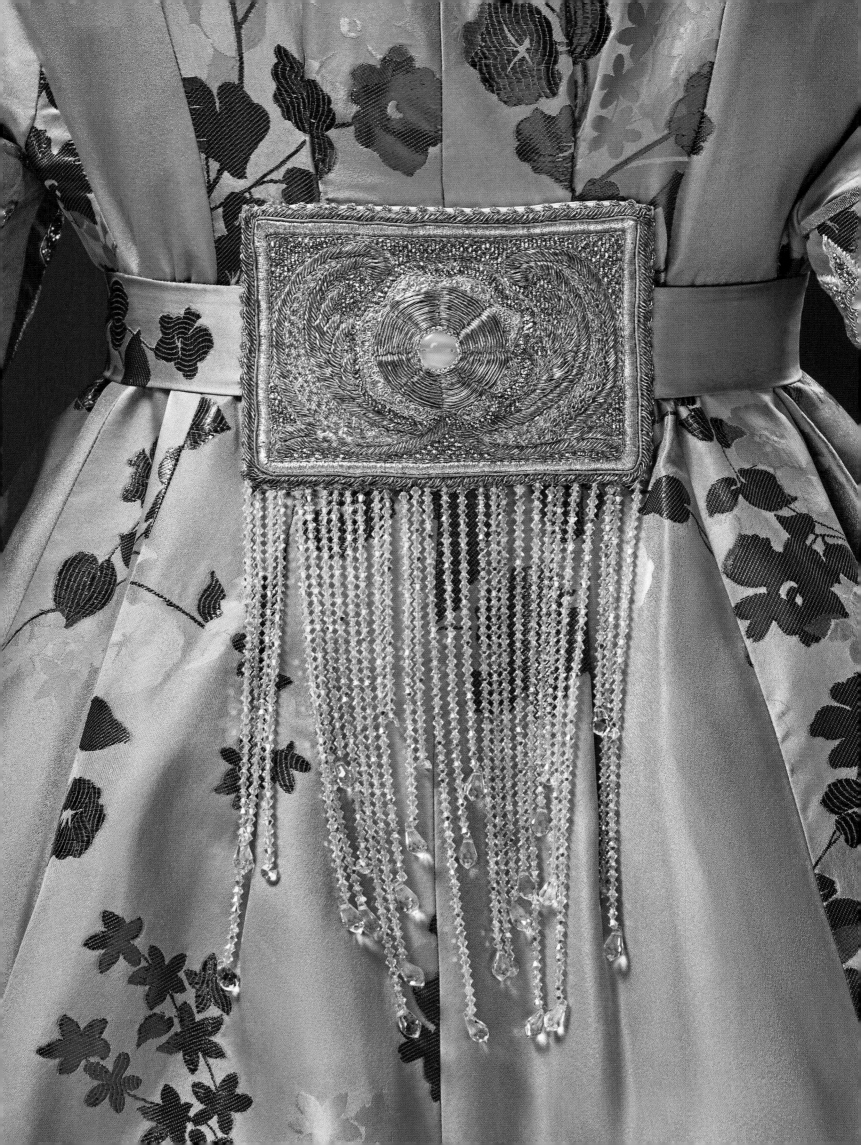

EXHIBITED WORKS

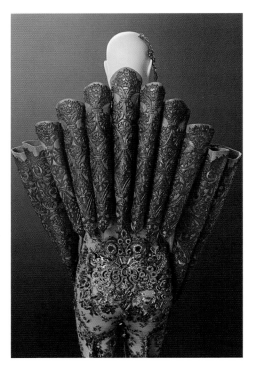

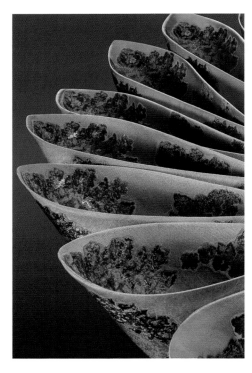

PAGES 12–17
ONE THOUSAND AND TWO NIGHTS
2010
Silk cloak embroidered with metal thread and silk- and 24-karat-gold-spun thread and adorned with silk bows and fox fur.

PAGES 18–21
ONE THOUSAND AND TWO NIGHTS
2010
Lace jumpsuit and silk jacquard jacket with mesh overlay and embellished with diamantes, gems, sequins, and copper appliqués.

PAGES 22–25
ONE THOUSAND AND TWO NIGHTS
2010
Silk jacquard dress embellished with beads, gems, Swarovski crystals, and copper appliqués.

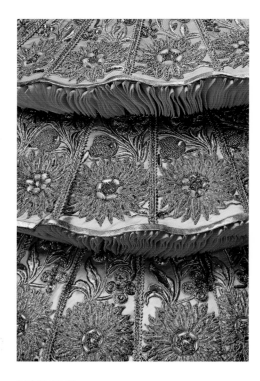

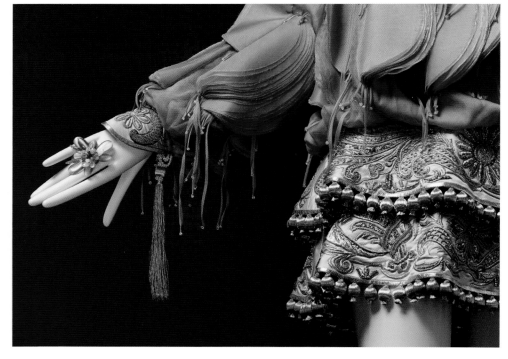

PAGES 28–31
AN AMAZING JOURNEY IN A CHILDHOOD DREAM
2008
Silk jacket embroidered with silk- and silver-spun thread and embellished with crystals, gems, and silk-covered beads; embroidered, pleated, and tiered silk dress embellished with crystals, gems, and beads.

PAGES 34–35
AN AMAZING JOURNEY IN A CHILDHOOD DREAM
2008
Silk dress embroidered with silk- and silver-spun thread and embellished with crystals and beads.

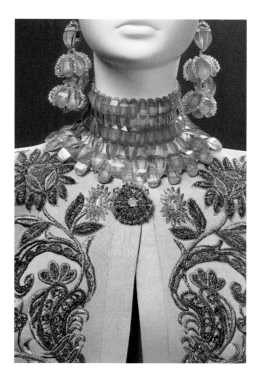

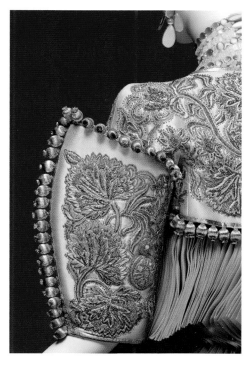

PAGES 36–37
AN AMAZING JOURNEY IN A CHILDHOOD DREAM
2008
Silk jacket and pants embroidered with silk- and silver-spun thread and embellished with crystals and beads covered in silk thread.

PAGES 38–39
AN AMAZING JOURNEY IN A CHILDHOOD DREAM
2008
Strapless, pleated silk dress embroidered with silk- and silver-spun thread and embellished with beads and crystals.

PAGES 40–41
AN AMAZING JOURNEY IN A CHILDHOOD DREAM
2008
Pleated silk dress embroidered with silk- and silver-spun thread and ornamented with beads; embroidered silk jacket with silk-covered bead fringe.

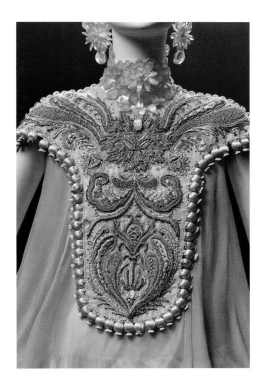
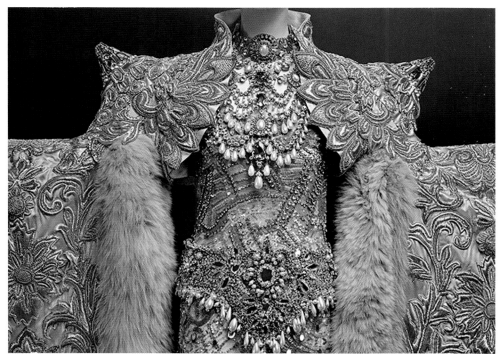

PAGES 42–43
AN AMAZING JOURNEY IN A CHILDHOOD DREAM
2008
Silk dress embroidered with silk- and gold-spun thread and embellished with crystals and beads.

PAGES 2, 46–51
ONE THOUSAND AND TWO NIGHTS
2010
Silk mesh gown embroidered with silk-, 24-karat-gold-, and silver-spun thread and embellished with crystals, gems, beads, sequins, and pearls; embroidered silk cape trimmed in fox fur; brass crown embellished with gems, Swarovski crystals, diamantes, and pearls.

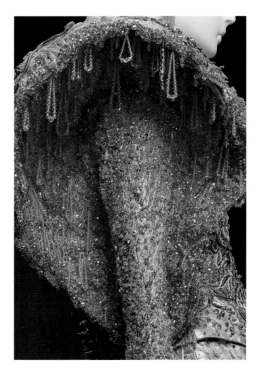

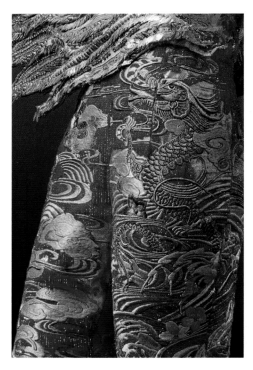

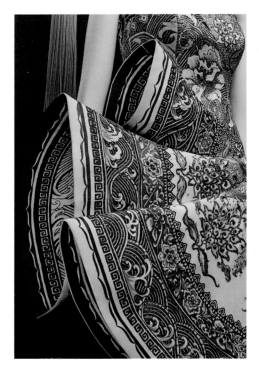

PAGES 54–57
LEGEND OF THE DRAGON
2012
Silk dress embroidered with silk- and 24-karat-gold-spun thread and embellished with beads, sequins, and Swarovski crystals.

PAGES 58–61
LEGEND OF THE DRAGON
2012
Silk jumpsuit embroidered with silk- and 24-karat-gold-spun thread and embellished with sequins, Swarovski crystals, and Swarovski beads.

PAGES 64–67
ONE THOUSAND AND TWO NIGHTS
2010
Embroidered silk gown with hand-painted motifs and embellished with Swarovski crystals; porcelain headpiece ornamented with crystals and silk tassels.

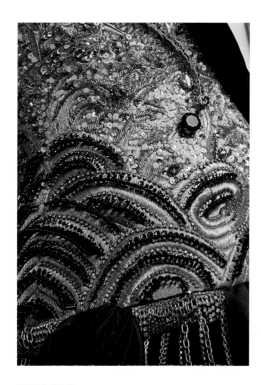

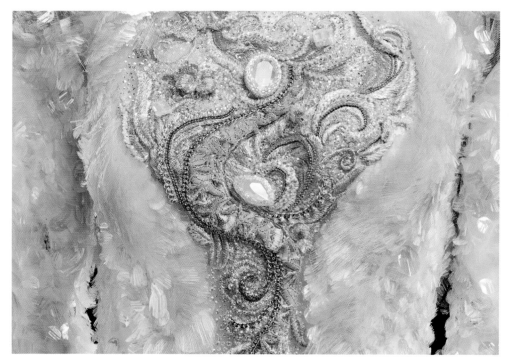

PAGES 70–71
ENCOUNTER
2016
Silk taffeta gown embroidered with silk- and 24-karat-gold-spun thread and embellished with glass beads, sequins, Swarovski crystals, and metal chains.

PAGES 72–73
ENCOUNTER
2016
Silk mesh gown embroidered with silk- and silver-spun thread and embellished with beads, Swarovski crystals, custom-made paillettes, and metal accents.

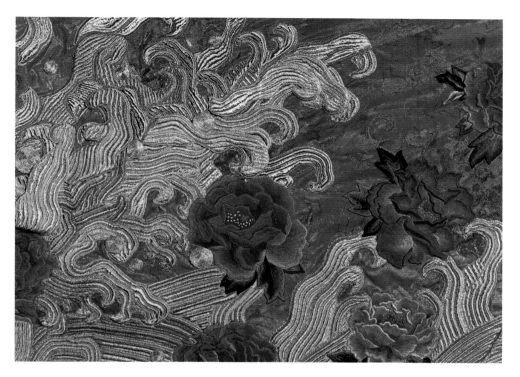

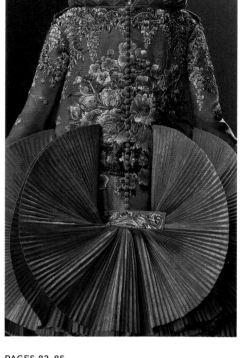

PAGES 76–81
LEGEND OF THE DRAGON
2012
Silk jacquard robe embroidered with silk-, silver- and 24-karat-gold-spun thread and embellished with beads, Swarovski crystals, and fur trim; gown embroidered with gold thread and embellished with beads, Swarovski crystals, and traditional Chinese silk peonies.

PAGES 82–85
LEGEND OF THE DRAGON
2012
Silk jacquard dress with plissé drop-waist skirt embroidered with silk- and 24-karat-gold-spun thread.

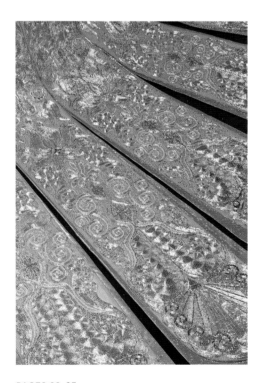

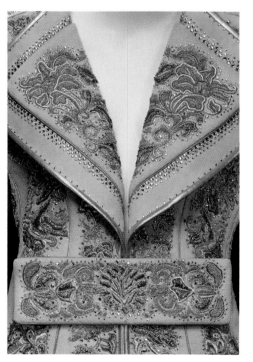

PAGES 88–93
SAMSARA
2006
Gown embroidered with wire and silk-, 24-karat-gold-, and silver-spun thread and embellished with Swarovski-sequin accessories.

PAGES 94–97
COURTYARD
2016
Structured corset and ball gown skirt made with embroidered foam to resemble leather and lace, embellished with beads, gems and brass florets.

PAGES 98–99
SAMSARA
2006
Embroidered wool and silk coat embellished with Swarovski crystals; chiffon and tulle skirt.

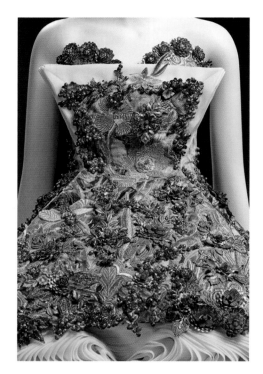

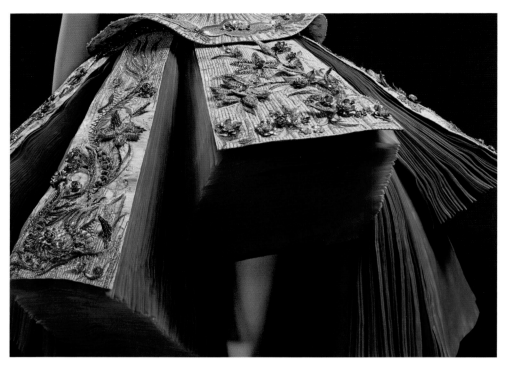

PAGES 4, 102–103
GARDEN OF THE SOUL
2015
Embroidered silk dress with hand-painted motifs and embellished with Swarovski crystals, brass beads, and brass florets; mask and headpiece with bead, crystal, and brass floret embellishments.

PAGES 104–107
GARDEN OF THE SOUL
2015
Embroidered silk and Lurex dress embellished with Swarovski crystals and brass florets; headpiece with bead, crystal, and brass foliage embellishments.

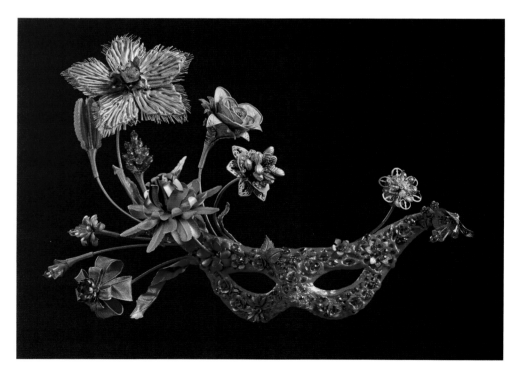

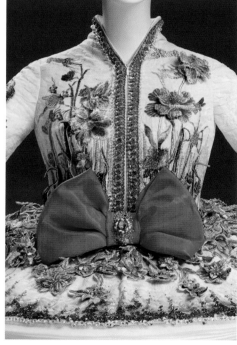

PAGES 108–111
GARDEN OF THE SOUL
2015
Embroidered silk and Lurex dress embellished with Swarovski crystals and beads, brass feathers, and brass florets; mask and headpiece with bead, crystal, and brass floret embellishments.

PAGES 112–115
GARDEN OF THE SOUL
2015
Embroidered silk ballet dress with hand-painted motifs and embellished with sequins, Swarovski crystals and beads, and brass florets; bouquet and headpiece with bead, crystal, and brass floret embellishments.

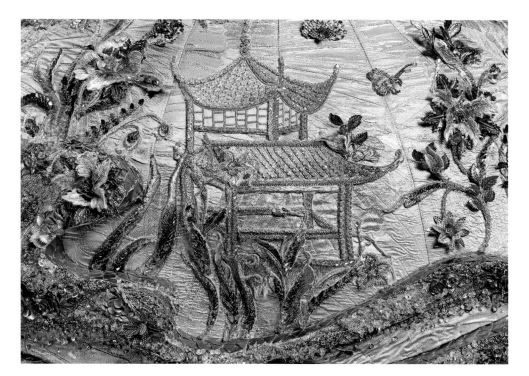

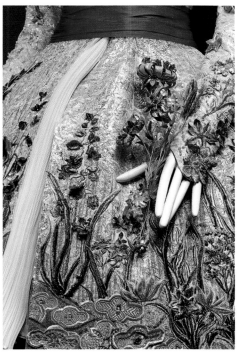

PAGES 116–117
GARDEN OF THE SOUL
2015
Embroidered silk and Lurex corseted dress embellished with sequins, Swarovski crystals and beads, brass trim, and brass florets; headpiece with bead, crystal, and brass floret embellishments.

PAGES 118–119
GARDEN OF THE SOUL
2015
Embroidered silk and Lurex coatdress embellished with sequins, Swarovski crystals and beads, and brass florets; bouquet and headpiece with bead, crystal, and brass floret embellishments.

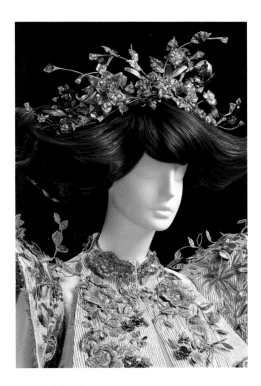

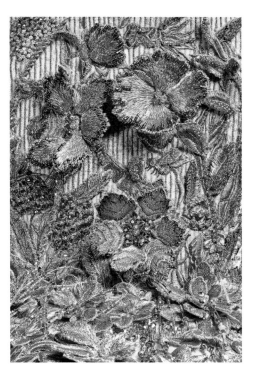

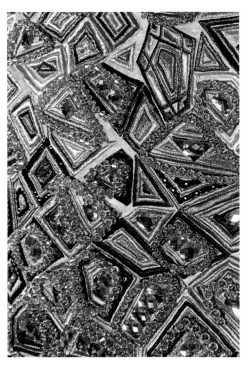

PAGES 120–123
GARDEN OF THE SOUL
2015
Embroidered silk dress with hand-painted motifs and embellished with sequins, Swarovski crystals and beads, and brass florets; bouquet and headpiece with bead, crystal, and brass floret embellishments.

PAGES 124–127
GARDEN OF THE SOUL
2015
Embroidered silk and Lurex bubble sleeve dress embellished with Swarovski crystals and beads; headpiece with bead, crystal, and brass floret embellishments.

PAGES 128–129
GARDEN OF THE SOUL
2015
Embroidered silk and Lurex arch-paneled dress embellished with sequins, gems, Swarovski crystals and beads, and brass florets; bouquet and headpiece with bead, crystal, and brass floret embellishments.

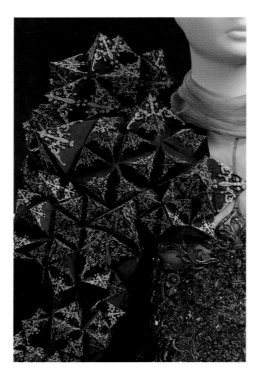

PAGES 132–137
ONE THOUSAND AND TWO NIGHTS
2010
Silk jacket embellished with embossed metal; bodice
embellished with crystals, gems, beads, sequins, and
copper appliqués; harem trousers embroidered with
copper wire and embellished with crystals.

PAGES 138–139
ONE THOUSAND AND TWO NIGHTS
2010
Silk dress with gold leaf and acrylic bodice and
mirrored geometric skirt with shoulder ornamentation.

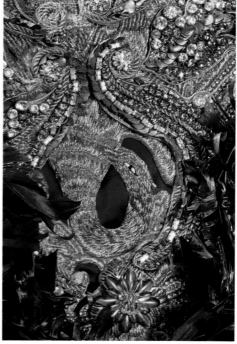

PAGES 142–145
LEGEND OF THE DRAGON
2012
Silk jacquard gown embroidered with silk- and
24-karat-gold-spun thread and metal wire and
embellished with Swarovski crystals and gems,
beads, and pearls.

PAGES 146–149
LEGEND OF THE DRAGON
2012
Silk gown embroidered with silk- and 24-karat-gold-
spun thread and adorned with feathers, diamantes,
Swarovski crystals and beads, and sequins.

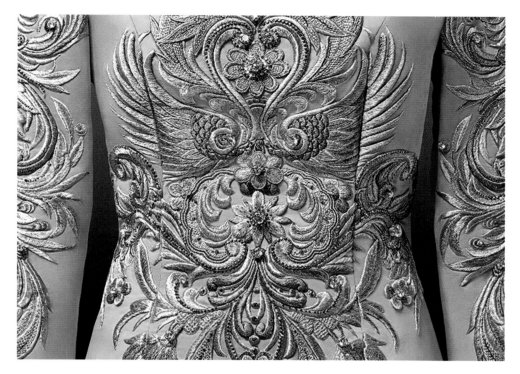

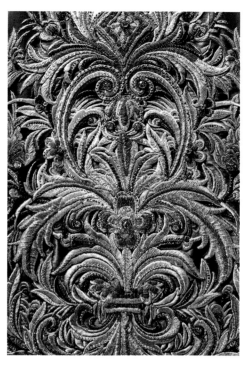

PAGES 150–151
COURTYARD
2016
Silk robe dress embroidered with silk- and silver-spun thread and embellished with crystals and diamantes.

PAGES 152–153
COURTYARD
2016
Dress embroidered with silk- and silver-spun thread and embellished with Swarovski crystals and beads.

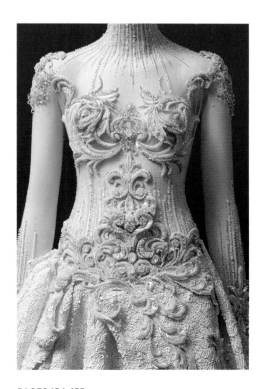

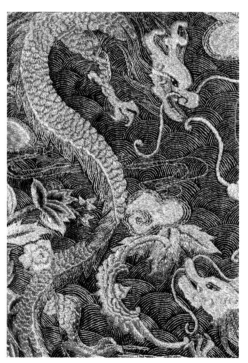

PAGES 154–155
COURTYARD
2016
Silk dress with mesh bodice embroidered with silk- and silver-spun thread and embellished with sequins and Swarovski crystals and beads.

PAGES 156–157
AN AMAZING JOURNEY IN A CHILDHOOD DREAM
2008
Silk jacquard dress and pants embroidered with silk- and silver-spun thread and embellished with crystals and beads.

ENDPAGES
ENCOUNTER
2016
Silk jacket embroidered with 12-karat-gold-spun thread and silver-spun thread and embellished with sequins, feathers, and Swarovski crystals.

GUO PEI
COUTURE BEYOND

This volume has been published in conjunction with the exhibition *Guo Pei: Couture Beyond*, first presented by the Savannah College of Art and Design at SCAD FASH Museum of Fashion + Film, September 21, 2017–March 4, 2018, and SCAD Museum of Art, October 27, 2017–March 4, 2018.

Published in the United States of America by

RIZZOLI ELECTA, A DIVISION OF RIZZOLI INTERNATIONAL PUBLICATIONS, INC.
300 Park Avenue South | New York, New York 10010
rizzoliusa.com

in association with

SAVANNAH COLLEGE OF ART AND DESIGN
scad.edu

SCAD FASH MUSEUM OF FASHION + FILM
1600 Peachtree Street | Atlanta, Georgia 30309
scadfash.org

SCAD MUSEUM OF ART
601 Turner Boulevard | Savannah, Georgia 31401
scadmoa.org

Library of Congress Control Number: 2017957333
ISBN: 978-0-8478-6066-1

Printed in the United States of America
2018 2019 2020 2021 2022 / 10 9 8 7 6 5 4 3 2 1

All images are © Savannah College of Art and Design (SCAD) unless otherwise noted. Any errors or omissions brought to the publisher's attention will be corrected in subsequent printings.

PAGE 6: Chia Chiung Chong
BACK COVER: © Timothy A. Clary/Getty Images

Designed by Design Press Books, a division of SCAD
Copyright © 2018 Savannah College of Art and Design

PUBLISHED IN ASSOCIATION WITH

SCAD CREATIVE TEAM

Paula Wallace, president and founder
Glenn E. Wallace, chief operating officer
Eleanor Twiford, associate vice president for creative direction
Kari Herrin, executive director of SCAD museums and exhibitions
Alexandra Sachs, executive director of SCAD FASH and Atlanta exhibitions
Rafael Gomes, director of fashion exhibitions
Jonathan Ashley Osborne, executive director of creative development
Eric Breen, executive director of visual media
Chris Ambrose, director of photography
Emily McKenzie Lynah, production manager
Amy Zurcher, executive director of creative ideation and design
Emily King, senior director of creative ideation and design
Jessie Ward, collections manager
Summer Orndorff, registrar and curator
Justin Ayars, registrar and gallery assistant
Emily O'Connor, art preparator
Rachel Evans, operations manager of SCAD FASH
Amanda McCall, communications manager
Rebecca Lucignoli, production assistant

RIZZOLI ELECTA TEAM

Charles Miers, publisher
Margaret Rennolds Chace, associate publisher
Loren Olson, editor
Alyn Evans, production manager
Kayleigh Jankowski, design coordinator

HOWL COLLECTIVE: Jim Lind, creative director; Patrick O'Brien, producer; Elliot Ross, photographer; Forest Woodward, photographer

PRODUCTION CREW: Jason Wang, digital tech; Riley Ames, Jack Schow, Josh Zoodsma, photography assistants; Ali Lind, production coordinator; Genevieve Allison, production assistant

RETOUCHING AND PHOTO ILLUSTRATIONS: David Field, Colin Douglas Gray, Jarred Joly, Jim Lind, José Márquez, and Scott Newman

WARDROBE STYLING: Justin Doss and Rafael Gomes

HAIR AND MAKEUP: Mary Chiang, hair and makeup agent; Rodney Groves, hair stylist; Mike Potter, makeup artist

MODELS: Julia Andhagen (Red NYC); Kate Bailey; Alyda Grace (Wilhelmina NYC); Alexxia Hipchen (NY Models); Puck Loomans (NY Models); Jing Ouyang (IMG Models); Jessica Stewart (Dallas Bugera); Stella Vaudran (Red NYC)

Guo Pei: Couture Beyond was photographed at the following locations:
GEORGIA: SCAD FASH Museum of Fashion + Film, Atlanta; Cockspur Island; Dungeness, Cumberland Island; Atlanta Botanical Gardens, Gainesville; Wormsloe Plantation, Isle of Hope; Blackwater Preserve, Register; Fort James Jackson, Majestic Oak, the Owens-Thomas House, the Ronald C. Waranch Equestrian Center, Savannah Film Studios, Savannah; Tybee Island.
SOUTH CAROLINA: Pearl Fryar Topiary Garden, Bishopville; Middleton Place Gardens and Inn, Charleston; Fort Fremont, Saint Helena Island.

ACKNOWLEDGMENTS

What I love most—beyond fashion and clothing, beyond couture—is a great book. Like delicate tapestries, books are embroidered with the wisdom of humanity and woven with the spirit of adventure. In books, writers and photographers seek to inspire, illuminate, and record the course of history.

For many years, I have dreamed of creating a book of my own, one that would tell my story and express my reverence for history, craftsmanship, and detail. I have always envisioned it being told as a story within a story, much like a fairy tale—my fairytale in fashion.

Fate is a wonderful thing indeed.

I first met SCAD President and Founder Paula Wallace in 2016. I felt an immediate connection with her. When she invited me to visit the university's campuses in Atlanta and Savannah, I had no idea I would be so moved by SCAD. In every aspect of the university, there exist elements of surprise and delight. I am grateful to Paula for her friendship and her vision, and for all that she and SCAD do to nurture young artists and designers throughout the world. Without Paula, *Guo Pei: Couture Beyond* would not have been possible.

I am honored to have had my first solo exhibition in the United States presented by the SCAD FASH Museum of Fashion + Film in Atlanta, and the SCAD Museum of Art in Savannah. My sincerest thanks to the museum curators and university staff who helped prepare and organize the exhibition.

Much appreciation also goes to the many SCAD staff and alumni who dedicated their time and talents to the making of this monograph. My heartfelt thanks to SCAD photography alumni Jim Lind, Patrick O'Brien, and Elliot Ross, who, along with photographer Forest Woodward, conceived of and produced these remarkable, captivating images. Together, as HOWL Collective, they sought to create a fantastical world, and they succeeded beyond measure. When I had the opportunity to view their images, I was drawn in completely. This is it, the book I have always wanted—my story within a story. What a perfect expression of fashion and photography.

Last but not least, my immense thanks to my new friends at Rizzoli for their support and determination to share this book with the world.

Thank you all for your passion, creativity and love.

—Guo Pei

除了服装之外，在这个世界上我最喜爱的就是书籍。如同我热爱的时装艺术，那是用针线将时光封存；而书则是将人类的智慧、将岁月的美好，记录在字里行间。

"缘分"是一种很奇妙的东西，2016年第一次见到赛凡纳艺术学院的Paula Wallace校长我就有一种莫名的亲近感，一直觉得似曾相识。在参观了整个校园之后，我被深深的感动了，学校的每一个角落都有惊喜，无不体现出Paula Wallace对教育和对艺术的真挚与热爱。当她提出要为我举办一个个人作品展览的时候，我希望她能给我出一本作品画册。于是便有了面前的这本作品集。

一直以来，都想拥有一本能够用画面讲述故事，用影调传递情感，用光影塑造梦境的作品集，我希望能有一个把时装当作故事来表达的摄影团队能够完成拍摄。在Paula Wallace的推荐下，三位毕业于赛凡纳摄影专业的Jim Lind, Patrick O'Brien, Elliot Ross和摄影师Forest Woodward共同完成了这次拍摄。当照片摆在我眼前的那一刻，我一下子就被拉进了梦幻神秘的奇幻世界。这正是我想要的，也是最完美的一次摄影表达。

感谢所有为了这本画册的诞生而努力付出的人，感谢你们的激情、创意和爱，这些也正是我想用我的作品所传达的情感。

—郭培

SCAD
THE UNIVERSITY FOR CREATIVE CAREERS

The Savannah College of Art and Design — a private, nonprofit, accredited university — was founded in 1978 in Savannah, Georgia, with academic degree programs designed to provide exceptional higher education and career preparation for students. Today, SCAD is an international university with four global locations spanning three continents — in Atlanta and Savannah, Georgia; Hong Kong; and Lacoste, France — as well as online via SCAD eLearning.

The university's more than fourteen thousand undergraduate and graduate students, who come to SCAD from more than one hundred countries, enjoy numerous academic and professional opportunities as they prepare for in-demand creative careers. Students may explore more than one hundred academic degree programs, partake in extended learning opportunities beyond the classroom, earn valuable professional certifications, and gain real-world experience before they graduate. Students transition seamlessly among the university's distinctive and complementary campuses to learn from stellar professors and develop abundant professional connections while experiencing the unique cultural milieu of each dynamic learning center.

Across all SCAD locations and programs of study, specialized educational resources enhance the university's innovative curricula. Students work with the same advanced technologies and tools available to industry professionals. Green screens, Cintiq drawing tablets, 3D printers, a Techno-Jib, fully equipped HD film and television studios, and a state-of-the-art sculpture foundry are among the professional-level resources available to help students realize their creative visions.

Premier creative firms and top-tier corporations — including Adobe, Coca-Cola, Disney, Fisher-Price, Fossil, Fox Sports, Google, Hewlett-Packard, Hershey, Microsoft, NASA, Nike, Reebok, and Saint Laurent — not only recruit and hire SCAD alumni, but they also work directly with students before they graduate. Students collaborate with corporate partners to create real-world design solutions through the SCAD Collaborative Learning Center, which engages students in authentic interactions with Fortune 100 companies.

Career preparation is woven into every fiber of the university. SCAD graduates embark on their careers ready to succeed from day one and are bolstered by an extensive network of credentialed faculty, accomplished alumni, and active staff members dedicated to career and alumni success. In a study of Spring 2016 SCAD graduates, 98 percent of respondents reported being employed, pursuing further education, or both within ten months of graduation.

SCAD provides students a robust and engaging university experience beyond the classroom and studio. Throughout the year at each of its locations, the university is host to a spectacular roster of sparkling events, from the SCAD Savannah Film Festival, SCAD aTVfest, and Game Developers eXchange to the SCAD Fashion Show, SCAD deFINE ART, and SCADstyle. These wow-worthy opportunities place students' work on center stage and connect students with the world's most celebrated creative professionals. The international network of SCAD museums, galleries and exhibition spaces forms a luminous beacon of inspiration and design innovation. Featuring today's most influential artists and renowned contemporary and historical works, the award-winning SCAD Museum of Art, the SCAD FASH Museum of Fashion + Film and the university's galleries enrich the education of SCAD students across disciplines and attract and delight visitors around the world.

As the first art and design university in the United States to offer a comprehensive intercollegiate athletics program, SCAD is fully dedicated to creating a well-rounded collegiate environment. The university's championship-winning sports teams hold recent national titles in equestrian, golf, lacrosse, soccer, and tennis.

With more degree options, course offerings, and global learning opportunities than any other art and design university in the world, SCAD champions talented students who go on to shape the future of the creative professions.

To learn more about the Savannah College of Art and Design, visit scad.edu.

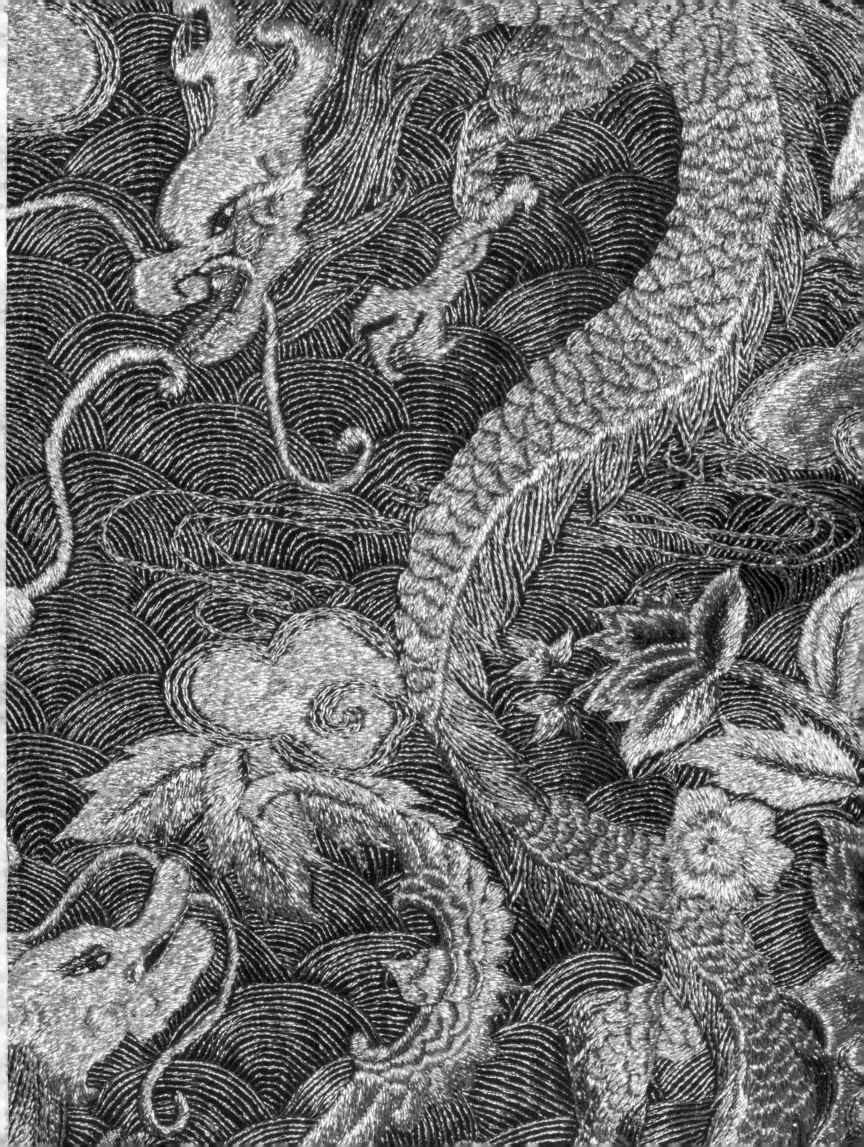

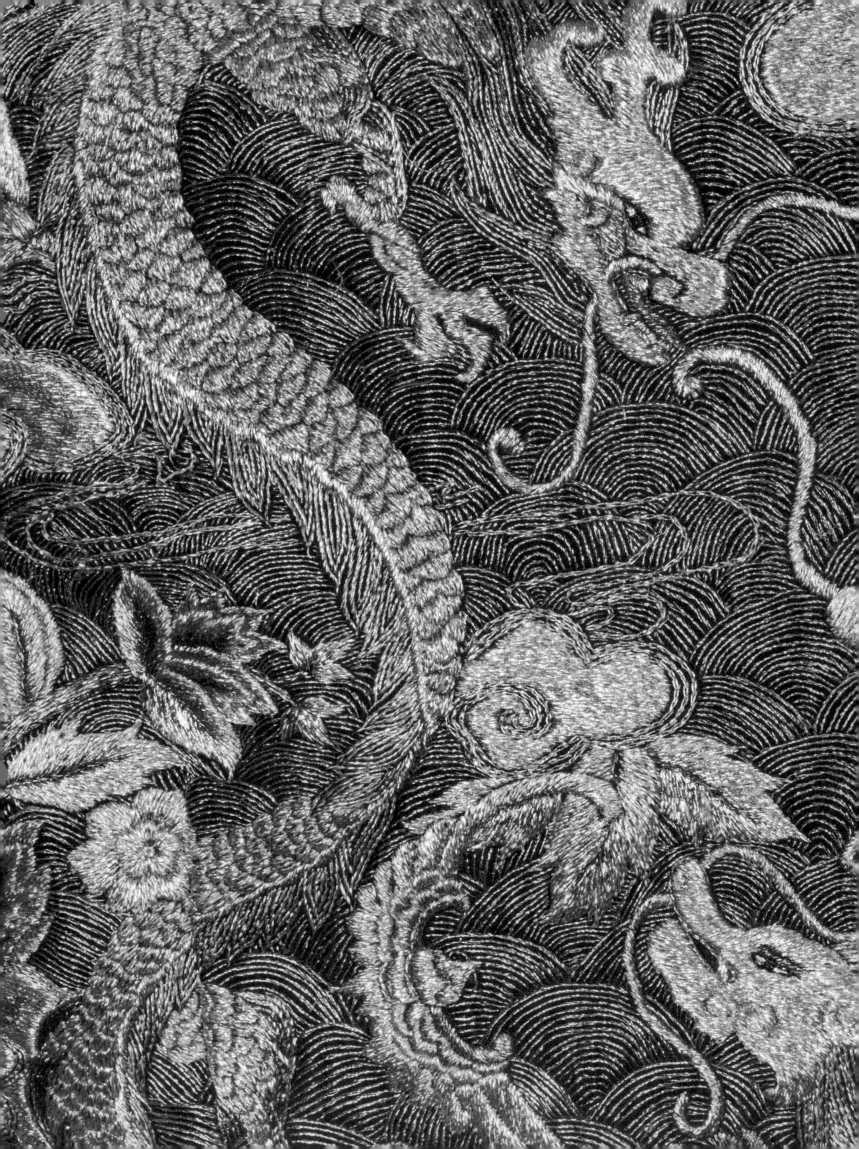